Young
Rembrandt

Young Rembrandt:
A Biography

Onno Blom

**Translated from the Dutch
by Beverley Jackson**

Pushkin Press

Pushkin Press
71–75 Shelton Street
London WC2H 9JQ

Original text © 2019 Onno Blom
English translation © 2019 Beverley Jackson

Young Rembrandt was first published as *De Jonge Rembrandt* by De Bezige Bij, Amsterdam in 2019

First published by Pushkin Press in 2019

This publication has been made possible with financial support from the Dutch Foundation for Literature

N **ederlands**
letterenfonds
dutch foundation
for literature

9 8 7 6 5 4 3 2 1

ISBN 13: 978-1-78227-559-6

Designed by Studio Jan de Boer and typeset in FF Quadraat by Tetragon, London
Printed and bound by Bariet Ten Brink The Netherlands

www.pushkinpress.com

Contents

Ich lebe ganz mit Rembrandt

I live my days entirely with Rembrandt

JOHANN WOLFGANG VON GOETHE, 1774

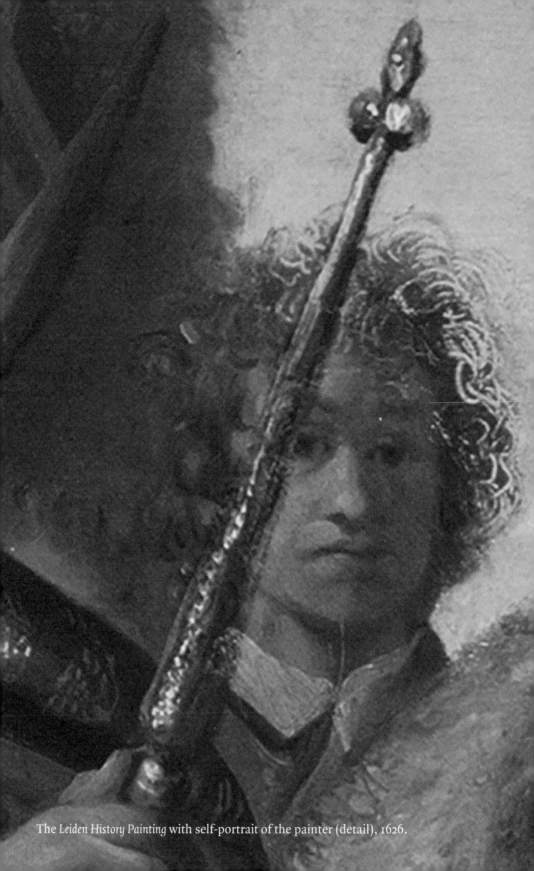

The *Leiden History Painting* with self-portrait of the painter (detail), 1626.

Prologue

I pulled the door shut behind me and walked into town, keeping the tower of the town hall ahead of me. The seventeenth-century step-gables glittered in the sunlight. After the bluestone in the middle of the surface of Breestraat, the crossing that marked the point where medieval Leiden was divided into four parts, I walked faster and with a lighter step because the street gradually slopes downward towards Noordeinde. There I turned right into the narrow passage.

Darkness. Only above my head glittered the brightness of blue sky. On the left the high wall of an old army barracks, farther on, to the right, a plaque in the façade of a monstrous block of flats commemorated an event of many centuries ago:

HERE was born
on 15th July 1606
REMBRANDT VAN RIJN

With the approach of the three-hundredth anniversary of Rembrandt's birth, a few mutterings sounded here and there among the people of Leiden. In Amsterdam, where the painter settled at twenty-five years of age to accumulate riches and fame, the magnificent house on the street then known as Sint-Anthonisbreestraat, where he lived and worked from 1639 to 1658, was purchased by the local council. It was restored and converted into a museum. Since then, the Rembrandt House has attracted hordes of tourists each year.

Nothing of the kind happened in Leiden. In 1906, a committee of erudite scholars descended upon the house of Rembrandt's birth. In the gloomy grime of this alley, the elegant gentlemen came upon a derelict stable. A soiled postcard of the interior survives from that era. It shows a crumbling tiled wall and a charred hearth.

A reporter from the local daily newspaper *Leidsch Dagblad* pocketed the card and went to have a look for himself on 17th May 1906. He was admitted by a stable-hand. On the ground floor was stationed a gleaming, jet-black carriage, "a new-fangled coach with the air of a well-fed parvenu". The journalist then proceeded to climb the stairs and had the sense of entering a haunted house. "The entire little room is full of shrouds from hearses, dangling from poles like mourning banners."

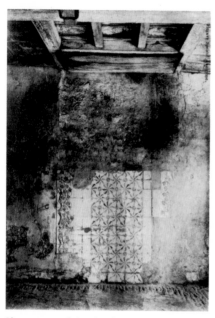 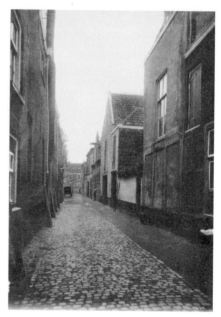

Picture postcard showing the remains of the house Picture postcard showing Weddesteeg, Leiden.
where Rembrandt was born, Weddesteeg, Leiden.

The committee had a modest plaque attached to the façade, but otherwise it rather pooh-poohed the house where the city's most famous son had been born. With the passage of time, all the buildings in Weddesteeg passed into the hands of the printing firm Nederlandsche Rotogravure, which demolished the house in 1927.

For a brief moment, Leiden showed signs of regret. In 1963, a sham Golden Age façade was erected where the house had once stood: just a wall with nothing behind it. The printing firm had plans to reconstruct the interior behind the fake façade. It purchased seventeenth-century items of furniture and stored them in the municipal museum, De Lakenhal. The plans fizzled out.

In 1980, Rotogravure went out of business and the fake façade was torn down again—along with all the buildings in Weddesteeg. Only the 1906 plaque was salvaged and later bricked into the outer wall of the new block of flats. Embarrassingly, the most recent meticulous research in the city archives reveals that even the plaque is in the wrong place: it should have been ten metres farther down the road. For that was where Rembrandt van Rijn was actually born. In a place that had vanished from the world.

When I arrived at the spot, I saw two foreign tourists pointing at the plaque and nodding excitedly. To me, the scene had an air of tragicomedy about it.

Several metres in front of me, a young man on foot wearing a wide-brimmed black hat crossed the bridge over Galgewater and disappeared from sight.

Where was Rembrandt?

Not here.

If I try to remember when and where I first stood face to face with Rembrandt, I hear the creaking boards of an old wooden floor. I must have been about seven, holding my father's hand on the threshold of the Large Press in the Lakenhal, the dark upper gallery of the Leiden museum, where the syndics inspected cloth samples in the seventeenth century. As I step inside, the wide oak floorboards sound as if they are cracking under my weight. It's like stepping onto thin ice that might give way at any moment.

It was in the Lakenhal that I saw my first Rembrandt: the 1626 *Leiden History Painting*, a jam-packed theatrical scene the subject of which is still not known today. It includes a cameo of the young Rembrandt, peering out from behind the sceptre of an imperial figure. Eyes in the dark and a head of wild curls, which he scratched into the wet paint using the back of his brush.

From across the centuries, he met my gaze.

My mother grew up in a house on the bank of the Rhine, where the river flows out of Leiden's old city centre. The upstairs apartment on Morskade where my grandparents spent their entire life together overlooked a sawmill, the Heesterboom. When the mill's sails were up and started turning, my grandfather and I would clamber into his little crimson boat and row across the Rhine. Together we would enter the mill and ascend the narrow steps up to the top, where we had a view of the entire city.

From within, the enormous machinery grated and bellowed. The axle went round and round, rotating wooden cogs that in turn caused huge serrated blades to move up and down in a rhythmic roar. In a fountain of wood dust, logs were sawn into pieces as if they were no more substantial than matchsticks.

Rembrandt was a miller's son: the fact with which almost all biographies of the painter begin. The importance of these origins should not be downplayed: Rembrandt's father, Harmen Gerritszoon, came from a miller's family that had lived and worked in Leiden for four generations. He and his family owed their entire existence to the malt-mill. They lived on the wind.

Over the years, many fanciful tales have been spun about Harmen's mill. We read that Rembrandt had a workshop in it as a young boy, learning about the effects

of light there because mills have such small windows. Charming fiction. Arnold
Houbraken, who published his lives of Golden Age painters in 1718–1721, informs
us that the mill was located between Leiderdorp and Koudekerk. An old picture
postcard of that "Rembrandt mill" bears a quatrain that may be rendered:

> When Rembrandt painted in his father's mill, still young,
> The glory of his artistic power
> Was not buried in the clouds of flour—
> From town to town it sounded and shone.

In reality, the mill belonging to Rembrandt's father stood on the western ramparts,
right next to the city gate known as Wittepoort. It was a wooden post-mill, with
no room for a studio or a boy painter. The mill of his ancestors had been located
just outside the city on the Rhine. It is marked in a bird's-eye map of Leiden prod-
uced by Jacob van Deventer around 1560. In fact it stood, I swear to God, a stone's
throw from the place where my mother grew up and my grandparents spent their
entire lives.

Through the tall windows came sunbeams that formed bars on the circular hall,
fell across the flared stone steps and illuminated the statue of an ancient goddess.
It was the day on which my father took me to enrol as a pupil of Leiden's municipal
grammar school. I was eleven years old.

We knocked on the door of the headmaster's room and entered a miasma of
cigar smoke. A man with a friendly face and glasses with rectangular lenses came
out from behind his desk. I noticed that the headmaster wore sandals and thick
grey woollen socks. As he spoke to my father, I tilted my head to read the titles in
the bookcase: Iliad, Odyssey, Metamorphoses, Aeneid. I would devour the ancient lit-
erature, although the translations often defeated me.

The headmaster, Antonius Coebergh van den Braak, was a mild-mannered
classics scholar. In retirement he would set about writing the history of six centuries
of Leiden's grammar school, which included the Latin school that Rembrandt had
attended.

All these chance convergences nourished a fascination in one boy from Leiden
for that other boy from Leiden. When I left home to go to university in Amsterdam,
this passion remained undimmed. Besides my main subject, Dutch language and
literature, I also attended lectures on art history, including those by Ernst van de
Wetering. From my father's bookcase I purloined Gary Schwartz's biography of

Rembrandt, and devoured it. I often visited the Rijksmuseum to gaze at *The Jewish Bride*—the painting still bore that title in those days.

What was it that Vincent van Gogh once said about *The Jewish Bride*? After a friend had left him gazing at Rembrandt's work in the newly opened Rijksmuseum in 1885, and returned half an hour later, Vincent was still sitting motionless in front of the painting. "Would you believe it," said Vincent, "and I honestly mean what I say, that I should be happy to give ten years of my life if I could go on sitting here in front of this picture for a fortnight, with only a crust of dry bread for food?"

My love of Rembrandt was rekindled while I was writing the biography of the sculptor, painter and writer Jan Wolkers. "Rembrandt passed like a fever through my blood," he wrote. From an early age, Wolkers was enthralled by the artist because he had painted so marvellously the scenes that his rigidly devout father read to him from the Bible three times a day. "Religion and brushstrokes appeared to coalesce."

The young Jan decided to become an artist: he would use paint to create his own world in opposition to the drab Calvinist world of his parents. In 1943, just before his eighteenth birthday, after a summons from the *Arbeitseinsatz* came through the letterbox at his parents' house in Oegstgeest ordering him to report for forced labour in Germany, he went into hiding in an attic room in the nearby city of Leiden. He did not consider it an ordeal. On the contrary, it was an opportunity to escape from his father's hard hand and the scourge of God. For Jan Wolkers, the German occupation meant his own personal liberation.

In the middle of the war, he was the last pupil left at Leiden Academy of Art, Ars Aemula Naturae, whose directors were both ardent supporters of the Dutch Nazi collaborators. At the academy, Jan stood at the mirror drawing himself, his sheet of paper on the easel flanked by reproductions of Rembrandt self-portraits. When the fascist director saw him at work, she said: "One day, you'll be the Rembrandt of the Third Reich."

Early in the morning of 15th July 1944, Rembrandt's birthday, he and a friend paid a tribute to his hero. They went to Weddesteeg, where the house of Rembrandt's birth had once stood, and hung a wreath to which they attached a quatrain that may be roughly translated:

> Of laurel wreaths you have no need,
> For speeches now the time has flown.
> And they are superfluous indeed:
> That you are the greatest by all is known.

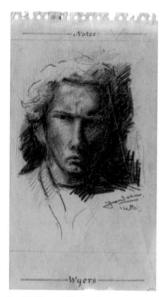

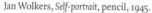

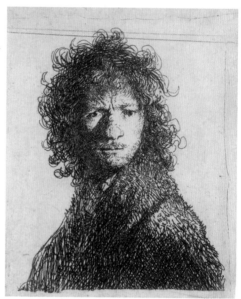

Jan Wolkers, *Self-portrait*, pencil, 1945. *Self-portrait*, etching, 1630.

Wolkers then sent an anonymous letter to the local paper, in which he suggested that he had seen two other boys hanging up the wreath. On 16th July 1944, the *Dagblad voor Leiden en omstreken* printed the final sentence of the letter: "It is all the more poignant that a couple of young lads from Leiden, in spite of this official lack of recognition, should have realized what Rembrandt meant for the Netherlands, and in particular for Leiden, the city of his birth."

Rembrandt had awakened in Wolkers not only the painter, but also the writer.

From the moment that I embarked on this biography of the young Rembrandt, I started retracing his movements on a daily basis. In the Lakenhal, in the Mauritshuis in The Hague and in the Rijksmuseum, I gazed into his eyes. In the municipal archives in Leiden I hunted down every letter containing a reference to him or the Van Rijn family. I scoured antiquarian stores and bookshops to get my hands on whatever I could find about him.

Lying on my desk is a copy of the book containing the very first biographical sketch of Rembrandt that was ever published: the *Beschrijvinge der Stadt Leyden* by Jan Jansz Orlers. In this voluminous chronicle, Orlers dedicated almost a page— exactly 350 words—to "one of the most renowned living Painters of our age" in the second, revised and expanded edition of his work, dating from 1641.

It is a glorious book, Orlers's declaration of love for Leiden. A potpourri of

descriptions of the city, history, miscellaneous scraps of information and several biographical sketches of leading public administrators and artists, including "Rembrant van Rijn". This was the artist's original spelling of his name: he did not add the "d" until he settled in Amsterdam.

For me, the book is priceless. It enables me to roam around my own city in the seventeenth century. Through neighbourhoods with evocative names like 't Land van Beloften, Paplepel and Pelicaenshoeck ("the Land of Promises", "Porridge-Spoon" and "Pelican's Corner") and alleys like Bouwelouwesteeg, Diefsteeg, Stinksteeg and Duizenddraadsteeg ("Bouwe Louwe Alley", "Thief Alley", "Stink Alley" and "Thousand Thread Alley").

Even better was the opportunity Orlers gave me to look through his eyes into buildings that no longer exist. Into the Church of Our Lady, of which all that remains is a vague pattern in the paving stones. Or the former chapel of the Faliede Bagijnen, where the new academy proudly built up its library and installed an anatomy theatre.

The vellum binding of my copy of *Beschrijvinge der Stadt Leyden* is smooth and soiled from centuries of use. Orlers would have felt gratified. He was a chronicler, but most of all he was a successful bookseller and city councillor. Four times he was elected as one of the city's burgomasters.

Not so long ago I stood outside the front door of De Gulden Laers ("The Golden Boot"), where Orlers lived. It was a house packed with books and paintings on Pieterskerk-Choorsteeg, a narrow alley in the shadows of the vast Gothic edifice of the Pieterskerk, the Church of St Peter.

Whenever I found myself unable to write, I set off following the ghost of Rembrandt, roaming the city. Suddenly I remembered that Leiden has its own local expression for a difficult childbirth: "the Pieterskerk must pass through the Choorsteeg".

It was as if Orlers was winking at me. Since scarcely any personal, intimate documents relating to the young Rembrandt have come down to us, I had to construct him in my biography from his surroundings, from what he saw every day all around him.

I built my sentences from the stones of my city.

LEIDEN, WINTER 2017–SUMMER 2019

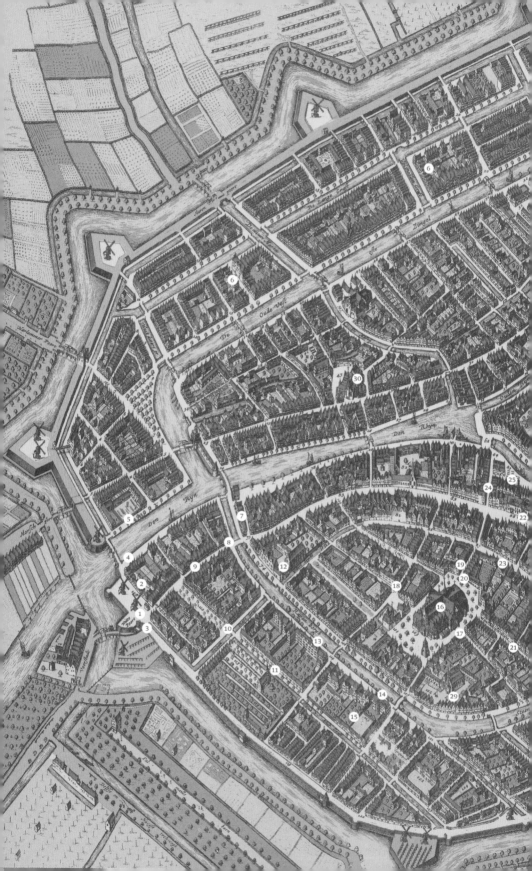

MAP OF LEIDEN, JOHANNES BLAEU, 1633

1 The malt-mill (De Rijn) of Rembrandt's parents.
2 The house in Weddesteeg where Rembrandt was born.
3 The city gate, Wittepoort.
4 Houses belonging to Harmen Gerritsz overlooking Galgewater, possibly Rembrandt's studio.
5 Main city carpentry yard.
6 Fourth expansion: Walenwijk, a new district built in the period 1611–23.
7 Parental home of Gerrit Dou on Kort Rapenburg.
8 De Drie Haringen, the inn run by the parents of Isaack Jouderville.
9 Noordeinde.
10 't Sand, Groenhasegracht.
11 Target-practice yard of the militia which Rembrandt's father left in 1611 following an accident.
12 Prinsenhof, Rapenburg, where the Winter King's children lived.
13 House of the Knotter family, where Remonstrant services were held.
14 University building where Rembrandt enrolled as an arts student in 1620.
15 Botanical gardens, academic herb garden with covered gallery or *ambulacrum*.
16 Pieterskerk, the church in which Rembrandt's parents married and were buried.
17 Quarter where the Puritans settled 1609–20.
18 Latin school attended by Rembrandt.
19 De Rosencrans, parental home of Jan Lievens in Pieterskerkchoorsteeg.
20 De Gulden Laers, home of the bookseller, city chronicler and burgomaster J.J. Orlers.
21 House of Hendrick Swaerdecroon, where Johannes Wtenbogaert lodged as a student.
22 Leiden town hall on Breestraat.
23 Studio of Jacob van Swanenburg, Rembrandt's first teacher, Langebrug 89.
24 Pharmacy of Christiaen Porrett, Maarsmansteeg.
25 Het Gulden Vercken at Vismarkt, the bakery where Rembrandt's mother grew up.
26 The citadel (De Burcht).
27 Church of St Pancras.
28 Saaihal, the main centre of the cloth trade.
29 Faliede Bagijnhof, university library and anatomy theatre.
30 Church of Our Lady (Onze-Lieve-Vrouwekerk).

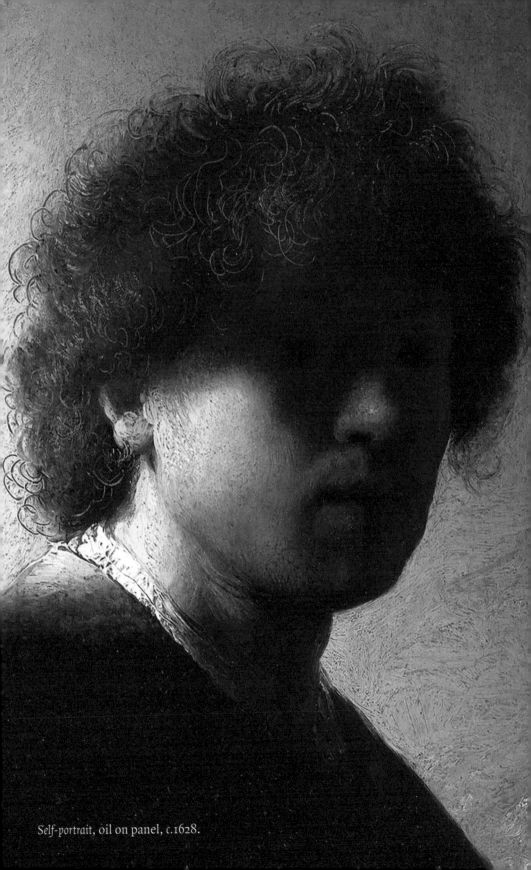

Self-portrait, oil on panel, c.1628.

I

RHL

THE YOUNG PAINTER STOOD IN HIS STUDIO AT SOME DISTANCE FROM the large panel, fixing it with his gaze: David staring at Goliath just before he raised his sling to slay the giant with a single, perfectly aimed shot.

Standing on the table are two bottles containing oil and varnish. Beside them lies the grinding slab, still bearing splashes of blue paint. On a nail hammered into the wall hang two clean palettes, the smaller over the larger one, like a fried egg.

The painter stands motionless. Rembrandt probably took himself as the model, but he is not very recognizable. He has parsed himself into a sketch. A stripe for the mouth, two black dots for the eyes. His clothing is layered. The blue-grey tabard, its sash tied elegantly around his waist, reaches down to his shoes. It cannot have been warm in the studio.

His right hand dangles, the brush held between thumb and index finger. His left hand is held against his chest: the rest of the brushes stick up, the palette is to the side, where we cannot see it. With his little finger he clasps the long maulstick, on which he rests the ball of his thumb as he confidently places his brush on the panel.

The studio is bare; there is just the painter with his panel. No visitors are to be admitted; the door is securely locked. There is no key. There are no objects that might interrupt the gaze—a gleaming shield, a musical instrument, a book or a snuffed candle—and suggest a symbolic interpretation. As a result, our gaze continues to hover in the space itself, in that golden light, past the shadow of the easel on the wide floorboards and the cracks in the stucco of the walls.

The painter works in a seated position: that much is clear from the worn places on the horizontal beam of the easel. So he must have moved the chair out of the way; it was blocking his view. What did he see?

The most fascinating thing about this little painting is that we have no idea. The artist has turned the dark back of the panel towards us, leaving us to visualize whatever image we please.

There is one possibility that solves the mystery while preserving it. It is that the painter is rapt in thought, still deciding what he is going to paint. Could the

panel be blank and bare, like the studio itself? That would mean that Rembrandt has here depicted the process of conception or *inventio*. In his mind's eye, the painter sees the image gradually form.

He thinks: *That* is how I will do it.

His life began in Leiden. Rembrandt Harmenszoon van Rijn was born in 1606 into a large family, as the youngest son of the miller Harmen Gerritsz and the baker's daughter Cornelia Willemsdr van Zuytbroeck, known as "Neeltje". He grew up in Weddesteeg, behind the western embankment on which stood his father's mill. The family took its name from the Rhine, the river that flowed out of the city at the end of the alley, towards the polders of Holland and onward to the endless sea.

"R" or "RH": that was how Rembrandt signed his work when he first set up as an independent artist in Leiden. Some three years later he switched to the letters "RHL", and in 1631, the year of his move to Amsterdam, he would occasionally sign "RHL van Rijn". The three elegantly penned initials stand for "Rembrandt

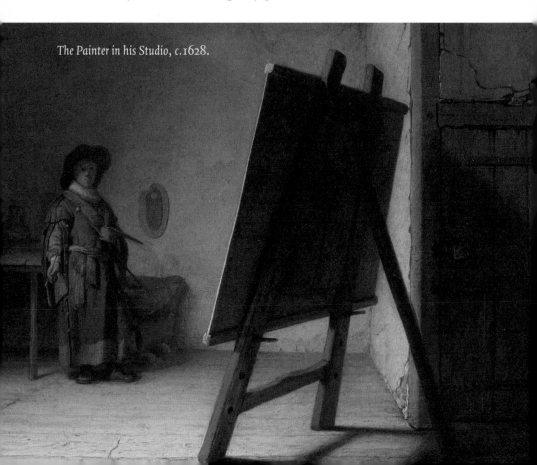

The Painter in his Studio, c.1628.

Harmenszoon Leidensis" and represented a tribute to his origins: to his father and the city of his birth.

The monogram echoes the first written evidence of Rembrandt's existence. On 20th May 1620 he enrolled as an arts student at the university. He was fourteen years old and living with his parents: "Rembrandus Hermanni Leydensis, studiosus litterarum annorum 14, apud parentes."

Rembrandt attended the Latin school, studied for a time and decided at a relatively late stage to become a painter. It was not until he had spent two years at the university that his father apprenticed him to a local master. But from his very first day as an apprentice, he threw himself into his art with boundless energy. He adhered to the maxim of Apelles, the greatest painter in antiquity, who could enchant and deceive humans, and even animals, with his brush: "Nulla dies sine linea." Not a day without a line drawn.

Ambition and enthusiasm gave him wings. When Constantijn Huygens, secretary to the stadtholder, Frederik Hendrik, and a connoisseur of art, visited Rembrandt's Leiden studio in the spring of 1629 and saw the history painting *Judas Returning the Thirty Pieces of Silver* on the easel, his mouth fell open with astonishment.

"I maintain," Huygens wrote excitedly in his memoirs, "that no Protogenes, Apelles or Parrhasius has ever produced, nor ever could produce even if they were able to return to this world, what has been achieved by a young man, a Dutchman, a beardless miller, in a single human figure and depicted in the totality [of the painting]. I stand amazed even as I say this. Bravo Rembrandt! To have brought Troy—indeed, all of Asia—to Italy, is a lesser feat than to capture for Holland the highest title of honour from all of Greece and Italy—and this by a Dutchman who has scarcely ventured beyond the walls of his native city."

In the late 1620s, Rembrandt developed at lightning speed. And over the next four decades he would garner fame—not just in Leiden, Holland or the wider Dutch Republic, but throughout Europe. The monk and art lover Gabriel Bucelin, from southern Germany, listed Europe's leading painters in 1664. The connoisseur enumerated 166 painters, including Titian, Leonardo, Tintoretto, and from his own age Poussin, Rubens and Van Dyck. Beside just one of these names, that of Rembrandt, he scribbled an addition—"Nostrae aetatis miraculum", the miracle of our age.

So how did a miller's son from a provincial city in Holland, born at the dawn of the seventeenth century, become one of the most famous painters in the world?

Jacobus Streybyg Borussus studiosus iuris annor 27
Daniel Heyn Borussus studiosus iuris annor 22
Henricus Heyn Borussus studiosus iuris annor 21
habitant apud D. Cliverum

16 Johannes Andrea Rostochiensis studiosus Medicinae
annor 20
Albertus Knopperus Rostochiensis studiosus iuris annor 21
apud Arnoldum Simons
Isaac Abrahami a Dorislaer studiosus Theologiae annor 16
apud Dnum Magistrum Ludolphi
Petrus Naaltwyk Briclanus studiosus Medicinae
annor 23 Apud Jacobum Wilhelmi
17 Daniel Castellanus Leydensis studiosus litterarum
annor 12 apud patrem
18 Wesselus Pompomus Groeninganus studiosus Medicinae
annor 20 apud Jelium Johannis
Adrianus Petri Ravestein Delfensis studiosus philosophiae
annor apud Johannes Maltzin
20 Michael Zybek Borussus studiosus iuris annor 24
apud Gerardum Johannes
Wolffgangus Hofman Boro de grünpuhl et sternzaw
dominus in Rabestein etc. annor
Ambrosius forster Briga Silesius studiosus iuris annor 30
Adamus Bielzemskei Silesius studiosus iuris annor 25

Jacobus Pfeudler Marcomannus
Nicolaus Toppincka Marcomannus annor 22
annor 22
Rembrandus Hermanni Leydensis studiosus litterarum
annor 14 apud parentes
27 Gerardus a Cranenburg Geldrus studiosus iuris annor 20
apud Gerardum Breech
28 Wilhelmus Johannis de Hoogh Delfensis annor 21
studiosus medicinae
Ubrandus de Cock Hagiensis studiosus Medicinae annor 20
apud Christianum Porret

30 Johannes de Watines Doctor Medicinae Ann 25 Apud D Arnoldum de Lanoy Pastorem Gallicum
Reynerus ab Efuelt Arnemiensis Ann 22 Apud Theodorum Ecclesiast op den Rhyn
Jacobus Gualteri Ann 21 apud Petrum Lefeure
Guilielmus a Groeningen Amsterod Ann 18 apud Jacobum

Volumen inscriptionum, 1618–31.

Very little is known about the young Rembrandt. From his boyhood days in Leiden—in contrast to his Amsterdam period—only a few dozen documents have survived: entries in administrative registers (*bonboeken*) relating to his family, the house and the mill, records relating to the neighbourhood in which he was raised, and notarial instruments. We have not a single personal letter, diary or notebook. Possibly none ever existed. The most intimate part of him that remains is his work.

Rembrandt is a mystery like Shakespeare, who also had neither influential family members nor an inherited personal fortune, and did not attend university. Yet Shakespeare conjured from such humble beginnings plays and sonnets teeming with intellectual and popular allusions that amaze the world to this day.

Notwithstanding his mythical status, Rembrandt was not always held in such high esteem. In fact, just before his death in the autumn of 1669—alone and destitute, in his rented apartment on Rozengracht in Amsterdam—the roughly painted work of his later years went out of fashion. His contemporary Gérard de Lairesse described Rembrandt's work as "liquid mud on the canvas", and referred sneeringly in his *Treatise on the Art of Painting* to the painter's "splotches". Arnold Houbraken wrote of Rembrandt, in his lives of the Dutch artists (*De Grote Schouwburg der Nederlandse kunstschilders en schilderessen*), that "close up, his paintings looked as if they had been laid on with a trowel". Houbraken, a pupil of Samuel van Hoogstraten, who himself had studied with Rembrandt, relates that if visitors came to the master's studio, he would tug people away who peered too closely at his pictures, saying: 'The smell of the paint would bother you.'

He was said to have painted a portrait that was so heavily impastoed "that you could lift it from the floor by its nose". "Thus you see also gems and pearls on jewels and turbans that are painted in such a raised manner that they look as if they have been modelled, a way of handling his pieces which makes them look strong even seen from afar." With this latter remark Houbraken defends Rembrandt in a manner of which the master himself would have approved. In a letter of 27th January 1639 to Constantijn Huygens, enclosed with a painting offered as a gift to ingratiate himself with the stadtholder's secretary, Rembrandt had written: "My lord, hang this piece in a strong light and where one can stand at a distance, so that it will sparkle at its best."

After a visit to the artist's studio, the secretary to Prince Cosimo, later Grand Duke of Tuscany and a passionate art collector, jotted down in an entry for 29th December 1667 in his travel journal that Rembrandt was a "pittore famoso". In these notes, he used the adjective *famoso* for only two other artists: Gerrit Dou, Rembrandt's "sorcerer's apprentice", and Frans van Mieris, the "prince of the

pupils" of Dou. In their day they were the most popular and most expensive painters in the whole of Europe—and they never left Leiden, the city of their birth.

The academic theorists of the mid seventeenth and mid eighteenth centuries reviled him. They preferred the classical, fine, smoothly painted style that was perfected, ironically enough, by Rembrandt's own Leiden pupils.

In the nineteenth century, Rembrandt was rediscovered. The influential critic and collector Théophile Thoré-Bürger (writing under the pseudonym of William Bürger) described the painter in his *Musées de la Hollande* as "mysterious, profound, and intangible". Compared to Rembrandt, said Thoré, Gerrit Dou was nothing but a slick conjurer.

After Belgium's secession in 1830, the Netherlands needed an icon, a Protestant national hero as a counterpart to the elegant Catholic artist Peter Paul Rubens. In 1852, a statue was erected in a square in Amsterdam, in honour of the miller's son from Leiden. He embodied the nation's ideals. Rembrandt took on the identity of the Netherlands.

In 1882, the much-feared critic Conrad Busken Huet called his history of the Netherlands *Het land van Rembrand*—"The Country of Rembrandt". Huet depicted the painter as the cleverest Dutchman who had ever lived, and urged historians to emulate his style: this meant writing "with many omissions, much exaggeration, and [shining] a great deal of light onto a handful of facts and motives".

Rembrandt's gift, his "cleverness", can be inferred not only from his exuberant style, his colours or his chiaroscuro, the dramatic effect of light and dark. His work is technically astounding, but above all it radiates the felt life. Spontaneous, authentic. True and real. That is the sensation that communicates itself to many who come face to face with one of his portraits: the quality of humanity.

Take the portrait that Rembrandt made of himself around 1628, at the age of twenty-two. A tiny panel measuring 22.6 x 18.7 cm, barely larger than this book. In the first half of the twentieth century it hung in a barn in Bearsden, a hamlet in the vicinity of Glasgow. Mary Winter, who had inherited it from her grandfather, had heard it said that the portrait was a genuine Rembrandt and assumed that it was a joke. She had once put the little painting up for sale in Scotland, but no one had displayed any interest.

In 1959 the portrait was purchased at a London auction by the art dealer Daan Cevat and subsequently transferred to the Rijksmuseum. In Amsterdam it initially commanded only lukewarm enthusiasm. Experts remarked on its strong resemblance to the self-portrait of Rembrandt in the collection in Kassel, but the latter was deemed more expressive.

Since then, the Rembrandt Research Project has performed an exhaustive analysis that proves that only the portrait in the Rijksmuseum is in fact a "genuine" Rembrandt. From scans it is clear that the painter was experimenting, as was his custom. The contours of the underlying sketch do not correspond exactly to those in the top paint layer. In contrast, the small portrait in Kassel was painted without any such corrections. It was most probably painted by a pupil after the original.

Today, we may find it almost impossible to comprehend that Rembrandt's portrait was not immediately recognized as a masterpiece. If you take a step back and look at that young man, you are overcome by a sense that you know him. Indeed, you don't just know him but feel what he is feeling. Although his eyes remain in the shadows, no more than two chasms into which your gaze vanishes, the image fills itself with Rembrandt's imagination. You are close to him.

Rembrandt's self-portraits are windows into his soul. They confront us with the imperfection of human existence and the inevitability of what will come. They convey an air of melancholy.

It was the film director Bert Haanstra, in *Rembrandt, Painter of Man* (1957), who first conceived the brilliant idea of placing a whole series of the master's self-portraits one after the other, starting with the portrait of the boy wearing a gorget—the metal collar of a suit of armour—in 1629 and ending with the self-portrait of 1669, the year of Rembrandt's death.

Each painted face merges with the next. They show Rembrandt ageing, his hair going grey, his wrinkles deepening and his face becoming fat and puffy. The bags under his eyes droop heavily. Gazing at the succession of images, I have the sense of looking into him. As if it is not just the artist's life but my own that is playing out before my eyes like a film.

Despite all this, it is questionable whether Rembrandt saw his self-portraits as chapters of his intimate autobiography. The word "self-portrait" did not exist in the seventeenth century; it is a nineteenth-century coinage that became synonymous with Romantic self-expression. In the painter's own day, such a likeness was called "a portrait of the painter by himself".

Furthermore, not all self-portraits were intended to be likenesses. Rembrandt painted a great many *tronies*, facial types. *Tronie* was the seventeenth-century word (originating from French) for a head or face, but in the art of painting it was used to denote a specific character or type: a wrinkled old man or a charming young lady, an Oriental or a member of the civic guard. The 1628 portrait, in which the shadow falls mask-like over his eyes, must have been first and foremost a study of light and dark. An experiment. As a history painter, Rembrandt had to give each

of his figures a different position in relation to the light, and wanted to know exactly how that looked.

In this small painting he tried to ascertain, seated in front of the mirror, how light falls on the face from an oblique angle behind the figure. Light grazes the jaws, the fleshy earlobe and the tip of his bulbous nose. Light plays around the curls in his neck, which have again been scratched into the wet paint with the back of the paintbrush. The eyes remain sunk in the shadows.

Are we looking into his soul here?

That is how it feels. However, that will not have been his primary aim. For his experiment, the painter chose his most patient model—himself.

When writers set about fathoming the mystery of Rembrandt, they are bound to seek parallels between the master's work and his life. Some end up conflating the two. "His extravagant style of painting corresponded to his way of life," wrote the Florentine biographer Filippo Baldinucci in his *Vita di Reimbrond Vanrein* (1667).

According to Baldinucci, the master was a vulgar oaf. "He was as sullen as he could be and did not care a fig for anyone else." Rembrandt paid no attention to his appearance and mixed with people below his social class. The "ugly and plebeian face [una faccia brutta e plebea] by which he was ill-favoured, was accompanied by untidy and dirty clothes, since it was his custom, when working, to wipe his brushes on himself."

Baldinucci's gibe was intended to show that the master's late work was much of a muchness with his appearance: low-class and slovenly. It is a curious misconception. There is no logic in suggesting that a slob will paint messily. You might just as well turn the artistic myth on its head: Rembrandt did not care a fig for anyone else, paid no attention to his appearance or to etiquette, because he was obsessed with his work. That is why he was such a superb painter.

Still, one of Baldinucci's points does hit home: if you look at the portraits that Rembrandt made of himself from the mirror, you cannot possibly claim that he was a handsome man. Certainly, he possessed a robust kind of charm, but he had a bloated, pockmarked face and a huge, bulging nose.

This becomes clear from the self-portrait that he made perhaps just a few days after the one in which he had painted his eyes without a gleam of light. Judging by the memories of Constantijn Huygens, Rembrandt then looked more like a child than a young man. Here he has the appearance of a truculent teenager. His lips are parted in a slightly gormless expression, as if he is exclaiming to his father: "Oh! You here too?"

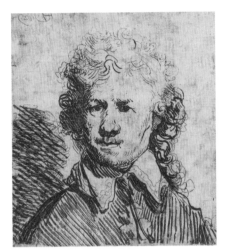

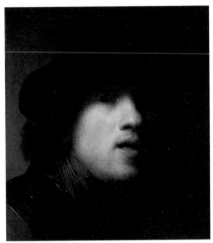

Self-portrait, Bare-headed, 1629. *Self-portrait in the Mirror, c.1627–28.*

The first blond and dark hairs of his emerging beard are just poking through the skin. On his stubbly chin are two shiny pimples.

Why did Rembrandt depict himself with such brutal honesty? This portrait is one in a series of paintings and etchings in which he experimented with rendering emotions. He showed himself laughing, sombre, stern, in pain. And in each of these likenesses he cast the shadow over his face in a different way.

This is Rembrandt's first life-sized portrait of his face. To achieve it, he worked at a short distance from the mirror—quite literally, close to the skin. He wanted to explore ways of rendering human skin as naturally as possible—the colour, the structure of the pores. How does a pimple, or a single hair in a man's beard, catch the light?

The uncompromising honesty with which Rembrandt captured his uncouth face is above all a mark of courage. He disdained outward show and did not seek to erect a vainglorious monument to himself. His striving transcended all such aims: he did not paint an ideal, but "nature".

He saw beauty in ugliness.

Joachim von Sandrart, the German painter and writer whose years in Amsterdam were spent in the shadow of the great master, scoffed in his *Teutsche Academie* that Rembrandt always insisted "that one must be bound only by nature and by no other rules".

The suggestion by Baldinucci and Von Sandrart that he just "messed around", as the modern Dutch master Karel Appel once described his own method, is quite wrong. The ostensibly simple assertion that Rembrandt painted from life, as did Leonardo and Caravaggio, contains a paradox: in the depiction of reality, he showed himself to be a master of illusion.

The verdict on Rembrandt—over four centuries, a whole library has been devoted to him—is often more about morality than art. Starting in the nineteenth century, a petty-bourgeois philosophy distorted the vision of his life and work. Since Rembrandt had been declared a genius, his character and conduct were expected to accord with this; his life must be a devout, righteous epic. The word "genius" invariably deals a death blow; it erases the human being behind it.

Carel Vosmaer, the first biographer of Rembrandt to base his work on historical documents in Leiden's archives, contrived to present an idyllic picture of the master's life. Human frailties were omitted. Much soil was left unturned. In an epilogue to the Dutch translation of Christopher White's biography (1961), we find the first reference to the fact that after Rembrandt quarrelled with his housekeeper Geertje Dircx, with whom he had had an affair and then fallen out over money, he arranged for her to be confined to the Spinhuis correctional institution in 1650. Even then, these sordid details were squirrelled away at the back of the book, in a small font.

By now, virtually every drop of paint from Rembrandt's brush, every panel and every thread of linen from his paintings, has been subjected to laboratory tests. The work of the Rembrandt Research Project has generated a wealth of information about the painter's methods. The six thick volumes of A Corpus of Rembrandt Paintings constitute an indispensable source. Hundreds of facts in his life have been retrieved from the archives and compiled in the superb Rembrandt Documents.

On the rebound from the image of the flawless genius, the past few decades have produced an entirely different picture of Rembrandt, based on facts from his later years—the episode with Geertje, the writ of cessio bonorum in which he relinquished all rights to his goods, and the application for bankruptcy that was submitted to the burgomasters of Amsterdam on 14th July 1656, a day before his fiftieth birthday. This revised picture was of a scoundrel and a spendthrift.

Could that, perhaps, be a rudiment of the Romantic notion that a real artist has a dark soul? His name is invoked to demonstrate the truth of the traditional Dutch proverb: "The greater the spirit, the greater the beast." And the painter Karel van Mander, the author of the Schilder-Boeck, commenting on his fellow artists, quipped acidly that in the popular imagination, "Hoe schilder, hoe wilder"—roughly, "The truer the painter, the wilder he is."

Was Rembrandt wild? Let us start from the bare, indisputable fact of his existence. Then, in our quest to find out who he really was, we will need to look very closely at many things. At his work, to begin with. At the way in which he communicates with us through his imagination. But to get a picture of his childhood, we must look around the Dutch Republic that was under construction, the city, the alley and the house in which he was born and bred.

Did Rembrandt's brilliance spring from the *genius loci*, the spirit of Leiden? Can it be traced to his family, his teachers, clients, rivals, fellow artists and friends? Or was his development a highly personal, idiosyncratic adventure?

How did Rembrandt become Rembrandt?

That is the question.

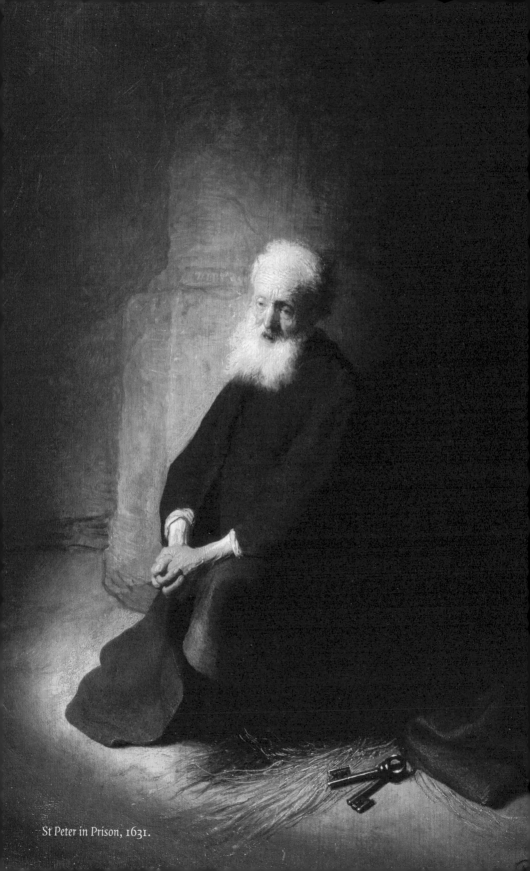

St Peter in Prison, 1631.

2

Rembrandt's native city

ANYONE WHO APPROACHED LEIDEN, WHETHER GOING ON FOOT THROUGH meadows and gardens full of fruit trees and grazing cattle, trundling along dusty paths in a coach, or gliding through the water in a barque, would be struck from miles away by its picturesque silhouette. The city glittered in the landscape like a star in the Dutch firmament.

In the bird's-eye plans dating from the early seventeenth century, this is clearly visible. Bastions and heavy earthen ramparts, which had replaced the medieval walls, formed a jagged pattern around the map. Seven gates gave access to the city from all points of the compass, or when necessary, could seal it off hermetically. Outworks, small pentagonal islands constructed in the outer canals to give extra protection from the cannons of enemy troops, formed the points of the star.

Leiden's skyline was dominated by three large churches: the Church of Our Lady in the west, the Church of St Pancras in the east and St Peter's—the Pieterskerk—in the city centre. Like three gigantic ships, they sailed across the ocean of the city's roofs, albeit without masts: the churches had no high towers. The first had a modest spire, and St Pancras had plans for one that never materialized.

The seventy-odd-metre tower of the Pieterskerk, nicknamed "King of the Sea" because it served as a beacon for sea captains navigating near the coast, had dramatically collapsed with a thunderous roar at the beginning of March 1512. Miraculously, not a single person was killed. Did St Peter himself reach down to protect the flock? His keys to the kingdom of heaven, crossed and blood-red, the blades facing upward, were displayed above the church's double doors and served as the city's coat of arms. "And I will give unto thee the keys of the kingdom of heaven: and whatsoever thou shalt bind on earth shall be bound in heaven: and whatsoever thou shalt loose on earth shall be loosed in heaven." (Matthew 16:19)

When Rembrandt produced his 1631 painting, he linked different parts of Peter's story: his imprisonment by King Herod and his remorse after he had denied Jesus

three times. While the light falls on the furrowed face of Peter and on his hands, folded in penitence, it illuminates in equal measure the crossed keys on the floor. Rembrandt's St Peter was a man of Leiden.

Here and there we do discern other towers projecting above the ramparts: that of the Saaihal, the main centre of cloth production, the spire of the chapel in the Faliede Bagijnhof and the tower of the town hall on Breestraat, whose twenty-three bells rang out every hour and were played at set times by the city's campanologist.

Holland was a river delta, its cities miniature island kingdoms. Leiden was a sparkling labyrinth of canals, watercourses, the Rivers Mare and Vliet and the majestic Rhine, which branched off outside the city walls and converged again in the heart of the city. They divided the city into dozens of tiny islands with houses, churches, monasteries and gardens that were all connected by scores of bridges. In fact, when the sixteenth-century Italian-Flemish merchant Lodovico Guicciardini

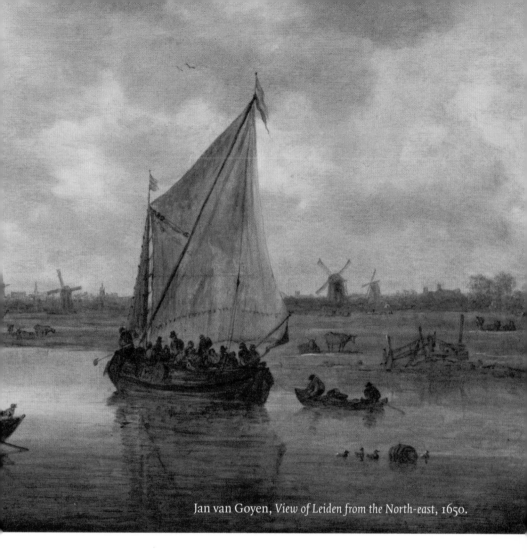

Jan van Goyen, *View of Leiden from the North-east*, 1650.

wrote his account of his travels around the Netherlands, *Beschryvinghe van alle de Nederlanden*, he counted 145 bridges in Leiden!

At the point where the two branches of the Rhine merge, on the crest of a hill, stood the stately citadel. This was where the first settlement had been built, eight centuries earlier, as a watchtower to guard over the river. From the circular citadel, the passage of ships was observed and taxes levied by the local nobleman. This was where inhabitants could retreat in the event of a siege or when the Rhine flooded its banks—a frequent occurrence. Leiden had been expanded in successive waves, like ripples spreading out from a stone tossed into the water. By the seventeenth century the citadel had long lost its military function, but it was still the central edifice of Leiden.

Crossing the city in a gentle arc from east to west, Breestraat followed the course of the Rhine. The street had been paved on top of the old dike running alongside

the river. This had once been the northernmost frontier or *limes* of the Roman Empire. The people of Leiden believed that their city's foundations lay on the citadel of the Batavians, the original inhabitants of the banks of the Rhine, who had valiantly resisted foreign rule.

During the siege of Leiden in 1574, when Spanish troops held the city in a vice and thousands of people died of starvation or the Plague, two local leaders, the town clerk Jan van Hout and the multitalented nobleman Jan van der Does—military leader and poet—breathed new life into the old legend of "Lugdunum Batavorum". Orlers eagerly repeated the story in his *Beschrijvinge der Stadt Leyden*. It fitted seamlessly into the story of the Revolt against the Habsburg rulers that had erupted in the Netherlands, a struggle that would last for eighty years.

History is written by the victors. Many of the stories that were told and retold in the seventeenth century about the Revolt and the courage, loyalty and bravery of the people of Leiden were coloured by propaganda or even distorted to serve the narrator's purpose. Yet those stories lived on. They did much to bolster local morale.

The seeds of the Revolt were sown when the Emperor Charles V announced his abdication. The Habsburg prince had ruled over a territory extending from the Mediterranean to the North Sea and the Baltic, from Europe to the colonies in the Americas and Asia: it was "the empire on which the sun never sets". In 1555, Charles abdicated, dividing his empire between his brother Ferdinand and his son Philip II. Ferdinand acquired the Austrian territories and was crowned Emperor. Philip II became the ruler over Spain, the Italian territories and related colonies—and the Netherlands.

Even under Charles V, relations with the Habsburg court had been problematic. "The Netherlands" did not constitute a contiguous territory, let alone a single country. The region between Wallonia in the south-west and Friesland and Groningen in the north-east was a patchwork of duchies, counties and cities, governed by miscellaneous nobles and city magistrates who invoked rights that had been acquired over many centuries.

Taxation was one problem. Imposing a centralized taxation system was hard in itself, especially in the lean years in which the inhabitants of the Habsburg Empire were expected to finance the wars. Then there were the religious conflicts, which proved increasingly hard to contain. Charles V, of course, was a Catholic ruler, and there were several pockets of opposition throughout his realm to the worldly, materialistic ways of the Roman Catholic Church. The voices of critical Christians and of Church Reformers became ever louder. In Germany, many

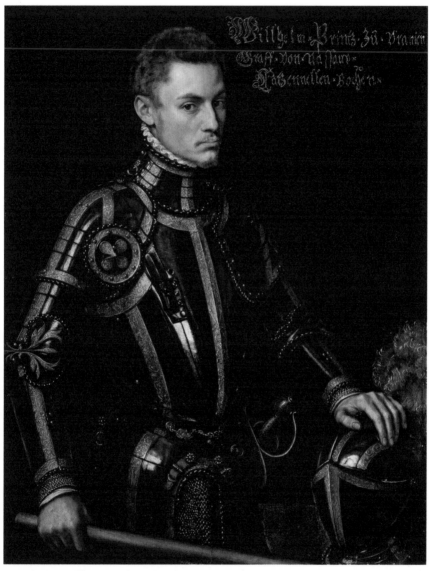

Antonio Moro, *Willem I* (1533–84), *Prince of Orange, c.1552.*

endorsed the ideals of Luther, while Calvin attracted a fanatical following in the Southern Netherlands.

Charles V had already tried to suppress the growth of Protestantism, but his son, who firmly believed that he was crowned by God, pursued this objective with even greater zeal. After his father's death, Philip proved a dogmatic despot,

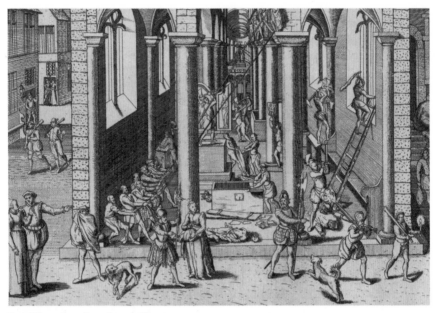

Frans Hogenberg, *Iconoclasm*, 1566.

under whose rule relations with the Low Countries steadily worsened. This even applied to relations with a Catholic nobleman on whom Charles had doted and who had been destined for a leading role at the Habsburg court: William of Orange.

In 1559, after his father's death, Philip bade Brussels farewell, never to set foot in the Low Countries again. Ensconced in the Escorial, his granite palace on the high plateau north of Madrid, he left the actual business of governing the Netherlands to his half-sister, Margaret of Parma. As governor, she was charged with centralizing the administration and tax collection. This pitted her squarely against the nobles and city councillors, who resented the assault on centuries of jealously guarded privilege.

Committed to what he saw as a divine mission, Philip demanded the enforcement of a strict Catholic regime in the Low Countries. Followers of Luther or Calvin or other dissident thinkers were threatened with the Inquisition. However, Margaret of Parma found herself unable to uphold the repressive religious policy prescribed by her brother. On 5th April 1566, in Brussels, an alliance of minor nobles presented a petition to Margaret in the presence of William of Orange and the Counts of Egmond and Horne, beseeching her to pursue a more tolerant course. The governor listened gravely and was moved to tears. The lord of

Berlaymont, one of Philip's most loyal followers, said to her: "N'ayez pas peur Madame, ce ne sont que des gueux." ("Fear not, Madam, they are only beggars.")

A few days later, a group of Dutch nobles who had gathered to dine repeated the word that had been used to mock them and adopted it as a proud sobriquet. The Count of Brederode downed a begging bowl full of wine in a single gulp and cried: "Vive les gueux!"—"To the Beggars!"

Margaret of Parma announced her intention to moderate the religious persecution for an indefinite period, but to no avail. Calvinist preachers took courage and gave sermons to congregations gathered in the fields. These gatherings became focal points for the rising resentment. In August 1566 the Iconoclasm erupted. Gangs of plunderers and Protestant fanatics tore through the Netherlands from south to north, destroying the extravagant, papist images of God in Catholic churches which they saw as contrary to the literal precepts of the Bible.

On 20th August 1566 the Iconoclasm reached Antwerp, and six days later it came to Leiden. On 26th August, violent Calvinist mobs "purged" the city's three large churches. Altarpieces, paintings and statues of saints were pulled down, dragged outside and burned in bonfires. The Franciscan church outside the Hogewoerd Gate and the Mariënpoel and Roomburg convents were vandalized.

In response to the Iconoclasm, Philip II despatched Alba—the "Iron Duke"—to suppress the insurgency by force. William of Orange, who had advocated religious tolerance in the Council of State, feared for his own safety and took refuge in his family's castle at Dillenburg in Germany. In spite of the favour that he had once enjoyed with the Habsburg rulers, and although he was a Catholic, he became the leader of the Revolt.

The Counts of Egmond and Horne were immediately arrested at Alba's behest and brought before the Council of Troubles, which the people soon nicknamed the "Council of Blood". From Dillenburg Castle William started raising funds, recruiting soldiers and preparing an invasion. On 23rd May 1568 an army led by his brother, Louis of Nassau, lured Spanish troops into the marshland near Heiligerlee. When Alba heard that his men had been defeated, he signed the death warrants of Egmond and Horne. On 5th June the two nobles were beheaded at the main market square in Brussels. Their heads were displayed on stakes.

The Iron Duke then swept through the Netherlands at the head of an army of mercenaries, seeking to prevent the Revolt from spreading. Amsterdam was spared, since at this point it was still loyal to the Habsburg ruler. Alba achieved a number

of bloody victories on land, but at sea he suffered serious defeats. A motley bunch of mercenaries, privateers and fortune-hunters evolved into a formidable guerrilla army: authorized by letters of marque signed by William, they conquered a steady succession of Spanish ships.

In the early spring of 1572, a small fleet with 1,000 men on board, under the command of Admiral Lumey, seized almost by chance the unguarded little port of Den Briel. Lumey—known as "Commander Long Nail", because he had taken an oath, after the beheading of Egmond and Horne, not to cut his hair or nails or to trim his beard until he could avenge their deaths—committed atrocities after the capture of Den Briel. On his orders, nineteen Catholic priests from Gorinchem were tortured horrifically and then hanged.

On 1st August 1572, Lumey was given a hero's welcome in Leiden. Since the city council had recently refused to allow a Spanish garrison under the royalist General Boussu to encamp within the city walls, Leiden had effectively joined the Revolt. This had been no easy decision. Like Leiden's *vroedschap*, the forty-strong advisory council from which the city's four burgomasters were elected each year, most of the city's population were moderate in their religious views. They preferred to avoid taking sides and to coexist in peace. At the same time, the conflict between strict Calvinists and devout Catholics was becoming more intense.

For the city's Catholics—which had been the entire population in the not-so-distant past—Leiden's decision to join the Revolt spelt disaster. Some prominent Catholics, fearing violence, fled from the city. They were ordered to return home, on pain of having all their property impounded. Even so, some would stay away for years.

One of the best-known of these escapees, referred to pejoratively as *glippers* (sneaks), was the former burgomaster Cornelis van Veen, whose son Otto was apprenticed to Isaac Claesz van Swanenburg, the city's most prominent painter. The Van Veen family sought refuge in Antwerp, after which their house on Pieterskerkhof was confiscated by the Beggars. Scenes of horror would play out in the house. Cornelis Musius, Prior of St Agatha's convent in Delft, was tortured for hours on end there on Lumey's orders in the night of 10th–11th December. After that, Commander Long Nail had the prior hanged from the gallows that had been erected in Breestraat.

Such egregious acts of violence were not confined to the Beggars. On 1st December 1572, Spanish soldiers went on a rampage through the small fortified city of Naarden, which had joined the Revolt but then surrendered, sowing mayhem with acts of plunder, murder and rape and then burning the city to the ground.

Haarlem fell on 12th July 1573, after a months-long siege. Soldiers garrisoned in rebel cities were hanged, beheaded or thrown into the River Spaarne with a weight attached to their feet.

It was in Alkmaar that the victory began. The city successfully withstood the siege, after the deliberate breaching of the dikes: on 8th October the Spanish troops were forced to flee before the rising water. Shortly after this ignominious retreat, Alba relinquished his position as governor. He had told Philip that six months and an army of 800 men would suffice to pacify the Netherlands. Now, after seven years of ruthless oppression, a fortune in soldiers' pay and thousands of men's lives, he had achieved nothing.

Alba's powers were transferred to Don Luis de Requesens, a Catalan diplomat who had no inclination to fight—or to get his feet wet. Philip II sent him north as a recalcitrant pupil who was unwilling to attend school. When Requesens studied a map of the Low Countries and took in the topography of Holland's cities, he exclaimed: "They are all islands!"

Filled with dread but dutiful, Requesens set about fulfilling his task. There was no question of the Spanish giving up after the liberation of Alkmaar. Only a few days later, troops commanded by General Francisco de Valdés marched south, towards Leiden. They built fortifications around the city and burned everything in their path. By 31st October 1573 the city was surrounded.

This was the first of two occasions on which the Spanish laid siege to Leiden, and the city withstood this initial ordeal quite well. Besides the militias and privateers—armed volunteers led by Andries Allaertsz—there was also a well-drilled army unit within the city walls: a garrison under the command of Governor George Montigny de Noyelles, appointed by William of Orange.

The tactics employed by the Spanish, who had learnt some wise lessons from the sieges of Haarlem and Alkmaar, focused on keeping fighting to a minimum. Their aim was to subdue and seize Leiden by means of isolation and starvation. This was initially unsuccessful, since the city was well stocked with food supplies. We read of the "indescribable number of horned creatures such as bullocks, heifers, and dairy cows" that initially grazed in the pastures around Leiden, which were now grazing in the public gardens. And the grain that was intended for the starving people of Haarlem was now piled up in storehouses on the banks of the Rhine.

In the spring of 1574, when stocks ran low and people started to worry, the danger appeared to have abated. On 21st March the Spanish lifted the siege to go and fight against the troops led by William of Orange, who had invaded the

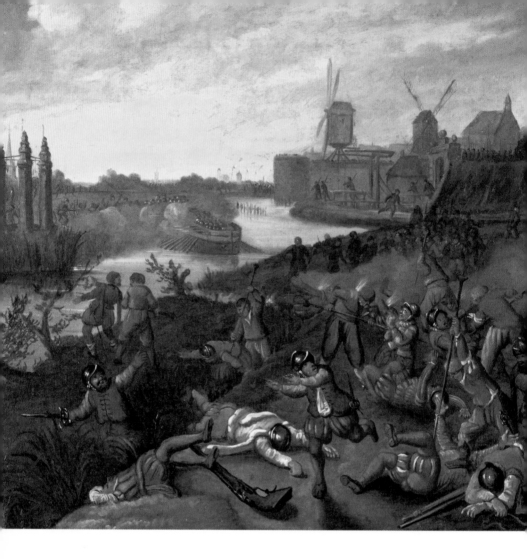

Netherlands from the east, partly with the aim of coming to Leiden's assistance. The resulting encounter was a terrible day for William. At the Battle of Mookerheide on 14th April 1574 his army suffered devastating losses. Two of his brothers, Louis and Hendrik of Nassau, were killed.

The troops led by Valdés had barely arrived on the battlefield when they heard that the battle had already been won. After a few weeks' delay—the Spanish soldiers demanded payment of back wages—they did an about-turn. In the night of 25th–26th May they suddenly reappeared outside Leiderdorp. Andries Allaertsz tried a sally with his privateers, but the manoeuvre cost him his life. Jan van der Does, lord of Noordwijk, a fierce young nobleman who also wrote fine poetry under the pen name of Janus Dousa, took command of the remaining troops.

This time, Leiden was poorly prepared for a siege. The soldiers had left and the city council had failed to stock up on food supplies. Valdés was able to

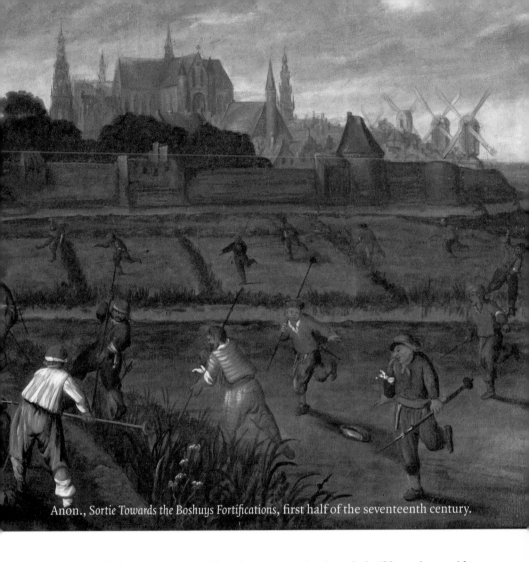

Anon., *Sortie Towards the Boshuys Fortifications*, first half of the seventeenth century.

reoccupy his former positions. The city was completely sealed off from the outside world.

The Spanish pursued the same tactics as before, aiming to isolate and starve the population. There was little fighting. They did not fire cannons; only snipers claimed victims where they could. The townspeople seemed to have no chance of breaking out. Yet in the middle of the night of 28th–29th July, privateers led by Jan van der Does made a sudden sortie towards the Boshuys fortifications. The aim was to ambush the snipers who had claimed so many victims among the guards of the city's militia on the walls.

Over sixty Spanish soldiers were killed with the aid of improvised truncheons and bottles filled with gunpowder. The privateers raided the vegetable gardens, pulling dozens of cabbages from the ground. These they brought back into the starving city, while also triumphantly displaying the severed heads and ears of the

dead Spanish soldiers. Still, the impregnable cordon around Leiden remained in place.

The storehouses along the Rhine were fast emptying. Food was scarce and prices soared. The city council tracked down and confiscated hoarded goods, distributed rations to the poor and had emergency paper coins printed, for the first time in history, to keep trade going.

Guilder paper coins bore the city's emblem of two crossed keys and the circumscription "GOD BEHOEDE LEYDEN"—"God Save Leiden". The reverse displayed the Dutch lion holding a lance with a liberty cap in its claws, around which was inscribed the legend "HAEC LIBERTATIS ERGO"—"For the Sake of Freedom". The local Protestant minister Den Taling protested at the text, claiming that it should have read: "HAEC RELIGIONIS ERGO"—"For the Sake of Religion". According to the writer Coornhert in his *Justificatie des Magistraets tot Leyden in Hollant*, a document known as the Leiden Justification, the minister railed at the city councillors from the pulpit of the Pieterskerk, calling them "Epicurean swine".

In the mid seventeenth century, the secretary to the Remonstrant scholar Petrus Scriverius wrote to the historian Gerard Brandt that the town clerk had reacted with fury at the minister's offensive remarks. Van Hout was a hot-headed, imperious character, who sought to impose his will on the population as if they were mindless animals. Indeed, the townspeople called Van Hout—whose name means "wood"—"the rod that flogs the dog".

In response to Den Taling's insults, Jan van Hout, seated beside Burgomaster Van der Werff in the congregation, leapt up and drew his pistol, aiming it at the

Jan van der Does Jan van Hout

minister's head. "Shall I remove it from his shoulders?" he demanded. The burgo-master barely managed to restrain Van Hout, arguing that the act would provoke public unrest.

In August 1574 famine began to take its toll and Plague erupted in the city. Penniless citizens protested outside the town hall, demanding to be given money or food. As later movingly described by Jan Fruytiers, counsellor to the Prince of Orange, in his *Brief Chronicle of the Harsh Siege and the Miraculous Salvation of the City of Leiden* (1574), "poor women crouched over dunghills, their cloaks pulled over their heads, searching for animal bones to take home. If they found a cabbage stump, they would devour it on the spot. Youths chewed on bones that had already been gnawed by dogs."

In the second, revised edition of his chronicle, in 1577, Fruytiers added the messianic scene that is still seen today as exemplifying the bravery of Leiden city council. When the starving protesters came to Burgomaster Pieter Adriaansz van der Werff, begging him to surrender the city to end the famine, he offered them his sword, saying, "If my death can help you, take my body, cut it into pieces, and distribute as many of them as you can. That will give me comfort."

In reality, Van der Werff had deliberated with the council in all earnestness about Valdés's proposal: clemency in exchange for surrender. Jan van der Does, furious that surrender was even being contemplated, wrote indignantly to William of Orange that Van der Werff had discussed the perilous state of the city in detail with the entire *vroedschap*, captains, sergeants-at-arms and several prominent citizens, giving ample consideration to the enemy's fine promises.

To bolster morale, the council deemed it paramount to maintain contact with those who were trying to liberate the city—the Prince of Orange and Admiral Louis de Boisot, commander of the Sea Beggars. How else would the people of Leiden know whether salvation was at hand? However, it was almost impossible to get messages in or out of the city, through the unrelenting stranglehold of the besieging Spanish troops.

The sixteen-year-old privateer Leeuwken had tried to skirt around the Spanish encampment near the hamlet of Ter Wadding, but he was discovered and taken captive. The Spaniards cut off his nose, ears and lips, and hung him up from one leg. When the agile boy almost succeeded in freeing himself, a Spanish soldier shot him in the head.

Salvation finally came two months after the dikes near Delft and Rotterdam had been breached, by order of William of Orange. The aim was to repeat the successful relief of Alkmaar, forcing the enemy to retreat by flooding the land. At

first the water level in the polders of the Rhineland crept up slowly. But when a west gale swept through the country, suddenly sending the water coursing towards the encampments, the Spanish troops fled in panic.

In the early morning of 3rd October 1574, those keeping watch on the city walls could not detect any movement outside. Thirteen-year-old Cornelis Joppensz, the son of a widow who lived in one of the small alleys behind Koepoort, bravely ventured out to reconnoitre the Lammenschans fortifications. He found the camp completely deserted. Another Leiden boy, Gijsbert Cornelisz Schaeck, came upon a metal pan in a dugout that the soldiers had left behind in their haste, containing *hutspot*—a mixture of boiled carrots and onion—with stewed beef. This tale has been revamped and mythologized in written accounts over the centuries. To add drama, Cornelis Joppensz was soon being described as a penniless orphan who had fetched the pan of stew from the Lammenschans. The people of Leiden still commemorate the event to this day by eating *hutspot* with brisket on 3rd October each year. The pan itself is proudly displayed in De Lakenhal Museum.

The Sea Beggars navigated up the Vliet through a hole in the southern city wall in their scows, flat-bottomed vessels that were less likely to ground in the flooded polders. Into Leiden they sailed, flying the orange, white and blue flag of the Prince of Orange and bringing bread and herrings for the starving population. The arrival of the liberators and the desperately needed food provoked wild scenes of relief.

"The emaciated people," wrote the great Dutch writer P.C. Hooft in his *Nederlandsche Historien* (1642),

> women and men, young and old, thronged to the banks of the river, leaning out as far as they could across the water, with outstretched shoulders, arms and hands, groping and grasping to snatch the bread, herrings, cheese and other foodstuffs that the Sea Beggars handed out or tossed from their boats. Some walked or leapt until they were up to their necks in the water, or swam to the boats. These people, dripping-wet as they were, and others who had secured something, returned with it, spreading the word that the city was saved. In every district and neighbourhood, the same cry was to be heard: "Leiden, Leiden has been freed. May God be praised to all eternity!"

The Catholic Otto van Veen, who had escaped from Leiden with his family and had moved to Liège to train as a painter, made a painting of the Sea Beggars' entry into the city, which he based on the horror stories he had heard from his brother and friends who had remained behind.

In 1576 it was safe for Van Veen and his family to return to Leiden. They took the painting with them and hung it on the wall of their house at Pieterskerkhof. There, Otto's younger brother Pieter made a copy of it to which he added a number of dramatic elements. Among the crowds of people kneeling in prayer, begging for food or gobbling herring and bread, the severed head of a horse lies in the street—perhaps because Fruytiers had related in his account that the citizens had even resorted to eating their horses. Pieter van Veen's talents were very meagre compared to those of Otto, who was highly gifted and would later accept Rubens as his pupil. Nonetheless, Pieter's painting reflects depth of feeling in his compassion for his fellow townspeople.

Stories about the siege of Leiden often draw biblical parallels with events such as the siege of Jerusalem by the Babylonian ruler Sennacherib. Like the people of Israel in the Jerusalem of the Old Testament, Leiden too seemed to have been saved by divine intervention. As for the distribution of bread and herrings, did it not put

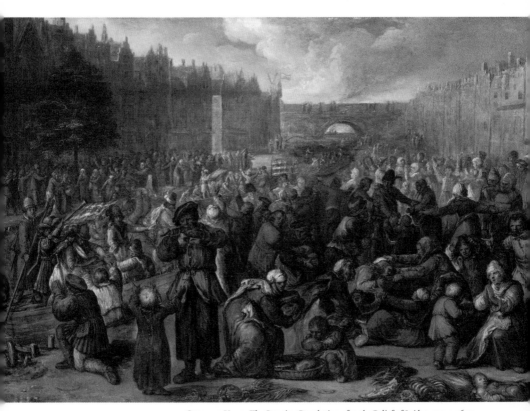

Otto van Veen, *The Starving Population after the Relief of Leiden*, 1574–1629.

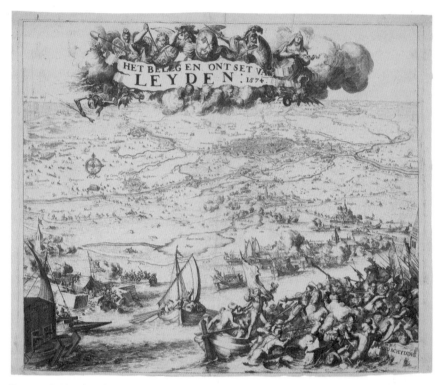

Romeyn de Hooghe, *Siege and Relief of Leiden*, 1574.

one in mind of the multiplication of the loaves and fishes on the shores of the Sea of Galilee?

Historians have questioned the emphasis on bravery and drama that has come to characterize the Dutch Revolt and the siege of Leiden in the nation's collective memory. How reliable was the eyewitness who recorded a nobleman shouting "Vive les gueux!"? Was Burgomaster Van der Werff's bold gesture of self-sacrifice added to Fruytiers's account by his own family? Was the episode of Jan van Hout waving a loaded pistol in the Pieterskerk not a tall story spun by Scriverius? Did Cornelis Joppensz really find the pot of stew? All legitimate questions.

Distortion and mythologizing always play a role in memories and depictions of real events. In the accounts of the Dutch Revolt and the siege of Leiden, these extend at times to blatant propaganda. Even so, many of the remarkable incidents, however much they smack of an adventure story, did in fact take place. The terrible hardships suffered by the inhabitants of Leiden are not in dispute. The siege cost

some 6,000 of them their lives—a little over one-third of the population. Many died of starvation, while far more succumbed to the Plague.

Every inhabitant of Leiden had a heart-rending personal story to tell of the siege. The city council did its best to preserve the memory of the brave resistance of the people of Leiden and the liberation on 3rd October 1574. In the Pieterskerk, an annual service was held on 3rd October to commemorate the thousands of people who had died during the siege. Books were written, plays were performed, paintings were made.

After the city's liberation, the painter Isaac Claesz van Swanenburg, who was then serving as one of Leiden's burgomasters, commissioned the Delft weaver Joost Jansz Lanckaert to make a tapestry measuring three by four metres depicting a bird's-eye view of the acts of war that had led to the relief of Leiden. After its completion in 1587, the tapestry was hung in the town hall, where the citizens flocked to see it. Every 3rd October the great tapestry drew crowds of visitors.

"Leiden's relief was Holland's salvation," wrote the historian Robert Fruin in his book *The Siege and Relief of Leyden in 1574*, first published in Dutch in 1874 to mark 300 years since the events described. It is an entirely defensible position. Since Amsterdam had remained loyal to the King of Spain and Haarlem had been seized, the fall of Leiden might well have led to a chain reaction, claiming Delft and Rotterdam as Spanish conquests and possibly bringing the Revolt against the Habsburg ruler to an end. If that had happened, the history of the Netherlands would have been completely different.

In 1588 the Republic of the Seven United Provinces was proclaimed. It was too late for William of Orange. He had been assassinated in Delft by a Catholic bounty hunter four years before, and legend has it that his final words were to beseech God to take pity on his poor people. The struggle for the independence and liberty of the Dutch Republic had been long and hard-fought. Still, what emerged was not yet one country, let alone a unified nation. Every burgher from the province of Holland still tended to see his own city as the centre of the world.

After Leiden's liberation, it developed rapidly and soon shook off its medieval character. So many had fallen victim to the famine and the Plague during the siege that the city was left with fewer than 10,000 inhabitants. However, the Relief unleashed a population explosion. Within the space of fifty years, Leiden's population would increase almost fivefold. At the beginning of the seventeenth century around 25,000 people lived in Leiden, and the 1622 census recorded a population of 45,000.

The growth came from outside. Leiden had become the symbol of liberty to Protestants who were suffering persecution in Europe, whose cities were being besieged and laid waste by Habsburg armies. The city was inundated with thousands upon thousands of immigrants, political-religious and economic refugees from all parts of Europe. Most were penniless, a few immensely wealthy. Crowds of paupers and beggars congregated around the city gates.

The arrival of the Calvinist immigrants gave rise to tensions, religious extremism and cultural confusion. But the immigrants also brought tremendous prosperity. The development of the "new draperies", the weaving, dyeing and sale of fine woollen fabrics in which the Flemish, Walloon and French refugees specialized, breathed new life into the cloth trade. Indeed, they ushered in what became for Leiden—and for the whole of Holland—the "Golden Age", a period of intense activity and creativity. An age of production and trade, speculation and consumption.

Something else crucial had happened that would change the atmosphere and life in the city for good. After the Relief it was decided, following a proposal by William of Orange, to establish the first Protestant university in the Netherlands, for the "firm support for and preservation of liberty", as he wrote in a letter to the States of Holland. The decision was not so much a reward, as suggested by Leiden's most famous historian, Johan Huizinga, as a fitting way to crown the courage, loyalty and persistence that had been shown by the people of Leiden.

The founding of the academy on 8th February 1575, and the boundless energy and determination of Jan van Hout and Jan van der Does, attracted scholars, students, printers, printmakers and booksellers from the whole of Europe. They made science possible and paved the way for a great flourishing of the arts. No longer were the most important commissions granted by monasteries, convents and churches: instead, they came from the city council and the urban élite. A market arose for portraits of professors, scholars and wealthy students, as well as for still lifes, landscapes, militia pieces and history paintings.

At the beginning of the seventeenth century, Leiden was Holland's second city, after Amsterdam, but it was also a small, enclosed cosmos: threatened by foreign powers, but relatively free, certainly after the Republic concluded a truce with the Habsburg overlords in 1609 that held for twelve years. After the epidemics—and afflicted by a lack of medical expertise and care provision—the people of Leiden knew all too well how it felt to stare death in the face. But that did not deter them from devising ambitious plans for the future or blunt their capacity for love.

In just two hours you could walk all around the city, following a leafy path along the canals, with an unimpeded view of the paradisaical gardens. To go straight

across the city took even less time. Within half an hour you could traverse Breestraat from west to east, from Wittepoort to Hogewoerdspoort. In the neighbourhoods, everyone knew everyone. Life was orderly while also containing the seeds of adventure.

Intimate and worldly-wise: that was the city into which Rembrandt was born.

The Blauwhoofd Bulwark with the Windmill De Bok (detail), Amsterdam, 1640.

3

The miller's son

THE SUNLIGHT REFLECTED IN THE RHINE: THAT LIGHT WOULD HAVE struck Rembrandt's eyes in earliest infancy. When the outside door to Weddesteeg was open, he could hear the water in the river sloshing and slopping against the quayside. And later, looking out from the upstairs window over the high embankment, he would have seen the light gleaming and flashing in an endless pattern of dancing green wavelets.

There, in the skyline of the city's western ramparts, where the Rhine flowed out of Leiden, stood his father's malt-mill. The sounds made by the mill would have woven themselves into the fabric of the boy's everyday experience. When the wind picked up, the mill's sails would whir and whistle and he would hear the wooden wheels grind and creak and the millstones turning as they crushed the malt to flour. When Rembrandt climbed the stairs to the cap and opened the door, he would see bright sunbeams piercing the swirling malt flakes in sharp bars of light.

It makes perfect sense that the visionary nobleman Don Quixote, the hero of the first great European novel, by Miguel de Cervantes (1605), mistakes windmills for "hulking giants" that could chop off your head with a single powerful swing of their long arms.

The importance of windmills to the people of the Netherlands can scarcely be overstated. "God created the earth, but the Dutch created the Netherlands," as the saying goes. It was the windmills that enabled the polders to be reclaimed, wresting land from water. And to keep the country's trade and industry going, to mill flour for bakers in wartime as well as peacetime, the cities of Holland relied heavily on their windmills.

Millers were highly respected. Mills represented the beginning of the industrial and technological revolution in the Low Countries and everyone knew that they generated income. So acute was this realization that in the seventeenth century the cities of Holland went so far as to introduce a special tax on wind. It specifically targeted millers, of course—the only people who could make a living from the wind.

Ironically, all the wonderful advantages of millers' lives end up being used against them in songs, sayings and stage plays. In folk tales, they are consistently portrayed as debauchees and bungling swindlers. To this day, the turning of the great axle in the wheels of a windmill is a common expression for deception: "iemand een rad voor ogen draaien", "turning a wheel to blur someone's sight".

In the farce *Meulenaer* ("The Miller"), written in 1613 by the celebrated Dutch playwright Gerbrandt Adriaensz Bredero, a miller in the polder offers a lady from the city a room for the night. Wily Pete tries to seduce Trijn Jans, but just when he thinks everything is going according to plan he discovers that he is spending the night with his own wife Aeltje, who has swapped beds with Trijn in the dead of night. Wily Pete is not so wily after all. He roars to the audience a few lines of doggerel that may be roughly rendered:

> Oh Citizens, let your Wives be guarded wellish
> Or send them to the Miller, he'll sort them out with relish.

Wily Pete is bothered by the bad reputation of his trade: millers were constantly being accused of giving their clients less flour than was owed from their grain. But his rant only makes matters worse, confirming the proverbial wisdom:

> Always they shout "Miller steals your grain"—
> And off he goes with bulging sacks again.

Whatever the dubious reputation of millers, the mills themselves were valued so highly as symbols of indomitability and vitality that during the siege of Leiden, when grain supplies were dwindling, the sails of the empty mills were kept up and running. In the city this became an expression for a meaningless gesture that nonetheless bolsters morale: "Keep the windmills turning for the Prince."

Before the siege in 1573, all the mills stood out in the countryside, where they could freely catch the wind. The one belonging to Rembrandt's grandfather, Gerrit Roelofsz, stood beyond the city walls on the Rhine. That section of the river was known as Galgewater ("Gallows Waterway"), after the nearby field where executed convicts were left swinging from the gallows, "to be consumed by the air and the birds", as the death sentence prescribed. Rembrandt was familiar with the sight of death from earliest childhood.

The father and grandfather of Gerrit Roelofsz had also been malt-millers. The first information about the family dates from 1484, with an entry in the register of

St Catharine's Hospital on Breestraat recording that Rembrandt's paternal great-great-grandfather had delivered "13 batches of crushed malt". From one generation to the next, the family supplied crushed malt that would be used to brew beer.

On 30th November 1573, a plume of smoke spiralled into the air above Leiden. Soldiers, militia guards and burghers flocked to Wittepoort to see where it was coming from. They gaped at the inferno on the opposite bank of the Rhine: the windmill was ablaze like a huge torch. The wood of the internal cap crackled and flared. Sparks sputtered from the sails and thick black smoke billowed skyward.

When rumours started circulating that the Spanish troops of General Francisco de Valdés were advancing on Leiden, the mills were hastily dismantled. Like gigantic wooden assembly kits, they were taken apart, loaded onto barges and transported up the Rhine and into the city to safety. They were reassembled on the ramparts to supply the people with grain and malt for bread and beer.

For Gerrit Roelofsz's mill, this intervention came too late. It had not been brought within the city walls in time to save it. The miller himself died in 1573. The exact date of his death is unknown, so we cannot be sure whether he saw his own mill go up in flames. In any case it was a double tragedy. His widow, Lijsbeth Harmensdr, was left to care for their four young children, of whom Harmen was the youngest. And left without a mill.

Harmen, Rembrandt's father, was just six years old when the Spanish troops laid siege to Leiden. The story of the destruction of the mill was deeply embedded in the Van Rijn family's collective memory. Rembrandt will have heard the story countless times.

Lijsbeth Harmensdr was not one to succumb to passive grief after her husband's death. Less than two months after the Relief, on 23rd November 1574, she obtained ownership of the Pelicaen, the corn windmill on the outermost tip of the city's western ramparts. She remarried. Her second husband was the miller Cornelis Claesz van Berckel; the last part of his name indicates that he came from Berckel, near Rotterdam. Rembrandt would call him "Grandfather".

On 8th August 1575, Lijsbeth asked the city council for permission to build a second windmill, next to the Pelicaen, "on the ramparts beside Wittepoort to the north". She was clearly an enterprising businesswoman and must have taken on a considerable debt to achieve all this within such a brief space of time. Her new husband probably contributed to the costs, although the tax records do not provide clear evidence from which to conclude that he had enough capital.

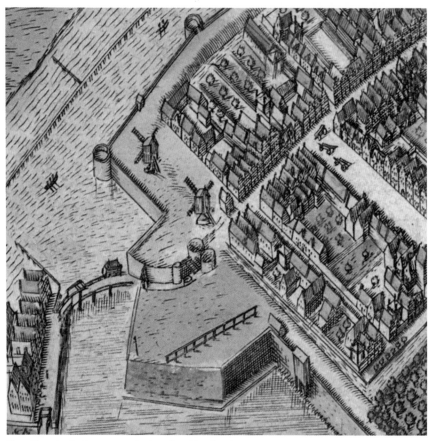

Pieter Bast, *Lugduni Batavor. Leyden in Hollant* (detail), 1600.

As soon as Lijsbeth obtained the city council's consent, she sold her share in the first mill and purchased a windmill from *jonkheer* Jan van der Does, a local hero during the Spanish siege. Her new mill was dismantled in Noordwijk and set up on the ramparts near the Wittepoort. The mill became known as the Rijn after the river, and from then on the miller's family added Rijn to its surname.

The new acquisition was a post-mill, the earliest type of windmill in the Low Countries. It was relatively light and narrow, was mounted on a forked post like a waterbird, and the mill's cap could turn towards the wind. Lijsbeth's decision to set her mill on the western rampart was quite deliberate, since that is the main direction from which the wind blows in Holland. The Van Rijn family looked out from their home towards the west: in the evening they saw the sun set over the meandering river.

The windmill had no living space at the foot of the post, the massive wooden base supporting the cap with its sails, axle, gears and millstones. She therefore bought the mill-house in Weddesteeg immediately behind the ramparts and moved in there with her children and her new husband. That was the place where Harmen, who would later take over as the miller, would grow up, and where his youngest son Rembrandt was born.

Rembrandt never painted or drew his father's windmill and never set up a studio in it, as was believed in the nineteenth century. The mill was simply unsuitable for such a purpose. Nor did he produce any paintings or drawings of Weddesteeg or the house in which he was born. At least, none have been preserved. We can hypothesize that as an apprentice, an assistant, or after he set up as an independent artist in his native city in 1625, he may well have practised in his immediate surroundings or on the landscape that stretched out beyond the Wittepoort. However, no such sketches have come down to us.

Only one drawing exists that might stir a little doubt. Around 1630, Rembrandt drew a dark path. To the left is the line of ramparts, while on the right the houses cast shadows across the path. At the far end we see an archway of some kind, with two figures walking below the structure. A diagonal accent runs through the composition, from upper right to lower left. In the upper-left corner the sky is bright and clear and the paper has scarcely been touched, while in the lower-right corner Rembrandt has applied brown ink: you can still see the brushstrokes. In the dark corner, with a few flourishes of the pen, he has added a sleeping dog, its head resting on its front paws.

This rough sketch appears to have been made en plein air. It is tempting to see the drawing as an image of Weddesteeg. If you entered the alley from Noordeinde, you would have the ramparts on your left—a two-metre-odd wall, with sand piled up behind it—and houses on your right. First the side of the last house on Noordeinde, then the mill-house—breadthwise—and finally a number of dwellings with neck and step-gables.

At the end of the alley, almost at the river's edge, stood a small stone gate. This was part of the city's old defences, which consisted of an internal canal, an immensely thick stone wall and a strip of land along the Rhine. Part of that bank was used by the painter's step-grandfather, Cornelisz Claes van Berckel, as a bleaching field. Rembrandt played there as a boy and it was there that his mother and sisters laid out the washing to dry.

In 1576 Jan van Hout had ordered a bird's-eye map from the local draughtsman Hans Liefrinck, to fulfil his mission of recording the city's physical features for

View of the City within the Walls, c.1630.

administrative purposes. And Liefrinck duly included the little structure with its
rounded arch. However, in maps of the city dating from after 1611 there is no such
archway. That was the year in which the old city wall around the corner from the
house in which Rembrandt was born was torn down and the inner canal was filled
in. The new quayside was aptly named Nedergeleyde Vestwalle—"Demolished
Rampart Wall".

In 1611, work started on the opposite side of the river on building a completely
new part of the city that would expand Leiden enormously. The new, modern
defensive works were constructed outside this new district. In 1612, a long wooden
bridge was built at the end of Weddesteeg to connect the two parts of the city.
Rembrandt was then six years old.

This means that the drawing of the city's outskirts that Rembrandt made in 1630

must depict the situation of his early childhood rather than the contemporaneous reality. It harks back to a distant memory. The drawing is sketch-like and scarcely evokes Leiden at all; it has an exotic air. It might be a study for a history painting or a biblical scene. Paintings depicting the Road to Emmaus in Judea, where Jesus appeared to two disciples on their way to celebrate Passover, are often set near a city gate. Rembrandt was not trying to capture the alley of his youth in this drawing: the aim was to explore the play of light beneath an archway at the end of a dark path.

Possibly, he never made any drawings of his physical surroundings in Leiden. Only later, in Amsterdam, did he make drawings and etchings of the landscape around the city—polders, gardens, trees, windmills. You can still follow in his footsteps as he trudged along the bank of the River Amstel. Indeed, he even drew himself in that landscape, wearing a hat to shield himself from the fierce rays of the sun, a sketchbook across his knees. It is astonishing what his hand could conjure up with just a few movements.

Rembrandt wanted to make history paintings, the genre that was most highly regarded: images of scenes from the Bible, mythology or history, in which the painter acquires the status of divine narrator. From this perspective, he did not yet take much interest in the genre of landscape painting. Whether in drawings or paintings, his immediate surroundings could not serve as the subject: landscape was only a setting, background scenery.

Even so, Rembrandt did paint a windmill that stirs the imagination. Some twenty years after he had bid farewell to his native city—we do not have a signature or date—he painted a windmill on some city ramparts. Or possibly we should say *the* windmill on *the* ramparts of *the* city. The painting has the atmosphere of a spooky fairy tale. A magic windmill stands amid an arcadian landscape, with dark clouds gathering overhead. The hulking giant raises a single sail in the manner of a sword piercing the welkin.

The landscape around the windmill is not very different from the topographical situation around the Pelicaen. The plump curves of the city ramparts make an authentic impression, resembling those drawn by others in the same period. That is what defensive works looked like at the beginning of the seventeenth century. Are those hedges, in the midst of the darkness? It is well known that the city's ramparts, as additional defences, were often overgrown with thorn bushes. And over there, to the left behind the windmill, is that the top of a façade? Is there an alley at the back there?

It might be Weddesteeg, but there are striking differences between this image and the historical situation. To start with, the Pelicaen itself has vanished from the

rampart in the foreground, which is depicted empty and abandoned. If you look closely, the windmill stands—as seen from the north—on a second rampart farther back. Just like his father's mill.

X-rays of the canvas reveal that Rembrandt had started by painting a stone bridge, at the spot where an oarsman is now gliding into the foreground and a washerwoman is causing ripples in the water. The crooked bridge to Wittepoort is missing, and on the other side of the water, where carriages and barges departed in the direction of The Hague, there are now grazing cattle. The little spire of a village church peeps out above the canopy.

Then there is something very odd, certainly for a miller's son who watched countless times as his father and his assistant hoisted up the sails and attached them to the mill, at which the sails would catch the wind and start the gears turning. Faster, faster, faster. In his painting, he has depicted the sails turning clockwise rather than the usual anti-clockwise direction. He did the same in an etching of a post-mill just outside Amsterdam. Did he fail to take account of the inversion of the image when the etchings were printed?

It is possible. Even so, the reverse direction of the sails in the painting remains puzzling. Rembrandt painted from life. Might he, on this occasion, have drawn on his astonishing visual memory? Did he think that he knew the landscape of his boyhood inside out? Did he think the play of light was more pleasing with the sails set in this direction?

We shall never know. All we can say is that whatever the accuracy of the sails, Rembrandt showed himself in this painting to be a master of illusion. For what a sense of drama he infused into the scene. The heavy bastion is reflected blackly in the water. The windmill, illuminated in sunny ochre, stands out against the brooding clouds.

A storm is coming.

The Mill, 1645–48.

The Holy Family with Angels, c.1645.

4

The cradle woven from willow rods

"REMBRANT VAN RIJN, SON OF HARMEN GERRITSZOON VAN RIJN, AND Neeltgen Willems van Suydtbrouck, was born in the City of Leyden, on the 15th of July in the year of 1606." This was reported by Jan Jansz Orlers in the very first published biographical sketch of Rembrandt.

It was in the second edition of 1641 of his *Beschrijvinge der Stadt Leyden* that Orlers added to his existing lives of the leading artists—local luminaries such as Cornelis Engebrechtsz, Lucas van Leyden, Isaac van Swanenburg, and his contemporaries Joris van Schooten, Jan van Goyen and David Bailly—a mini-biography of Rembrandt.

Orlers's brief life of Rembrandt is viewed to this day as an important source. We still adhere to the date he gives for Rembrandt's birth, 15th July 1606, since it appears in the first line of the first biographical sketch. We have no way of verifying the date since the Pieterskerk, the church attended by the Van Rijn family, did not start keeping a baptismal register until after 1621.

Orlers would undoubtedly have conducted his own enquiries to eke out facts about Rembrandt's life. The chronicler lived diagonally opposite the needlewoman Lieven Hendrixcz, whose son, the artist Jan Lievens, was Rembrandt's closest friend and associate in his youth, as well as his fiercest rival.

This gifted young neighbour also featured in Orlers's book with a little biography that was clearly designed to impress. It was twice as long as Rembrandt's. From the 1640 inventory of Orlers's household effects, we learn that he possessed a fantastic library and ten works by Jan Lievens, including *The Four Evangelists, Painted from Life* and a *Peasant Breakfast*. He did not own a single painting by Rembrandt.

Orlers probably consulted the Lievens family on the matter of Rembrandt's date of birth. He may even have gone over to Weddesteeg to ask Rembrandt's mother. Neeltje was still alive in 1640, a year before the publication of the second edition of the *Beschrijvinge der Stadt Leyden*. Nonetheless, that does not mean that

the date is definitely correct. In the seventeenth century, people often had quite a fuzzy idea of even their precise age. In the second state of an etching with a self-portrait in which Rembrandt depicted himself wearing an elegant black hat, and which he himself dated 1631, he initially carved a note into the etching plate to the effect that he was twenty-seven, "AET 27", only to change the "27" into "24". The latter would mean that he was born in 1607.

This is relevant, since when he and Saskia van Uylenburgh gave notice of their intention to marry, on 10th June 1634 in the Oude Kerk, Amsterdam, he registered his age as twenty-six, which also suggests that he was born in 1607. Neither of these inscribed ages agrees with the date of birth given in the *Beschrijvinge der Stadt Leyden*. Still, since even Rembrandt got his dates mixed up, the date of birth recorded by Orlers is the one that has been adopted in the history books.

In planning anniversary celebrations, the Rijksmuseum in Amsterdam takes 1606 as the year of Rembrandt's birth. Yet the wall plaque in the gallery of the *Night Watch*—the altar in the Netherlands' national cathedral of art—states that the master was born in 1605. Even this is not inconceivable. The very first record we have of his name, an entry for 20th May 1620 in the *volumen inscriptionum* of Leiden University, states that he was fourteen. If we assume that the given birthday of 15th July is correct, he was born in 1605.

In a "literary sketch" published in a periodical in 1860, "Een pelgrimstocht naar de Weddesteeg", Carel Vosmaer describes a pregnant woman rushing to hide herself, one fine morning in mid July 1606, in an alcove bed shielded by curtains made of *saai*, Leiden's best-selling cloth. Her small daughter, Machtelt, is hurrying down Noordeinde, the nearby thoroughfare leading to the district on the opposite side of Kort Rapenburg, some 200 metres away—the district called Paplepel.

Vosmaer writes: "I see [the child] fetch the woman above whose door hangs a plaque with a picture of a tiny child, with the inscription 'GOD IS MY HELP'; I see that woman follow the little girl, who runs ahead and keeps looking back over her shoulder at her, all the way to the green *saai* curtains. Quick, Harmen, down from your mill—and good luck with the little boy that has been born!"

In the seventeenth century, childbirth was women's business. Men were kept out of the way until it was all over. Not until the child had drunk from the mother's breast and been carefully bound in cloths was it placed in its father's arms for a moment, like a neat parcel. Each delivery was a perilous event. It was not uncommon for women to die from the complications of childbirth or from puerperal fever, and newborn infants often failed to survive. Frequent though such deaths

were, the misery they occasioned was no less intense. The whole family grieved, then as now.

Cornelia Willemsdr van Zuytbroeck ("Neeltje") was no longer young when she gave birth to Rembrandt. We do not know her date of birth, but she must have been around thirty-eight or thirty-nine. Rembrandt was her ninth child—the sixth to survive, after Gerrit, Adriaen, Machtelt, Cornelis and Willem. After Rembrandt would come one more girl—Elisabeth, who was known as Lijsbeth, like her grandmother. Three of Neeltje's children died very young, possibly as newborn infants. Two were buried without names in the Pieterskerk in 1604. Neeltje must have been thinking of her two dead babies when she got the cradle out, ready for a new child.

By a stroke of good fortune, we know what that cradle looked like. In one of the "testimony books" that are preserved in Leiden's archives is a signed statement drawn up on 26th October 1612 by "Harman Gerritsz, miller". He took an oath that the "infant's cradle, woven from willow rods," from the probate inventory of the bargeman's son Gerrit Pietersz belonged to him.

Harmen was the uncle and guardian of this Gerrit Pietersz. When the latter declared bankruptcy, Harmen made it clear to the city's sheriffs that he had lent his nephew the cradle. Otherwise it would be seized by the bailiffs. This was the little cradle in which Rembrandt must have slept as an infant.

The cradle's financial value was negligible, and certainly cannot explain why Harmen went to such lengths to get it back, even submitting his claim to the city's tribunal. This document makes it clear that he was driven by an emotional attachment. In 1612 he did not expect to have any more children. Neeltje was forty-three—a late arrival was highly unlikely. Even so, Harmen wanted the cradle back. It represented the love he felt for his family.

In Rembrandt's painting *The Holy Family with Angels* (1645), Mary sits reading by a flickering hearth, her feet on the foot stove. In the background, Joseph the carpenter is hard at work. His tools hang on the wall. Out of a corner of heavenly light, a few cherubs tumble down into the domestic scene.

Karl Marx once wrote: "Rembrandt painted the Mother of God as a Dutch peasant woman." About this, Marx was quite right. That is the joy of this painting: it is totally unpretentious. The Virgin Mary radiates an ostensibly simple beauty. Heavenly and earthly qualities merge: the sacredness is woven into the scene's everyday domesticity.

Rembrandt enchants us here with the heavenly light that touches Mary's white collar and headdress and is reflected in her open book. But he also moves us by showing a single tender gesture: a mother, anxious to check whether her little child

can sleep with all that hammering going on, lifts a corner of the veil that she has laid over the hood of the cradle: a rocking cradle woven from willow branches.

The house in which a cradle stood would determine the course of a life: family relationships were crucial. Rembrandt's mother was the daughter of a baker. She was the third child of Willem Arentsz van Zuytbroeck and Elisabeth Cornelisdr Vinck. Her father originated from Katwijk and his ancestors may possibly have come from the hamlet of Zuytbroeck, near Noordwijk aan Zee. Neeltje's mother was a daughter of the prosperous grain merchant Cornelis Meesz Vinck (also known as Van Tethrode) and Reympgen Cornelisdr van Banchem. Both came from distinguished Catholic families that had lived in Leiden for generations and remained Catholic when the city's strict Calvinists took control.

Rembrandt was named after his great-grandmother Reympgen. It was an unusual name—something that would prove useful in later life. He did not really know his maternal great-grandparents or even his grandparents: his grandfather died shortly before his birth, followed by his grandmother when he was just three years old. The house, Het Gulden Vercken (the "Golden Pig") on Vismarkt, was where his grandparents lived and ran their bakery. It was a large building overlooking the New Rhine in the heart of the city, very close to where the river's two branches converge. On the other side of the water, the great castle's battlements towered over the houses.

Along the quaysides of the New Rhine, market salesmen sold their wares each week. Fishermen from Katwijk stood outside the Gulden Vercken, washing and filleting their herring, plaice and bass. Seagulls that had tracked the fishing boats from Katwijk swirled around the market. Fisherwomen walked across the polders from Haarlemmermeer (Haarlem Lake) with baskets of freshwater fish on their heads. Farmers from Zoeterwoude brought butter, milk, cheese and eggs to the city. Less than fifty metres downstream, the great city crane hoisted goods onto the quayside outside the weighhouse all day long. At a stone's throw from the bakery, on the bridge over the Rhine, was the corn exchange, the scene of a brisk trade in barley, wheat and rye, where Neeltje's family conducted much of their business.

On market days, the streets were jam-packed. Many doors were left open, since most people lived and worked in their houses. In the Golden Age, unlike the Middle Ages, burghers worked from dawn to dusk, six days a week. In the tower of the town hall a loud bell tolled, ringing out across the city, alerting people to the beginning and end of each working day. Children worked alongside their parents as soon as they were able—from about six years of age.

Jan Steen, *The Fish Market in Leiden*, c.1646–49.

Neeltje helped out in the bakery as a young girl. She went to serve customers when the baker's assistant had blown his horn to indicate that there was fresh bread on the shelves. It seems unlikely that she was sent to school to learn to read and write. She signed documents such as her last will and testament with a scribble or a shaky cross. Could she read the Bible? We do not know.

Her sister Maritge married a baker and her brother Cornelis became a baker in the house Loth in the street known as Hogewoerd. Neeltje married a miller's son—not the same trade but the same social circle. Their fathers would have met frequently at the corn exchange. Neeltje's parents would have seen Harmen Gerritsz as a suitable match for their daughter.

Harmen and Neeltje were married on 8th October 1589 in the Pieterskerk. On 27th November that same year, Cornelis van Berckel transferred ownership of half of the malt-mill and the southern half of the house on Weddesteeg to his stepson. Harmen paid him 1,800 guilders for the property. Cornelis and Lijsbeth continued to live in the left half of the mill-house, while Harmen and Neeltje were soon raising their young family in the other half.

The information in the city archives is extremely complex because of all the structural alterations, property transfers and allocations and reallocations of land that took place. In 1600, a year after Lijsbeth's death, Harmen received another portion of his inheritance. Another half of a house, to be shared with his sister's children. He separated that part of the house from the rest and provided it with a new front door.

The house in which Rembrandt was born, as revealed by the latest, meticulous study of diverse records in the land register, was about six metres wide and three metres in depth. It had a small extension on the south side. In the garden stood an outbuilding that later became the home of one of Rembrandt's aunts. The Van Rijn family home was more spacious than the houses of most of the city's weavers, but not by much. Once Harmen and Neeltje's youngest child had arrived, the house was bursting at the seams.

On 18th October 1622, the Van Rijn family of Weddesteeg, in the district of North Rapenburg, was counted in a census. Each member was duly listed in a column: father, mother and "6 children", in order of age:

Harmen Gerritszoon van Rijn
Neeltgen van Suydtbroeck
Gerrit
Machtelt
Cornelis
Willem
Rembrant
Lijsbeth.

The eldest brother but one, Adriaen, was already married and lived with his wife on Aalmarkt. In addition, a marginal note records that Willem no longer lived at home, but was lodging with the baker Jan Gerritsz on Koepoortsgracht.

Rembrandt made drawings and etchings of families in interiors that give an impression of the living room of his childhood. Parents and children huddle around

a single candle with their books or games. We can imagine the youngest boy working endlessly on chalk drawings by the fading light from a smoking oil lamp.

Mother resolutely places her squawking young son outside the door, father admonishes the scamp, while behind their parents the other children watch in curiosity from the doorway. A toddler in a walking-trainer stretches out both arms towards the nursemaid. At night the children sleep together in the alcove bed in one of the rooms. Rembrandt will seldom have been alone. It was never quiet.

When you entered the house—the upper part of the Dutch door would often be left open to admit light—you would step straight onto the tiled floor of the largest room, which extended across the width of the building. An alcove bed nestled in one rear corner, beneath the corkscrew staircase to the upper storey; in the other corner blazed the hearth. Some houses had fireplaces in each room, but not this one. According to a 1644 entry in a city register, it had only two.

Even when both hearths were kept burning day and night, the house was almost always cold and clammy in winter. The plaster on the walls was cracked and full of damp patches caused by rising seepage from the nearby river. Everyone wore multiple layers of garments, which were seldom washed. The house had no bathroom, and the toilet consisted of a wooden barrel covered by a plank with a hole in it, under a lean-to in the small backyard.

In the living room stood a heavy wooden table with benches on either side and a cupboard for tableware: pewter plates and earthenware bowls and jugs. A few stone

The Naughty Boy, 1635.

steps led down to a small basement, with a catch basin for rainwater and a few kegs of beer. Sometimes there was a small stock of food: a little basket containing cabbage, parsnips, carrots and onions, and a few apples picked from one of the trees in the kitchen garden that Harmen had purchased in 1610, just beyond Wittepoort.

There were undoubtedly paintings hanging on the walls of Rembrandt's parental home. At the October market, part of the annual celebrations of the relief of Leiden, the Vismarkt square was full of stalls and dozens of paintings were hung on the walls of the town hall's main chamber. People could buy a small landscape or a genre painting for a guilder or a little more. And a great many did so.

In between the houses were small alleyways leading to the backyards. The name Weddesteeg derives from *wedde* + *steeg*. A *wedde* is a ford along the river where horses could drink and cool off; *steeg* means "alley". The ford was actually moved outside Wittepoort when Rembrandt was a boy. Even so, the clattering of hooves often resonated between the quayside and the houses. The horses belonging to the owners of houses on Noordeinde, whose long gardens extended to the water's edge, often passed by. Rembrandt's father would frequently have stationed a donkey or a horse in the backyard for use by the servant whose task it was to deliver sacks of malt flour to their customers. Many people in Leiden kept a goat or a few chickens and geese. And a dog.

Rembrandt loved dogs. In any case, he certainly loved to include them in his drawings, etchings and paintings. Tail-wagging dogs abound throughout his oeuvre. While Joseph is telling his dreams, a dog is licking its genitals clean. In the foreground of *The Good Samaritan* there is a defecating dog. A black-and-white canine

Sleeping Dog, 1638–42.

barks at the severed head of Goliath as David presents it to King Saul. And in a scene drawn from everyday life, a small child, startled by a dog, takes refuge in its mother's arms.

Only once did Rembrandt make an etching in which the dog itself is the subject. It was doubtless the kind that might often be seen lying outside the door in Weddesteeg. Asleep, head resting on its back paws.

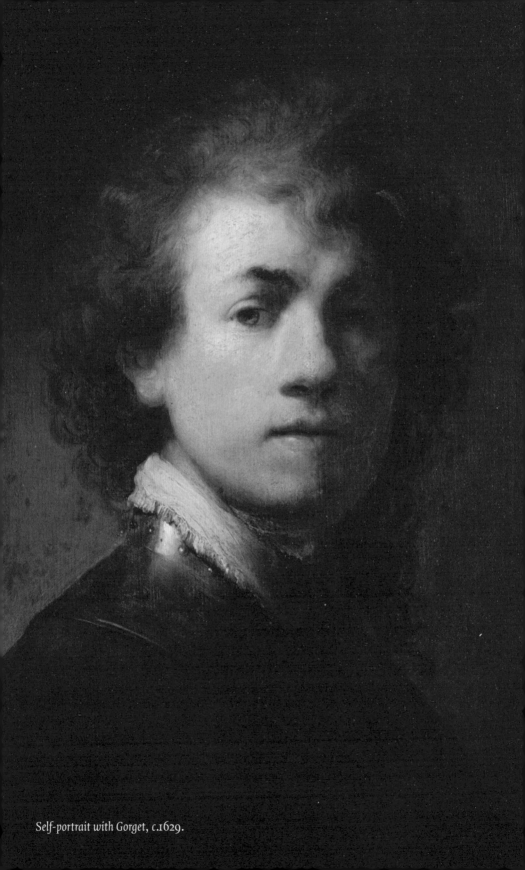

Self-portrait with Gorget, c.1629.

5

The exploding musket

REMBRANDT GREW UP IN THE BUSTLING NEIGHBOURHOOD BEHIND Wittepoort, where all travellers from the direction of The Hague entered the city. Checks were performed at the gate, not only on individuals but also on goods to prevent excise fraud. It was easier for a camel to pass through the eye of a needle than for a person to enter Leiden unnoticed.

Just outside the gate, a bridge spanned the ring-shaped external canal. It had been built at a bend in the canal, to prevent an enemy firing a cannon from it straight into the city. The siege of 1574 had struck terror into the people of Leiden and prompted them to strengthen their defensive structures. The gates were key to these efforts.

Inside the city gate, along Noordeinde, carts and carriages rattled to and fro all day long. The wide street was peppered with taverns and inns bearing names such as De Eenhoorn, De Gulden Wagen and De Drie Haringen, where merchants and travellers stopped off to eat, drink and sometimes to spend the night. Merchandise was laid out invitingly under awnings, and fire baskets brightened the scene, with people roasting chestnuts and making pancakes.

The list of local property owners commissioned in 1606 by the town clerk Jan van Hout consisted almost entirely of craftsmen: coppersmiths, glaziers, carpenters, glue-makers, cobblers, turners, chamois-makers, bricklayers, tailors. The largest number of entries are those for farriers, waggoners and wheel- and saddle-makers. Horses were shoed at the corner of Weddesteeg, and the regular beat of hammer on anvil in Pieter Woutersz's forge filled the air. The street heaved with horses and carts, and to relieve congestion a small canal at right angles to Noordeinde had been filled in—named 't Sand, after the material used to make it—to serve as a parking area. Once a week a pig market was held there.

Amid the jostling and shoving in 't Sand, tempers sometimes flared. Rembrandt's father was once called to testify as a witness after a row between two waggoners in 't Sand had escalated into a violent brawl. The report of 2nd October 1594 drawn

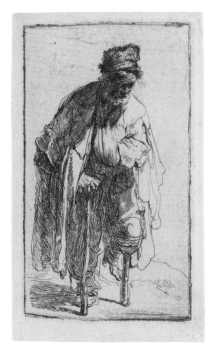 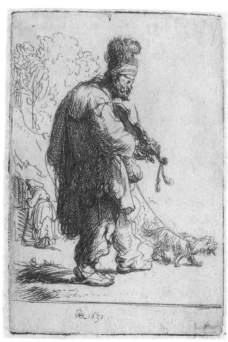

Beggar with a Wooden Leg, 1628–32. *The Blind Fiddler*, 1631.

up by the Leiden notary Willem Claesz van Oudevliet states that the waggoner Harmen Willemsz van Dincloo took offence at the words of his fellow waggoner Jan Symonsz from Delft. The former had offered to transport "human cargo" for four stivers, and the other man, incensed, accused his rival of undercutting. The report does not indicate how the case was resolved. When Harmen Willemsz van Dincloo heard himself being branded a scoundrel and a "dishonourable thief", he flew into a rage. The dispute spiralled out of control and was recounted in front of the notary, in the presence of the city's bailiff—and of Rembrandt's father, "a miller of around twenty-nine years of age", as a witness. His signature appears at the bottom of the document.

The area around the Wittepoort and the inns abounded with beggars and tramps, as well as miscellaneous foreign travellers. Where these strangers came from, the locals had no idea: for convenience's sake they were all known as "Orientals". In around 1630 Rembrandt turned out a quantity of sketches, drawings and etchings with finely observed portraits of people he had seen in the street: a beggar leaning on a stick, lepers and maimed soldiers, a beggar couple with an emaciated dog, a man with a hurdy-gurdy, a blind fiddler—oddly holding his bow in his left

hand—and an old beggarwoman in rags with a bottle gourd hanging from a leather cord at her hip.

The city council endeavoured to provide shelter for the poor and sick and to feed the hungry, but constantly fell short. In 1577, Jan van Hout had drawn up a Poor Report, in which he proposed that the city take responsibility for organizing poor relief and remove this task from the churches. Begging was prohibited in the statute book (*Keurboek*) of 1583. In practice, however, the influx of destitute people was too great and the poor relief too meagre. The begging simply continued.

Rembrandt was familiar with the colourful figures who haunted the streets. They had been part of his everyday surroundings from his earliest years. In the late 1620s they started to fascinate him, and he would make sketches of them with a few bold lines in his sketchbook or on an erasable tablet, on Noordeinde and just outside Wittepoort, sitting at the side of the road.

To learn the art of portraying people he saw in the street, Rembrandt studied the work of the French printmaker Jacques Callot, who achieved great success with his *gueux*. Some of Rembrandt's own etchings of beggars in his neighbourhood are based directly on those of the popular French artist. He differed from Callot, however, in that he did not work with neatly drawn lines: he scratched and carved, allowing his etching needle to follow its own capricious path.

These images must have served Rembrandt as studies: exercises for the hand and eye for figures to be included in biblical scenes. The blind beggar would be used for the blind Tobit, who stumbles to the door in the hope that his son, despatched to fetch money deposited with someone for safe keeping, has finally returned home. In Rembrandt's etching, Tobit almost trips over his little dog.

Rembrandt's sketch of two weary travellers applying to De Gulden Wagen for a place to sleep as darkness fell would serve him well later on, in a nocturnal scene with the *Flight into Egypt*. Joseph was modelled on a beggar.

The grumpiest-looking beggar in his etchings has the face of the artist himself. Rembrandt could take on any role, from Oriental to Apostle and from prince to pauper. There he sits, leaning back against a little hill in a ragged tabard. His toes stick out of the holes in his tattered shoes. He accosts passers-by, demanding alms with an aggrieved expression. The signature reads "RHL 1630".

Was Rembrandt drawing attention to the distressing situation of the poor? Did he identify with the wretched of the earth? It is possible. In any case, Rembrandt did not have to give this beggar alms to ask him to sit still for a minute.

Some of the etchings from Rembrandt's Amsterdam period provide a retrospective picture of what he had seen in and around Leiden. A game of *kolf*, for

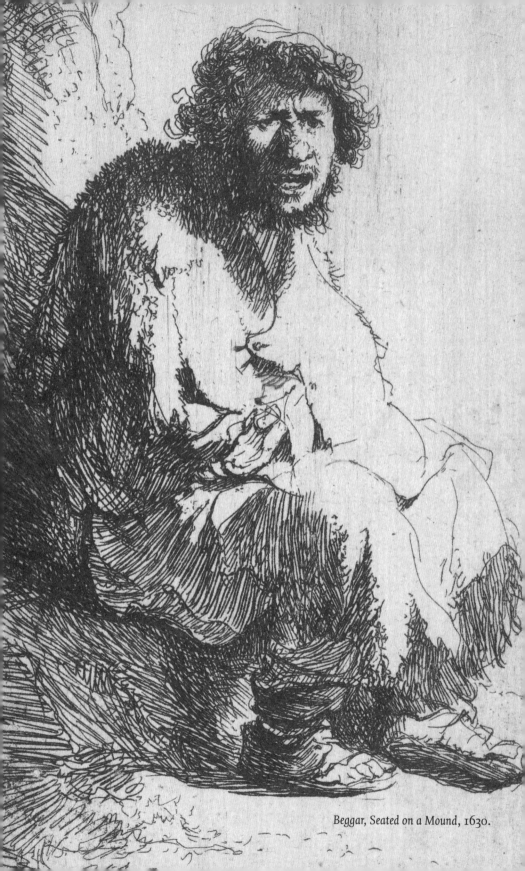

Beggar, Seated on a Mound, 1630.

instance—a sport halfway between today's hockey and golf. Or *beugelen*, pell-mell, a game similar to cricket. There was a long pell-mell pitch just outside Wittepoort.

In the winter, when the Rhine and Rapenburg were frozen over, games were played on the ice. Rembrandt made an etching of a skater gliding along gracefully with a long-hooked stick over his shoulder. In Leiden a long stick of this kind was given the same name (*verrejager*) as the spiked pole used in bullfighting. The skater has one eye squeezed shut against the cutting wind.

Seventeenth-century winters in the Netherlands were "biting-cold", as Rembrandt wrote in a caption to an etching of a man with chattering teeth. The sky seemed made of ice, in brittle blues, greens and greys with streaks of flake-white. Take the winter landscape he painted in 1646, for instance, in which a woman shuffles over the ice followed by her dog, while her husband sits on the bank, attaching his skates.

When the snow came whirling from the sky like "chopped feathers", as the great diplomat and poet Constantijn Huygens would have it, the Rhine merged with Leiden's canal system to produce a large expanse of picturesque winter. The chronicles report that when William of Orange visited Leiden on 6th November 1572, he watched people skating on the Vestgracht, the former moat. In one of the oldest pictures of the university on Rapenburg, a gouache in a Leiden law student's *liber amicorum*, we see students donning their skates and a woman who has slipped and fallen on the ice. The gouache has a wonderfully pretentious caption: "Dear viewer, this drawing displays the University of Holland and shows you how the student flocks gird their loins when the wintry north-wester makes it impossible to cleave the Dutch waters with the ship of the Dionysian goddess."

When special guests entered the city through the Wittepoort, Rembrandt would have been right at the front of the gaping crowd. In one of the testimony books in Leiden's archives, we find statements made by his brother Adriaen and others in 1642 (over ten years after his move to Amsterdam) about a scuffle that had erupted in the mill yard between civic militiamen and Adriaen's son Jan, Rembrandt's nephew, who was then still a minor.

It happened on 7th June 1642, when Henrietta Maria, the Queen Consort of England, paid a visit to Leiden. Her young daughter Mary had been betrothed to the fourteen-year-old Prince of Orange, the later stadtholder Willem II, the year before. The Queen Consort entered the city with her retinue, passing between two lines of civic guardsmen. The inhabitants of Weddesteeg and the Van Rijn family sat at the foot of their mill on corn sacks to watch the procession from close by.

Suddenly events turned nasty. Were the militiamen manhandling spectators in their over-zealous determination to keep them at a distance? In any case, one of them took a pike to a woman, Claertge Dircxdr van Driel, wounding her. Another, Adolf Paulsz van Westervelt, struck the little son of the miller's assistant Jacob Corsz van Rijn a hard blow in the face as he sat on his father's lap, causing the child to bleed. As the father tried to push the pike away, he pulled a pennant off it.

The exchange that followed was recorded in the testimony book: the militiaman Adolf thought that Jan Adriaensz van Rijn was trying to steal his pennant and said: "Do you think you're dealing with a load of *stopgens*?"

The term *stopgen* referred to men hired to guard the city gates and keep order at night time, and had a bad reputation. The militiaman evidently felt greatly superior to these impoverished guards. Nor did he display any respect for the residents of Weddesteeg.

Jan said to the militiaman: "Are you lot better than *stopgens*?"

"Say that again, if you have the nerve!"

"I would say that you're just like a *stopgen*."

At this, without further warning, the militiaman struck Jan so hard that his pike broke in two. The militiamen stormed the mill yard and beat the people back.

The records do not indicate how the fight ended or whether the militiaman was reprimanded. However, this anecdote certainly shows that it was not without danger for youths to be out and about in Leiden, certainly not for those endowed with such a quick temper as Rembrandt's nephew.

As darkness fell and Wittepoort was bolted for the night, the streets remained crowded. Visitors found a place to sleep at one of the inns and men might go in search of entertainment. They would not have far to go. In the alleys between Noordeinde and the parallel Groenhazengracht, the authorities turned a blind eye to the "stews", the brothels.

On the other side of the water were the grounds of the Doelen complex, where the militiamen—musketeers—had their target practice. They would sometimes haul a plank to the water and improvise a bridge to get across to the "women of easy virtue" in Sliksteeg as quickly as possible. The canal they crossed was named after Groen Haesge, a young prostitute from days long past.

The neighbourhood to which Weddesteeg belonged at the end of the sixteenth century had a particularly colourful name. Billenburg ("Buttocks Burg"), between present-day Galgewater, Kort Rapenburg, Rapenburg, Groenhazengracht and the outer canal, was named after a shapely fifteenth-century girl known as "Fye with the bottom".

In 1602, the district of Billenburg was divided up and the area containing Weddesteeg was named Pelikaanshoek. That same year, Rembrandt's father was appointed neighbourhood master or *buurtheer*—a post that conferred social standing but no power. Harmen's neighbours would have called on him in emergencies, since the master was responsible for poor relief and took an active role in baptisms, weddings and funerals.

So it happened that on 14th February 1605, at the request of "Harmen Gerritsz Moelenaer as master of his neighbourhood", two young orphans of Walloon immigrants, the brothers David and Pieter Daeffuidt, aged fourteen and eight, were admitted to the Orphanage of the Holy Spirit on Hooglandse Kerkgracht. The care for the poor, sick and orphans was tightly organized at this time: partly from Christian and humanitarian motives, and partly from self-interest. In fact, the local authorities would sometimes fetch orphans from other cities and bring them to Leiden to fill vacancies in the flourishing cloth-manufacturing industry.

In the event of a death in the neighbourhood, it was the master who had to make sure that the person was given a decent funeral. This was no sinecure. In 1603, a year after the district's partition, the residents of the houses in the section of Noordeinde between Zand and Vest submitted a grievance to the city council. They complained that they did not have the strength to carry their dead all the way to the cemetery and petitioned to be reassigned to Pelikaanshoek. However, their petition was denied.

Burials were governed by strict social rules. Supervision was not easy at the best of times, and during smallpox or Plague epidemics it was a hellish task. In the family chronicles of the Leiden families Van Heemskerck and Van Swanenburg, we find the following entries in 1624: "Number of deaths during the Plague: 4,765." A few hundred people succumbed every week in the months of September, October and November. The numbers gradually fell after that, "thanks to the special grace of God".

Everyone was afraid of being infected by a sick person or a body. When the Black Death was abroad, bodies were piled up in the graveyard while others lay unburied in houses. From early morning until late at night, the streets were awash with people hauling biers and pushing wheelbarrows with coffins. Doctors scarcely had time to attend to their patients and were helpless in the face of the scourge: they always arrived too late.

The neighbourhood master applied the rules strictly. He insisted on family members removing dead bodies from the house and burying them with all due speed. When the supply of coffins ran out, bodies would sometimes have to be

bundled together on planks or old sofas and tipped unceremoniously into the pit. During the Plague epidemic of 1635, the Pieterskerk cemetery was so crowded and its ground raised to such a height that the city council decreed that the dead must henceforth be buried on the ramparts or outside the city. Funeral bells tolled dismally almost without interruption.

Harmen served as neighbourhood master for twenty-two years. In 1624 he was discharged from his duties on account of physical frailty, according to the city's records. The task had become too arduous for him. That may have been related to an accident that had taken place many years before. At a meeting of the civic militia on 22nd February 1611, he asked to be relieved of his obligation to serve because a musket had exploded in his hands. Although he made a partial recovery, his hand sustained permanent damage that made it hard for him to shoot—a disability that must also have affected his work as a miller.

Harmen was exempted from serving in the night watch—at a price. He was obliged to pay six guilders a year for the exemption, which permitted him to retain his rifle. Every member of the civic militia purchased his own tailor-made weaponry and armour, consisting of a morion (helmet), breastplate, a sword or halberd, a lance, a dagger and a knife—often a double-edged hunting knife known by the grisly Dutch name of *hartsvanger*—"heart-catcher". And a musket with a cartridge of lead pellets. The militiaman kept his weaponry at home so as to be able to leap into action in the event of a riot, a sudden enemy incursion or some other emergency. There was no time to go to the Doelen complex, even it if was only five minutes' walk from his house.

Rembrandt may well have worn his father's own gorget for the 1629 self-portrait. The painting shows a self-assured, pugnacious figure with his hair styled in fashionable curls complete with an aristocratic "love lock", a tapering corkscrew curl. A little neckscarf completed the outfit. Rembrandt was proud of the fighting spirit of Leiden's civic militia. Although he probably never fired a shot himself, the bright illumination of the portrait depicting him as a military dandy conveys his allegiance to the men of arms.

Harmen's obligation to pay an annual fee for his exemption was speedily revoked, we learn from the minutes of a meeting of 22nd February 1611, provided one of his sons served instead. Affluent families were required by law to help protect the city from danger, and most families were proud of their contribution. We see this pride reflected in the numerous portraits that civic militias commissioned of their members in the seventeenth century. They wanted themselves and their loyalty immortalized for all to see. The civic militia was the symbol par excellence

of liberty and of the townspeople's determination to resist any attempt at rule by outsiders.

In 1626, the Leiden artist Joris van Schooten, almost twenty years Rembrandt's senior, was given the city's most prestigious painting commission. He managed to produce seven large paintings of militia companies for the large hall of the Doelen complex, including an extraordinary fifty-eight portraits of fully costumed officers. The paintings, each one several metres wide, were paid for by those depicted: twelve guilders each.

The gifted portrait painter David Bailly, a contemporary of Joris van Schooten's and an officer of the company of Captain Harman van Brosterhuyzen, with its orange, white and green standard, was incensed that he had not been chosen for the commission—so incensed, in fact, that he painted his own portrait in the group rather than allow his colleague to do so. Bare-headed, soberly dressed in black with a white collar, Bailly glares out at us from amid the profusion of bright-orange plumes on the officers' hats. With his defiant action, he saved himself twelve guilders into the bargain.

In 1642, Rembrandt was at the peak of his fame. By a cruel stroke of fate, he was struck just then by the saddest of personal calamities. His wife, Saskia van Uylenburgh, died on 14th June of that year at just twenty-nine years of age and was buried five days later in the Oude Kerk. In the midst of this turbulence, he put the finishing touches to his largest and most important painting of a militia company. The group portrait of the militia company of the city's District II for the large banquet hall in the Kloveniersdoelen, the musketeers' shooting-range complex, was a highly prestigious and lucrative commission. Each of the sixteen militiamen paid him 100 guilders.

This meant that when Rembrandt set about painting "The company of Captain Frans Banninck Cocq and Lieutenant Willem van Ruytenburgh ready to march out", as Captain Banninck Cocq called it in his family album, he was working in a genre with which he was very familiar and which he boldly interpreted in his own way. Instead of a column of men in battle array he showed a bustling crowd of individuals, amid the turmoil that precedes their marching off.

One of the militiamen is preparing to fire his weapon, while another is blowing on the cock of his musket to clean it. Scans of *The Night Watch* reveal that Rembrandt was so fascinated by the scene that he erased part of Ruytenburgh's shoulder in order to paint the mechanics of the musket with precision.

One musketeer in a red suit is loading his musket. We know the musketeers' names: this man was Jan van der Heede. He is steadying one of the twelve small

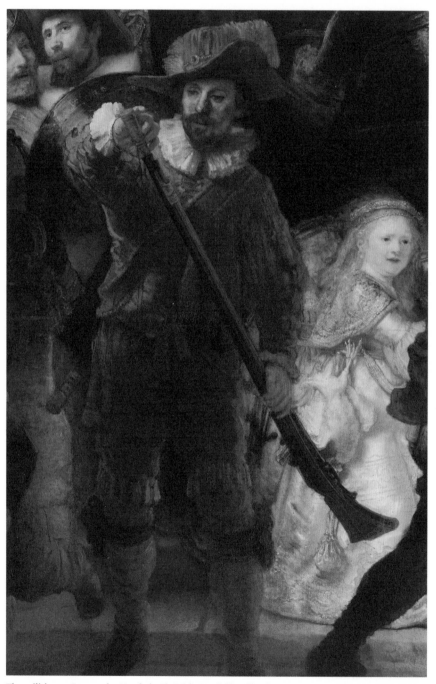

The militiaman Jan van der Heede in *The Night Watch* (detail), 1642.

powder kegs from his shoulder belt, known affectionately as "the twelve apostles", at the muzzle of his weapon, ready to slip the powder into the barrel.

Firearms experts tell us that Van der Heede is holding his musket awkwardly for loading. Instead of placing the butt on the ground and standing the gun up vertically, he has it at an angle. Moreover, on closer inspection you see that Van der Heede's palm is scarcely bent as he grasps the heavy weapon—he is not even clasping it with his thumb. A dangerous way to handle a gun. Could his father's accident have been playing through Rembrandt's mind when he depicted this man's ineptitude?

In his Leiden days he had already made drawings in red chalk of soldiers, along with those of beggars and other characters he saw in the streets. For the soldiers' poses, Rembrandt studied the figures drawn by Jacques de Gheyn 11 in his *Wapenhandelinghe* ("Handling of Arms"). This drill manual was published in 1607 and served an important military purpose. It was commissioned by Maurits of Nassau, who used it to convert a ragged band of mercenaries into the well-drilled army of the Dutch States.

When it fell to one of Harmen's sons to replace him in the militia, his eldest son Gerrit could not oblige, since he too had had some "accident with his hands". Nor did he succeed his father as miller. Gerrit must have suffered from some frailty or disability. On 16th March 1621, Harmen and Neeltje summoned the notary, Craen, because Neeltje lay deathly ill in bed. They had a last will and testament drawn up, which stipulated that Gerrit was to receive a pension of 125 guilders a year upon the death of both his parents. This precautionary measure turned out to have been unnecessary. Neeltje recovered. She did not die until 1640, at the age of seventy-three, having survived her husband by ten years and Gerrit by nine years.

The second son did sign up with the militia. On 10th October 1617, Adriaen enlisted with the second company of the sixth district, serving under the standard of Adriaen Claesz van Leeuwen. He took his oath, adding the note "m" for musket, thus redeeming his father's debt.

It seems likely that Adriaen was mobilized in 1622, a year after the end of the Twelve Years' Truce. Leiden sent its entire militia to occupy the Brabant city of Grave on the River Waal, making it possible for Prince Maurits, the son of William of Orange, stadtholder and general, to march his troops to Bergen op Zoom. It has been suggested that sixteen-year-old Rembrandt was also called to arms, but there is no evidence whatsoever for this.

Adriaen, nine years older than Rembrandt, took over from his father as miller. That had not been the original intention; he had been sent away as a boy to be

Jacques de Gheyn II, *Soldier Blowing Sparks off*
the Pan of his Musket (no. 16), *c.1600*.

Soldier blowing sparks away in *The Night Watch*
(detail), 1642.

apprenticed to a cobbler. In 1619, Adriaen married Lijsbeth van Leeuwen, who
came from a prominent, affluent Leiden family that had produced a number of
millers. For several years he and his wife ran a cobblers' workshop at what is now
Aalmarkt 13.

It was around 1624, when Harmen was relieved of his duties as neighbourhood
master, that Adriaen ended up in his father's business. Through his parents-in-law
he inherited several properties and half of another windmill, De Vechter—a bas-
tardization of the name "Victor", St Victor being the patron saint of millers. After
his mother's death, Adriaen inherited the other half of the family mill and moved
into his parental home on Weddesteeg.

Initially, his business prospered. However, after just a few years he was com-
pelled to sell the houses he had inherited and his share in De Vechter. In 1644 the
city council demanded that he move the mill De Rijn, which he kept running day
and night, to the ramparts to the south of the Wittepoort. He was given a grant to
arrange the move, but it was a severe setback nonetheless.

Adriaen's business slumped with the declining demand for malt. It was a bad
time for breweries. People were cutting down on their beer consumption because
of rising prices. Brewers could no longer draw their water from the Rhine, moats,
and canals, which had all become badly polluted by the cloth industry, but had to

transport it by barge from the dunes. In the absence of demand for malt, Rembrandt's brother sought to convert his malt-mill into a flour-mill. In 1651, he obtained the necessary consent.

In spite of his financial setbacks, Adriaen maintained his position as the proud head of the Van Rijn family in Leiden. He was evidently well respected in the community. On 22nd October 1643 he was appointed master of the Pelikaanshoek district, like his father before him. He died nine years later. On 19th October 1652 he was buried in the Pieterskerk, just a few stone slabs removed from his parents: in grave number 101 in the central section of the nave.

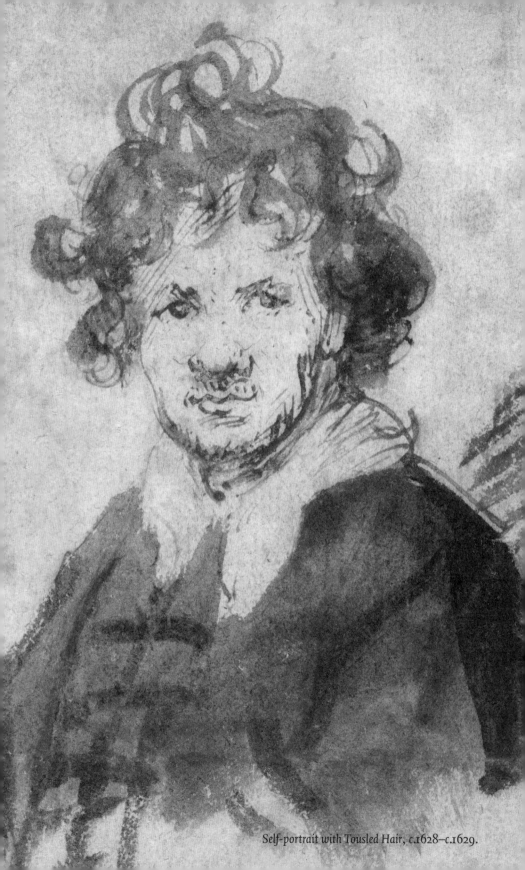

Self-portrait with Tousled Hair, c.1628–c.1629.

6

The new city

FROM THE AGE OF FIVE, REMBRANDT'S EARS WOULD HAVE RUNG WITH the daily cacophony of hammering and sawing drifting across the River Rhine. Turning out of Weddesteeg towards the river, he would have seen the craftsmen and labourers in the main carpentry yard on the other side of the river hard at work building the new city. Huge oak logs were imported from the Baltic States, hoisted onto the wharf and sawn to size. Cobblestones, solid black round stones for the street, and bricks for houses, walls and quaysides were piled up and trundled away in carts and barrows. The yard was a construction site for a boom town.

The 1574 relief of Leiden had attracted a sheer endless flow of immigrants. Leiden's successful stand for liberty had made it an appealing destination for religious refugees from Germany, England, France and Flanders. The city council welcomed them with benevolent enthusiasm. During the siege, famine and Plague had decimated the city's workforce, as a result of which the city's cloth trade, mainstay of the city's economy, had shuddered to a standstill. New blood was vital to the city's revival.

In 1577, Jan van Hout journeyed to Colchester, in the English county of Essex, to recruit workers among the communities of Flemish and Walloon refugees who had settled there. Van Hout offered them the prospect of housing, freedom of religion and burgher status free of charge. He returned with groups of dyers, carders and sheep-shearers in his train.

The largest contingent of refugees came from the Southern Netherlands. In 1582, the major textiles centre of Hondschoote in French Flanders fell to Spanish troops. And from Ypres and Poperinge in West Flanders too, hundreds of Protestants fled to Leiden. The fall of Antwerp, on 27th August 1585, after an exhausting, year-long siege by troops led by Alexander Farnese, the Duke of Parma, triggered a fresh influx of immigrants.

In the spring of 1609, a group of Puritans, Calvinist dissenters from the Church of England who feared repression under King James I, sought asylum in Leiden. The separatists stayed close together, living in the shadow of the Pieterskerk. Their

minister, John Robinson, preached in private homes and became embroiled in fierce theological debates at the university. The former Cambridge undergraduate William Brewster printed their dissident books on the group's own press. Most of the Puritan community, however, toiled for a pittance in the cloth industry.

Life in Leiden was onerous for the newcomers. Not only because of the hard work, but primarily, in a curious stroke of irony, because they saw the religious liberty on the basis of which they had been given sanctuary as posing a threat. The Puritan refugees feared that the lax views of many of the locals—who allowed their children to play freely in the street and who kissed them goodnight at bedtime—set a bad example to their own children. They were afraid of assimilation.

In 1620 some of the Puritans decided to leave Leiden. These Pilgrim Fathers crossed the Atlantic in the barely seaworthy *Mayflower*, eventually disembarking at Plymouth, New England. They would come to be seen as the founding colonists of the United States. Some of their customs and habits derived from their time in Leiden. The festivities held to mark their first harvest, in the autumn of 1621, have endured to this day: the feast of Thanksgiving may have its origins in Leiden's annual celebrations on 3rd October.

Leiden was bursting at the seams. There was an acute lack of homes for the thousands of immigrants. The city council and private individuals initially sought to solve the housing shortage by partitioning houses and rapidly filling gardens and open spaces around the city with new dwellings. It even ordered houses to be built against the city walls.

The Nazareth convent in Maredorp, a settlement to the north of the castle that had been incorporated into the city in the fourteenth century, had been dispossessed by the Protestant city council after the outbreak of the Revolt. In the courtyard of the old convent, sixty-three cottages were built back to back in 1596 to accommodate weavers: social housing *avant la lettre*. But the tiny homes were so cramped that the residents of Maredorp nicknamed the old convent "the Anthill".

In 1611, after long prevarication, the city council gave its consent for the "Fourth Expansion", designed by the surveyor Jan Pietersz Dou, as a result of which Leiden acquired a huge swathe of land to the north. A year after work began, Rembrandt's parental home no longer stood in a blind alley: the road had become a busy thoroughfare. The little archway at the end of Weddesteeg had gone, the old ramparts had been torn down and the inner canal around the corner had been filled in.

A long wooden bridge spanned the river, leading to "the land of promise in the new city", according to a memorial plaque in the wall of a corner house at Beestenmarkt, the cattle-market square. The tablet depicts two men carrying two

huge bunches of black grapes hanging from a pole resting on their shoulders. With the new city came a prolific new harvest.

Rembrandt would have crossed the bridge over the Rhine with his father and siblings, roamed the streets and along the canals, over bridges and the triangular cattle market, gaping at the transformation. Not so long before, this area had been full of wide expanses of market gardens, fields with grazing cattle and flowering apple trees.

The structure of the network of waterways and roads would have astonished him. It was worlds apart from the medieval labyrinth of the city centre. Dou had used a ruler to mark the contours of the "Fourth Expansion", and the digging and building had adhered faithfully to these lines. A totally straight canal, aptly named Langegracht ("Long Canal"), extending east–west across almost the entire width of the city, with wharves on either side, was crossed at regular intervals by smaller, equally straight canals for drainage, such as Oostdwarsgracht and Westdwarsgracht. In between were rectangular plots of land, with blocks of labourers' dwellings, dyeworks and fullers' workshops in a mathematical pattern.

The new city was built not only to alleviate the acute housing shortage, but also to drive the cloth industry out of the city centre. Decades earlier, in 1591, Jan van Hout had issued an alarming report on the pollution of the canals caused by the

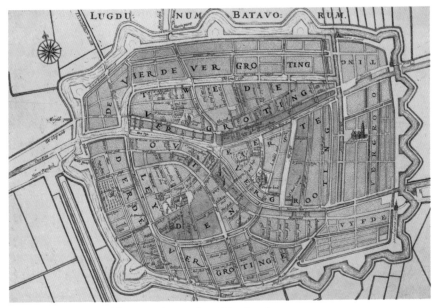

Jan Pietersz Dou, map of the waves of expansion of the city, 1614.

textile industry: fullers and dyers freely discharged a mixture of uric acid and dye into the water. Marcus van Boxhorn's 1622 description of the cities of Holland (*Toneel ofte Beschryvinge der steden van Hollandt*) praises Leiden as "celebrated for cleanliness". Yet the city must nonetheless have been pervaded by a fearful stench, especially on hot days.

With the new expansion, fullers' workshops could move out of the centre to the outermost canals. An ingenious system was invented to pump the filthy water in Volmolengracht out of the city as rapidly as possible through the *vuilsloot*—"waste ditch". Whatever the stench, and however inhospitable the living conditions, the transformed surroundings must have held an almost surreal fascination for Rembrandt. The water in the canals would turn cobalt-blue or vermilion, according to the dye being dumped in it. On dry, sunny days, flakes of sheep's wool drifted through the air and covered the streets like snowfall.

Rembrandt will also have been struck by the strangeness of the language being spoken all around him: a mixture of French and Flemish that would end up enriching Leiden's vernacular. To this day, the city's local dialect has the soft, sing-song intonation of Flemish and a rolling "r" sound. Lists of local residents abound with French names—Labrujère, Laman, De la Court, as well as literal translations such as Schaap (Mouton), De Wekker (Reveillo) and Kwaadgras (Malherbe) and bastardized forms such as Wijnobel (Vignoble).

Besides manpower, the immigrants also brought new skills and a knowledge of innovative techniques. Since the fourteenth century, Leiden had been producing thick cloth from English wool and selling it to the Hanseatic cities. With the outbreak of the Dutch Revolt, that market had collapsed. The Hanseatic cities lost their strong grip on trade and the thick cloth in traditional colours went out of fashion.

The refugees from the Southern Netherlands possessed a different kind of expertise: they were expert at producing lighter materials, made of thin worsted yarn—or combinations of worsted with silk, cotton or goat's wool: *saai*, baize and bombazine. The city council gave permission for the production of the "new draperies", made from wool from Dutch sheep, and more frequently still—in spite of the war, strangely enough—wool imported from Spain.

The quality of the new fabrics was not inspected by a guild but indirectly by the city council itself through trading companies known as *neringen* that were responsible for part of the cloth production. The leading production centre was the Saaihal, whose premises were the former St James's Hospital (Sint-Jacobsgasthuis) on Steenschuur. Isaac Claesz van Swanenburg, one of the city's leading artists, won

the commission to depict the various *neringen* in large panel paintings for the walls of the privy chamber in the Saaihal, where the governors held their weekly meetings.

Six of Swanenburg's paintings have survived. Two depict allegorical scenes: in one, we see the Maid of Leiden gently supporting the Old *Nering*, an elderly woman clad in drab, heavy materials. Around them are cherubs, the central one having a conspicuously empty purse. With her open left hand, the Maid of Leiden welcomes the New *Nering*, a young woman dressed in supple, light-coloured garments. She flies in on the arm of Hermes, the messenger of the gods, who lands gracefully but forcefully on the earth, flattening the scythe of Time.

In the second allegorical painting, the Maid of Leiden hands a book of hallmarks to a woman who has the words "DIE NERINGHE" embroidered in gold letters on the seam of her dress. This painting depicts both the new production method and the way in which the city council monitored and administered the quality of the new cloth. The purse of the little cherub who accompanies the woman is now full.

Oddly enough, Van Swanenburg chose to paint himself and his fellow local officials standing on an imaginary balcony. Moreover, the city in the background of his paintings presents a baffling appearance. His Leiden is endowed with a range of fictional elements and has been portrayed quite clumsily. For this scene, he could have chosen to depict the platform at the top of the steps to the town hall's brand-new façade.

In 1597, the city-appointed stonemason Claes Cornelisz van Es furnished the medieval town hall with a long, sandstone façade. Its design, by the architect Lieven de Key—a refugee from Flanders—abounds in allusions to the siege and relief of Leiden. Two bluestone plaques bricked into this façade—one of which was an old altar stone from the Pieterskerk—were inscribed with lines of verse by Jan van Hout. One contains a numerical riddle or chronosticon that yields the number "1574", while the other urges the people of Leiden not to allow affluence and good fortune to tempt them into pride.

The prosperity came from elsewhere: the people of Leiden knew that all too well. The Oriental patterns carved at intervals into the stone conjured up associations with the Alhambra. The most outlandish additions were the copper crescents balancing on pointed cones atop a long row of stone balls. The crescent moons were an allusion to the motto of the Sea Beggars: "Better Turkish than Popish." Leiden's Calvinists saw conversion to Islam as a lesser evil than embracing Roman Catholicism.

In the four remaining paintings, Van Swanenburg provided synoptic images of the cloth-production process, akin to those of a comic strip. In the first painting, large bales of fleeces are imported into Leiden, after which the wool is washed in the canal and sorted. In the second painting, raw wool is spun into yarn; we see the wool being loosened from the sheepskin by hand and with the shears. Next, *vlakers* beat the coarse dirt from the wool, using a stick or their hands, and *smouters* grease the wool with oil or melted butter until it is smooth and flexible, ready to be combed.

The third painting shows the process of spinning with the "Big Wheel": the beaming of the warp, the winding of the yarn onto the bobbin, and the weaving process. Many Leiden weavers had their own looms at home: the loom would occupy almost the entire living room. The centre of the wool trade was at the aptly named Garenmarkt ("yarn market"), a square in the southern district, just over the bridge near the Saaihal. This was where weavers sold their wares. Many were self-employed and were compelled to work for a pittance.

The fourth painting shows the fulling and dyeing of the wool. The *saai* had to be cleaned and degreased. The fullers stamped on the material in large wooden tubs filled with a mixture of soil, urine and soap, until it was soft and felted. The long pieces of cloth were then rinsed in the canal. The fullers would hang the cloth up on a frame between posts, so that it would maintain precisely the right length. Each section had to be between thirty-six and forty ells long—roughly twenty-five metres.

Next, the cloths would be immersed in a warm bath and dyed black, blue, ochre or red. In the final stage, the sampling officials or "syndics" would check the product's quality by cutting a tiny strip from the fabric as a sample and matching it against earlier samples of high-grade cloth. If the new cloth passed muster, the syndics would affix a hallmark in the form of a slug of lead with the crossed-keys imprint.

Leiden's lead discs served to guarantee quality, and the syndics were seen as the custodians of the city's reputation in the world. This authority shines through in the group portrait that Rembrandt made in 1662 of the five syndics of the Amsterdam Drapers' Guild and their servant. For a Leiden boy, it was a familiar picture. Similar group portraits for syndics were commissioned at the same time in Leiden. They were hung in the splendid, majestic Lakenhal that had been built in 1640 in the middle of the Marewijk quarter by the city architect Arent van 's-Gravenzande.

In the case of the Amsterdam group portrait, all the men depicted here have been identified: apart from the servant, they are two Catholic cloth-buyers, a

Isaac Claesz van Swanenburg, *Washing the Skins and Grading the Wool*, 1594–96.

Isaac Claesz van Swanenburg, *The Removal of the Wool from the Skins and Combing*, 1594–96.

Isaac Claesz van Swanenburg, *Spinning, Cutting the Warp and Weaving*, 1594–96.

Isaac Claesz van Swanenburg, *Fulling and Dyeing*, 1594–96.

Mennonite (a follower of the religious leader Menno Simons) cloth-buyer and art collector, a Remonstrant patrician and a Reformed Protestant from a prominent family. Only in the Dutch Republic would you have found such a diverse group sitting around the table together in the seventeenth century in such a spirit of congeniality. "Look at the syndics," wrote the Leiden historian P.J. Blok in 1906, "are they not Dutchmen through and through, distinguished citizens, imbued with a sense of duty and their weighty task?"

It is fascinating to see how Rembrandt managed to spin such a dull commission into a captivating scene. He uses a theatrical trick: he paints the moment at which an unsuspecting viewer suddenly enters the room. Without knocking. One of the syndics rises from his chair, another falls silent mid-sentence, a third stops leafing through the book of hallmarks. In concert, the syndics turn their gaze on us.

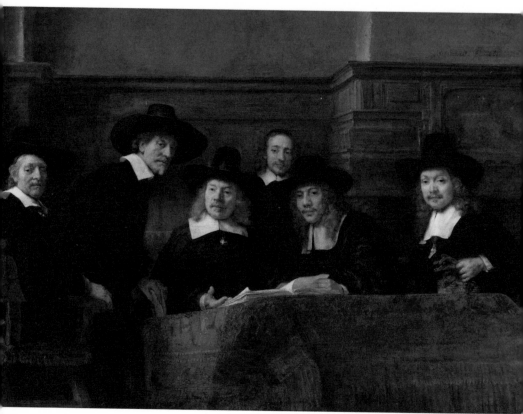

The inspectors of the Amsterdam Clothmakers' Guild, known as *The Syndics of the Drapers' Guild*, 1662.

Rembrandt has left the real reason for the syndics' meeting—the cloth to be inspected—out of the picture. The dark-blue or black strips are laid out on the table, but we cannot see them. We are denied a view of the table because of the low perspective chosen by Rembrandt. He knew that the painting was going to be hung high up on the wall of the Amsterdam Drapers' Guild Hall, the Staalhof.

Even so, Rembrandt could not resist the opportunity to display his gift for painting fabrics. The light catches the edge of the table, which is covered with a precious Persian rug. Rembrandt did not elaborate the rug's pattern in delicate detail using a sable brush; instead he daubed, smudged and stamped. The rug flares with colour. In Rembrandt's hand, paint becomes material.

The cloth trade provided chances for weavers, fullers and dyers to build new lives in Leiden. It also abounded in investment opportunities, and speculation was rife. Any resident of Leiden who had any capital purchased plots of land, built

houses on them and rented them out. So too Rembrandt's father. In 1614, Harmen bought a large plot, around the corner from the Weddesteeg. He built five dwellings on it, moved relatives into them and rented out rooms. To collect the rent due, he simply walked down the alleyway that led from his backyard to the water—a passage built for this very purpose.

The fact that Harmen was able to make this investment shows that he was a decidedly affluent man. That is confirmed by the last will and testament that Rembrandt's parents had drawn up on 16th February 1614. When Harmen van Rijn received a demand in 1623 for payment of the 200th penny—Leiden city council had levied 0.5 per cent tax on the estimated assets of its burghers, since every city in Holland had to contribute to the Republic's war chest—he was assessed for a bill of forty-five guilders, which he managed to get reduced to thirty-five guilders after a "reassessment". Even so, this means that his assets were assessed at a value of 7,000 guilders.

When Neeltje died in 1640, ten years after Harmen, and the couple's assets had to be divided among the four surviving children, the estate was valued at a good deal more: including household effects and a grave and a half in the Pieterskerk, it came to 12,000 guilders.

This was a very substantial sum of money. It is hard to calculate precisely what value this represented in today's terms, given that both the currency and purchasing power were subject to fluctuation, but we can multiply that sum by at least 100— perhaps 200. In 1640, a carpenter's salary was no more than one guilder a day.

The miller's family was flying high.

Minerva in her Study, 1635.

7

Behind Minerva's shield

IN THE WINTER IT WAS STILL PITCH-DARK WHEN REMBRANDT MADE HIS way to the Latin school. Lessons started at 7 a.m. He had the choice of at least two routes from his house, each one less than ten minutes' walk. He could go straight on from Noordeinde into Breestraat and then turn right into the long, narrow Schoolsteeg. Alternatively, he could turn right at the Drie Haringen inn on Noordeinde and walk along Rapenburg. That was the more fashionable route, leading past tall, majestic houses with bell- and step-gables whose reflections gleamed in the smooth water of the canal. This was where the wealthiest merchants and most prominent families lived. The Prinsenhof residence, where members of the House of Orange and their princely guests stayed when they came to the city, was also on Rapenburg.

In the morning, Rapenburg was still quiet and you could hear the wind rustling through the leaves of the linden trees. By the afternoon, however, it was buzzing with activity. Wealthy merchants with elegant hats and lavish cloaks hastened home, servants and maids were sent on errands. Just before Rapenburg curved gently towards the Vliet, you would encounter scholars and students rushing off to a lecture or to the university library.

Sometimes a procession of professors would pass by, dressed in black robes with gleaming white collars. Accompanying them was a terrified student on his way to defend his doctoral dissertation, perspiring for all the world like a condemned man on his way to the gallows. At the front of the procession marched the beadle, grasping his staff with its jingling bells. The procession would disappear through the archway between the university building and the bookshop and printing house of Elsevier, which would have the title pages of new publications pasted to its shutters.

When Rembrandt had crossed the Doelenbrug, halfway down Rapenburg, it was just a few steps to the little square outside Gravensteen, a building that had been erected by the counts of Holland in the Middle Ages and was used as a prison and house of correction. Behind the dungeon bars, as thick as a man's arm, sat the prisoners who had been convicted by the Court of Justice.

At the front of the building lay a square execution yard, planted with grass to absorb the blood. The "patch of green" was surrounded by a ditch to keep the public at a distance. Locals sometimes referred to the square as Schoonverdriet—"Pure Sorrow". Hangings were rare in Rembrandt's day, but the city's executioners frequently administered corporal punishment in public. Convicts were bound to a post, beaten with a stick or branded. The young Rembrandt would have been familiar with the sound of breaking bones and the hissing of scorched human flesh.

Diagonally opposite the field of Pure Sorrow stood the Latin school, a large building endowed with a step-gable as elegant as the one gracing the central carpentry workshop, and windows enlivened by red-and-white shutters. The building had been erected in 1599 after the old school could no longer contain the influx of schoolboys. With the explosive growth of the population and the founding of the university, just a few months after the relief of Leiden, the Latin school was desperately short of space. Daily attendance now stood at over 300 boys.

The old building, which dated from 1431, long known simply as the "Big School" and attached to the parish of the Pieterskerk, no longer met the requirements of the day. The affluent Flemish and French immigrants who sent their sons to the Latin school encountered a physical environment that was badly in need of an upgrade. Where they had come from, all the streets were paved and the roofs tiled.

The city council issued an ordinance obliging burghers to build their houses of stone and to ensure that roofs were tiled to reduce the risk of fire. Renovations were subsidized and those who remained in violation were fined. The city could not remain in violation of its own rules. The old Latin school had a thatched roof. Its wooden structure could not support tiles, so a brand-new building was erected.

Harmen van Rijn must have registered his youngest son

Jan Jacob Bylaert, the Latin school, eighteenth century.

Rembrandt in 1613, following the boy's seventh birthday. This was the customary age for a boy to start school. It was in itself remarkable for a miller to be sending his son to the Latin school, which was a prestigious institution and relatively expensive. Most of the boys came from well-to-do families.

None of Rembrandt's siblings had attended the school. The boys had all been apprenticed to learn a trade. Gerrit was to take over the mill, but then proved unable to do so. Adriaen was apprenticed to a cobbler, and it was he who eventually took over the mill. Willem started off as an assistant in the bakery and was later employed as a corn-bearer.

Girls did not attend the Latin school. One-third of the girls in the seventeenth-century Dutch Republic did enjoy some form of education. Rembrandt's sisters probably had some instruction in reading, writing and arithmetic, but little will have been expected of them beyond a suitable marriage. Until that time, they would help their mother in domestic tasks. Machtelt, who was five or six years older than Rembrandt, did not marry, and continued to live at the house on Weddesteeg until her death in 1625. She probably took on a good deal of the care for her little brother. A clever little boy.

All the children in the Van Rijn family will have spent a short period of time at a private school or have had lessons with a local teacher. Except, perhaps, the youngest, Elisabeth. It seems likely that she was feeble-minded, since her parents had a clause added to their last will and testament specifying that she was to be placed under the supervision of one of her elder brothers after their death. Like Machtelt, she remained single, and lived her entire life at the Weddesteeg house.

Rembrandt probably started his own education at one of these little private or trade schools. The city had dozens of informal classrooms, presided over by schoolmasters from the Southern Netherlands or an occasional immigrant from England or Germany. It was useful for local children to learn some French, to communicate with newcomers. We do not know if Rembrandt had a command of French: we cannot tell from the handful of his surviving letters, the maxims accompanying his etchings or the books he owned, as listed in the inventory drawn up when he declared bankruptcy in 1656. He did read Latin, however, the *lingua franca* in the world of religion and learning.

That was the whole point of the Latin school: to prepare boys for a position of rank and dignity, starting with an official post in the city. In his *Beschrijvinge der Stadt Leyden*, Orlers wrote that Rembrandt's parents sent him to school "to ensure that he mastered the Latin language... thereafter to be admitted to the Leiden Academy, that he might in due course be able to serve the City and the Public Good with his

learning and help to promote its interests". Harmen and Neeltje must have judged that his future and that of his family would be best served by his becoming a Church minister, a lawyer or a physician.

Boys could enrol in the Latin school from seven years of age. The classes were numbered in reverse order: new boys entered the *octava*, the eighth class, where they learnt their ABC and were therefore known as *abecedarii*. Many boys left school once they could read and write. After the *octava* came the *septima*, *sexta*, *quinta*, *quarta* and *tertia*. At this point the boy might go on to university or another form of higher education. Sometimes there was an additional class, the *secunda*, and the most successful schools had a *prima*. Rembrandt probably completed the *quarta*: possibly even the *tertia*.

The Latin school was a spartan environment with hard wooden benches arrayed in cold classrooms. The pupils wrote on a slate with a slate pencil as the master prowled the room, peering at their work. Latin was drummed into the children by rote: letter by letter, word by word, case ending by case ending. Grammatical rules, cast in the mnemonic form of rhyming lines of verse, were recited and endlessly repeated. Anyone too slow to commit the rules to memory would get a beating. Discipline and order were paramount, in accordance with Proverbs 29:15: "The rod and reproof give wisdom".

In the classroom, the master wielded the cane, a wooden stick with a flat spoon attached to the underside. A pupil who misbehaved or made too many mistakes when reciting his lessons would be caned on the hand or the back. Some of these punishments must have been ferocious. When the school building later underwent restoration, canes were discovered in an old cesspit. They had ornate handles and a flat disc attached to the other end. The handle of each one was broken in half.

The headmaster of the Latin school was an imposing figure who was held in high esteem in the city. When he strode down the street dressed in his robes, a cane dangling from his belt, men would doff their hats to him. He lived around the corner from the school in a house with a diminutive walled courtyard on Pieterskerkgracht. In 1613 a tympanum was bricked into the wall above the little archway in the courtyard wall with the motto: "TUTA EST AEGIDE PALLAS": "Pallas Athene is safe because of her shield."

It is not surprising that we have two known paintings by Rembrandt—and one by his pupil Isaack Jouderville—depicting Minerva, the Roman name for Pallas Athene. The goddess of wisdom and of war—according to the myth, she was born from the head of the supreme deity Zeus, wearing a full suit of armour—was a

popular subject in the city. Minerva was the patron saint of both the Latin school and the university.

In Rembrandt's 1631 painting, the goddess meets our gaze with a fierce, indomitable expression. She wears a long, blood-red cloak. On the table before her are a lute and a book as symbols of art and knowledge. Above her head, a laurel wreath on her blonde hair, hangs her shield displaying the head of Medusa with its coiling serpent hair. Minerva exemplified the pride of Leiden: knowledge as a weapon.

The first headmaster of the Latin school, the Calvinist scholar Nicolaus Stochius, was known for his formidable intellect. Stochius had fled from the advancing Spanish troops to Essen. Following the Relief of 1574, the city council had invited him to Leiden, offering him an annual salary of 400 guilders as well as board and lodging. Under his leadership, the Latin school grew from a city school to a venerable institution. Stochius dedicated himself heart and soul to the school. He died in 1593 and was buried in the ambulatory of the Pieterskerk. His portrait, painted by Van Swanenburg, hung in the school to honour his memory.

Rembrandt's headmaster was Jacob Letting, or "Lettingius", a former law professor, who was appointed in 1613. He taught four hours a day: he began the day with a class on dialectics or logic, after which he gave classes on Cicero and Virgil as well as the Greek classics. His duties also included "training the youths in style, declamation, learned debate and other scholarly requisites, and... examining their accomplishments in accordance with the set standards".

In the twelve years of his time as headmaster, he did not build up the same mighty reputation as Stochius. Whenever his tenure was extended, his reappointment was subject to a pledge to refrain from accepting gifts of money from pupils beyond the prescribed maximum in school fees. This was evidently a live issue, despite his annual salary of 750 guilders and rent-free headmaster's house. In January 1625, Lettingius was dismissed for heavy drinking and for continuing to accept proffered gifts of money.

He was succeeded in the post by Dirk Schrevel, known in accordance with custom by the Latinized form of his name, Theodorus Schrevelius. Like Stochius, Schrevelius wielded considerable intellectual and moral influence over his pupils. He was initially headmaster of the Latin school in Haarlem, but following the Synod of Dort—Dordrecht—in 1618 he was obliged to sign a declaration of belief in the profession of catechism of the Reformed Church. He requested time to consider before signing, because he had not yet had an opportunity to read the synod's

decrees. However, this demurral aroused so much suspicion that when he indicated his willingness to sign the declaration six weeks later, he was dismissed from his post after all.

In the autumn of 1620, Schrevelius moved to Leiden, where he initially worked as a private tutor, teaching the sons of influential Leiden families such as those of Van der Werff. In 1625, after the death of Maurits and the installation of the much milder Frederik Hendrik as stadtholder, he was appointed as headmaster of the Latin school in Leiden.

Schrevelius was much loved and was admired for the editions he published of the works of Ovid and Homer. Both the wealthy Remonstrant Petrus Scriverius, a humanist scholar with a private income who lived for literature and art, and Caspar Barlaeus, who had lost his position as professor of logic at Leiden University after the Synod of Dort, wrote odes to him. An art lover, he paid close attention to the painters in his city, including Rembrandt, a former pupil of his school.

In 1628 the Utrecht lawyer and art lover Aernout Buchelius was a guest at the headmaster's house. We know this because Buchelius kept notes on his trips around the country, visiting collectors, art dealers, auction houses and artists' studios, entitled "Res pictoriae".

Schrevelius showed the visitor his art collection, including the still lifes by David Bailly and the little portrait that Frans Hals in Haarlem had made of him on an oval copperplate. He also presented him with a gift: a print made by Jan van de Velde after Hals's portrait of their mutual friend Scriverius.

The two men discussed art, including the work of the young painter who was making a name for himself in the city. The Haarlem inventory of 2nd October 1652, which describes what Schrevelius left to his eldest daughter Brigitta in his will, includes "a small panel painting in an ebony frame, being a fat *tronie* by the cele-brated Painter Rembrandt van Leiden". Schrevelius saw the promise in Rembrandt. Even so, after his visit to Leiden, Buchelius noted: "The son of a miller is also held in high regard, but that is premature [*ante tempus*]."

The learning inculcated at the Latin school included lessons in art, cultural civilization and religion. In addition, the 1613 archives name an art master who taught classes in the neighbourhood of Rapenburg for several hours a day: Henricus Rieverdinck. This Rieverdinck was probably the first to instruct Rembrandt in the art of draughtsmanship, the first to teach him how to write his own name in calligraphy.

The subjects taught at the Latin school were based on the humanist tradition and the writings of Erasmus, who insisted that fathers must concern themselves

with their sons' education from an early age. Petrus Bloccius, who served as deputy headmaster of Leiden's "Big School", published a didactic poem in 1559, "Praecepta formandis puerorum moribus perutilia", to teach young children good manners, which he dedicated to his own son. It may be roughly rendered in English as follows:

> Study Christ and good manners, my son, and scholarship,
> For without these—believe me—life is only death.
> Just as Aegeus' son was helped to flee the Labyrinth
> Because Ariadne of Knossos gave him the thread
> That showed the way: thus too will this little book
> Smooth the path to Christ, to good manners, to Pallas.

A knowledge of the Bible and of the classics, Pallas as well as Christ, constituted the foundations of a boy's education. We do not know which of the classical authors Rembrandt read at the Latin school, or which textbooks he used. It was not until 1625 that the States of Holland introduced a standard curriculum in a so-called *schoolordre*. However, we can safely assume that he read Cicero, Virgil and Ovid, although the lessons will have focused primarily on the linguistic properties of the text rather than the content of the stories and the emotions they conveyed, in which he would later excel as a painter.

When Rembrandt painted *The Rape of Proserpine* in 1631, he knew the story from Ovid's *Metamorphoses*. And when he imagined the scene in which Pluto abducts the daughter of Ceres, the goddess of agriculture, and spirits her away to the underworld, he could consult Ovid's own words:

> usque adeo est properatus amor. Dea territa maesto
> et matrem et comites, sed matrem saepius, ore
> clamat

("so swift as this, is love. The frightened goddess cries out to her mother, to her friends, most of all to her mother, with piteous mouth").

But Rembrandt did not leave it at that. He also read up on the myth in the popular interpretation by the fourth-century poet Claudian, *De raptu Proserpinae*. In Claudian's epic, Pluto drags the girl off brutally and slams her into his chariot. Proserpine's hair dances in the wind as she thrashes with her arms and shrieks in vain to the clouds for help.

The Rape of Proserpine, c.1631.

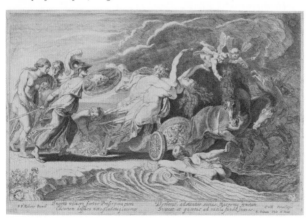

Pieter Claesz Soutman,
after Peter Paul Rubens,
The Rape of Proserpine,
1616–57.

Rembrandt also used a print by Pieter Claesz Soutman after a painting by Rubens. The latter too shows Diana, goddess of hunting, clinging to the skirts of Proserpine. Rembrandt tries to surpass Rubens in his painting, and indeed succeeds. Instead of painting demi-gods and sterile, idealized figures, he depicts a real woman who is seized and hurled onto the chariot. In Rembrandt—unlike Rubens—Proserpine's gold cloak is close to ripping under the strain, and as Diana and Minerva hold on they are dragged along through the splashing water.

Rembrandt learnt at school that artists would base a new work on the centuries-old classical and Christian tradition and on famous examples. He was taught that painters and writers work in a three-stage process of *translatio*, *imitatio* and *aemulatio*: translation, imitation and emulation. The process itself was an imitation of antiquity: had Virgil not taken Homer's *Odyssey* as his example when writing the *Aeneid*, and successfully moulded it into his own creation?

All learning began with imitation. Borrowing was seen not as a refined kind of theft but as a tribute. The yoke of tradition did not weigh Rembrandt down, but he was always exhilarated by the prospect of competition and rivalry, even with celebrated predecessors. When he drew an etching of Leonardo's *Last Supper*, Rembrandt made a few essential alterations to the Apostles' positions relative to Christ.

Painters think with their hands. At the Latin school he learnt to think with his head. Knowledge preceded understanding and intuition. Rembrandt would develop into an ingenious painter who felt intuitively what needed to be done. But he also possessed a keen intellect. He was intelligent and erudite. It is scarcely possible to overstate how much he would draw on his knowledge of Latin and his familiarity with stories from the Bible and classical sources in his work as a painter.

He made contact with poetry and tradition, just as Aristotle placed his hand on the sculpted head of Homer—a scene that Rembrandt depicted magnificently in a painting he produced in 1653: scholarship bows to art.

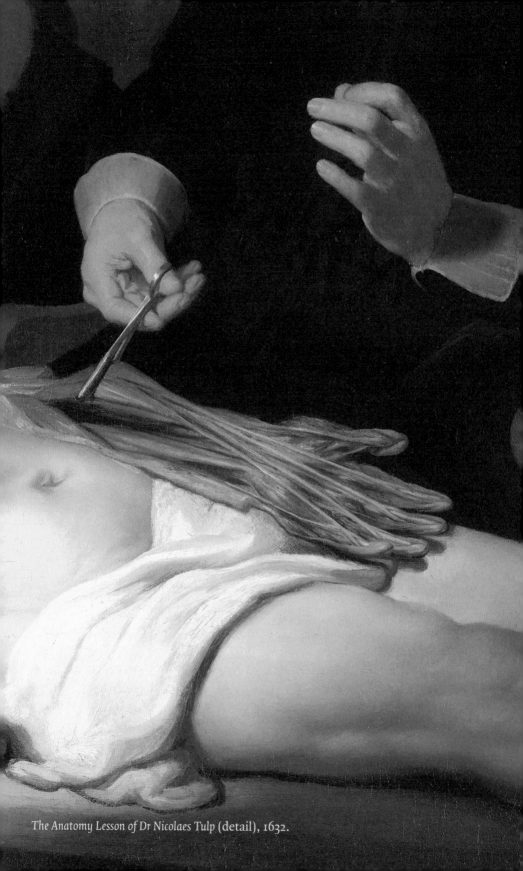
The Anatomy Lesson of Dr Nicolaes Tulp (detail), 1632.

8

The hand of God

ON 20TH MAY 1620, REMBRANDT'S FATHER TOOK HIS SON TO ENROL AS an arts student at the University of Leiden. This enrolment was customary once a boy had completed the *tertia* at the Latin school, cost fifteen stivers, and conferred certain benefits: Leiden students paid no tax on beer and wine, were subject to academic law and were exempt from service in the civic militia.

Until quite recently, it was assumed that Rembrandt had enrolled with a view to securing these advantages and that he did not actually attend lectures. He was the most famous student ever to have been "sent down" from Leiden University.

A discovery made in the university archives in the summer of 2019 sheds new light on the artist's undergraduate days. Students were required to re-enrol each year, inscribing their names in registers or *recensielijsten*. The lists from the first half of the seventeenth century have not been preserved. Only the register of matriculations or *volumen inscriptionum* for 1622 has survived, but it seems not to have been carefully scrutinized before. It contains Rembrandt's name.

In February 1622, the principal placed an asterisk beside the name of "Rembrandus, Hermanii, with his parents", indicating that he had re-enrolled and paid the required five stivers. His age, "14", is deleted and replaced with "15". Evidently the principal asked his age once again—and Rembrandt's reply indicates that his date of birth may indeed have been 15th July 1606.

Far more importantly, however, the entry shows that Rembrandt spent longer at university than we thought. It is highly likely that he also enrolled in the lost *volumen inscriptionum* of 1621. He may even have still been a registered student in 1623, but the list for that year has not survived.

How seriously he took his studies we shall never know for sure. But it is no longer possible to make light of the time that "Rembrandus" spent at Leiden University. He must have studied for at least two years. This helps to explain his spectacular development as a history painter as well as his knowledge and understanding of the Bible, which he would go on to apply with such ingenuity.

Rembrandt moved in academic circles. He lived in a city that challenged his intellect and fired his curiosity every day afresh.

Since 1575, Leiden had been a busy hub of learning. Less than four months after the Relief—William of Orange had rushed to ensure that Philip II, the lawful ruler, would be faced with a fait accompli if he were to conclude peace with Holland's other cities—the new University of Leiden was commended to the grace of God at 7 a.m. on the bitterly cold morning of 8th February 1575. The Pieterskerk was jam-packed. After the service, an inaugural procession wound its way through the streets, devised and designed by Jan van der Does, who had been appointed principal of the new university. The locals would have lined the streets, gaping at the spectacle.

In the vanguard of the procession strode the men of the civic militia, beating their drums, brandishing their banners, and "with a great din and a marvellous hubbub of muskets, small arms, and pistols", wrote Orlers. Then came a float with the *Sacra Scriptura*, the Holy Scriptures, represented by a woman clad in a virginal white robe. Flanking her on foot were the Evangelists Matthew, Mark, Luke and John. Next was the mounted figure of Justitia, blindfold, holding her scales and sword. She was surrounded by Roman legal scholars.

After Justitia came Medicina, with a twig of herbs in one hand and a urine bottle in the other. The men marching in her train represented celebrated physicians

Fokke, *Procession Celebrating the Inauguration of the University of Leiden*, 1575.

from history, such as Hippocrates and Theophrastus. Behind them came the patroness of the new university, Minerva, in a suit of armour made of starched cloth and a shield displaying the fearsome Medusa, shaking her serpent hair. Minerva was accompanied by Aristotle and Plato, Cicero and Virgil.

The highlight of the procession was the "triumphant ship" that sailed along the water of Rapenburg, carrying a lyre-playing Apollo accompanied by the nine Muses. Neptune stood at the helm, as the god of the sea and winds who had raised the surge of water that had driven the Spanish troops from the city. The ship was a vision of a marvellous future in which art and science would represent the city's quintessence.

In the years following the inaugural procession, the governors set about finding suitable premises in the city for the new academic institution. The university started off at St Barbara's convent, which had been evacuated after the Iconoclasm, but the building soon proved inadequate. In 1581 it moved to the former convent of the Cistercians, farther down Rapenburg, where the university library too was set up, until the move, fourteen years later, to the opposite side of Rapenburg, in the old chapel of the Faliede Bagijnhof. That chapel, which the university shared with the English Reformed Church, also accommodated an anatomy theatre and a school of fencing.

During Rembrandt's days at the Latin school, the university saw an entire generation of scholars come and go—or pass away. Leiden attracted scholars and students from all over Europe. By the time Rembrandt enrolled, he was joining an institution with some 2,500 students. They were welcomed as enthusiastically as the new cloth-workers. Indeed, the board of governors did its best to appoint the most famous scholars of the day as lecturers or professors. This headhunting operation was quite successful, certainly when you bear in mind that Leiden was still as poor as a church mouse and the young Dutch Republic was still in a state of war.

The great humanist and philologist Justus Lipsius, famous for his treatise *De constantia*, served four terms as chancellor of the university before returning to the Southern Netherlands to take up a position at his old alma mater, the Catholic University of Leuven. The man invited to replace him was a celebrity scholar. This was the French humanist Josephus Justus Scaliger, renowned for his incisive biblical exegesis, his editions of the classics and Oriental thinkers and his remarkable writings on horology.

On 26th August 1593, Scaliger arrived in Leiden and the city hosted a banquet in his honour at the inn called De Clock on Breestraat. The large company of diners included Jan van der Does, Jan van Hout, the burgomasters, the chancellor, Johannes

Heurnius and Professors Junius and Beyma. The feast ended up costing 112 guilders and eight pennies, over half of which went on alcohol. The guests drank a total of 110.8 litres of wine.

Scaliger had been cajoled to Leiden by some uncommonly attractive terms of employment. He was exempt from teaching duties, received a far higher salary than the other professors and was entitled to free board and lodging. To emphasize his unique position, Scaliger was to lead every procession and was permitted to wear a scarlet gown rather than the standard black.

In his large house on Breestraat, immediately opposite the town hall steps, he wrote his *Thesaurus temporum* ("The Treasure-house of Time"), and held fireside meetings with students such as Hugo Grotius, Caspar Barlaeus, Petrus Scriverius and Daniël Heinsius. "There was that time," wrote Heinsius in his funeral oration for Scaliger, "when the house of one man in this city was the Museum of the world: when distant Maronites and Arabs, Syrians and Ethiopians, Persians and some of the Indians had in this city the man to whom they could unfold their thoughts through the interpretation of language."

Scaliger was a prickly character, prey to pugnacious outbursts. He engaged in polemics with the Jesuits on the interpretation of biblical passages, wrote withering comments on colleagues or rivals in the margins of his books, and carped at the poor living conditions in Leiden. A friend recalled the humanist scholar's complaints about the lack of decorum he encountered in the city: "One may cause a nuisance to one's neighbour with impunity. My neighbours are wont to shout loudly, and I cannot prevent them from doing so. During Lent they start drinking at a very early hour."

Another pet hate was the weather. Scaliger railed at the cold and the damp, the foggy haze that hung over the canals on wintry days. He called Leiden "a swamp within a swamp". Even the remedy against the cold, burning peat in the fireplace, did not escape his

French school, *Joseph Justus Scaliger* (1540–1609), sixteenth century.

censure. "The peat emits sulphurous fumes. From the first moment I arrived here in Leiden, I noticed that others turned white by the fireside. I thought they were fainting, but I was told that it was caused by the bitumen in the peat and by the sulphur."

Scaliger had the fright of his life when his landlord suddenly sold the house on Breestraat. The overheated conditions on the housing market had created havoc in Leiden and made it extremely hard for Scaliger to find a new place to live. When he finally did, he was aghast to discover that the roof of his new home was full of leaks, posing a threat to his large, precious library.

Scaliger developed a curious antipathy to the "Flemish and Walloon rabble"— immigrants like himself. In 1607 he scribbled the following satirical poem into his copy of Lipsius's *De militia Romana*. The Latin lines of verse may be roughly rendered as follows:

> Leiden! See your citizens supplanted by strangers, Belgian filth.
> Partition threatens every house: from each one they make seven.
> Growth has made this one-time village a town of easy wealth.
> Blossom you may, yet soon you'll be one overflowing tavern.

Besides expressing Scaliger's aversion to the crowds, it also shows that, in getting so worked up about the changes, he had come to feel like a true local—to feel at home, after all, in the foggy swamp.

Upon his death in 1609, Scaliger left most of his library—208 Oriental books and manuscripts—to the university. In the university library, which he called a *magna commoditas* ("a great convenience"), these were kept in a separate bookcase displaying the inscription "legatum Josephi Scaliger" and his family coat of arms: a small ladder. The Scaligers hailed from Verona and their name was originally "Della Scala"—"Of the Steps".

Rembrandt is unlikely to have spent much time in the library. Possibly he never went there at all. Only the librarians, professors and city councillors were given a key. But in 1605 it was decided to revoke all rights to the key (the *ius clavium*) and to close the library to the public because books were being stolen. The doors would not reopen for another twenty-five years.

Rembrandt was naturally familiar with the library's appearance, for instance from the four prints by Willem van Swanenburg (son of Isaac), which also showed the fencing school, the botanical gardens and the anatomy theatre, and which had been published by Andreas Cloucq of Leiden in 1610. The prints were sold

separately, but they were also reprinted in Orlers's *Beschrijvinge der Stadt Leyden* as well as in *Athenae Batavae*, the richly illustrated history, prospectus and "Who's Who" of the university for 1625, written by Johannes Meursius. Meursius was an erudite professor of history and linguistics whose arrogance was so off-putting that other scholars were loath to praise his work. Scaliger goaded Meursius by calling him in Latin *ignorant*—"a dunderhead".

For his engraving of the "bibliotheca lugduno-batavae", Willem van Swanenburg had based his composition on Jan Cornelis van 't Woud's drawings of the library when it was still in the central university building. He depicts gentlemen conversing against the background of Scaliger's display cabinet and walking between the rows of open shelves, the books all ordered by subject matter. Two men are studying a globe while two others peruse books on a lectern that are attached by copper chains to the bookcase to prevent theft.

In 1595, the first public library catalogue in the world was made: the *Nomenclator*. Although theology was the university's main discipline, followed by law, the subjects best represented in the catalogue were classical literature and linguistics. Through purchases made by successive librarians—in Rembrandt's day that was Daniël Heinsius—but above all through donations and bequests from scholars who left their books to their alma mater, the library soon possessed a large collection of a high intellectual calibre.

William of Orange himself had donated the very first book at the university's inauguration: it was a polyglot Bible containing the text of the Scriptures in parallel columns: in Hebrew, Aramaic, Syrian, Greek and Latin. The book was a triumph of typography from the printing house of Christophe Plantin in Antwerp. Ironically, the polyglot Bible was printed by order of Philip II. Since Leiden University had been officially founded in the name of the Habsburg ruler, the Prince of Orange was acting provocatively by presenting this *Biblia Regia* in the role of Philip's faithful representative.

The "Praesidium Libertatis" or "Bastion of Liberty", as the university styled itself, attracted dozens of publishers, printers and booksellers to the city. Without fear of persecution or censorship, they could print what they wanted—until 1619. Furthermore, they saw a perfect opportunity to market their books to a highbrow readership.

Christophe Plantin, Europe's most celebrated printer, had come to Leiden in 1582 at the invitation of Lipsius. Since the Spanish Fury—the violent sacking of cities in the Low Countries by Spanish troops in the years 1572–79—Plantin had lived in fear that the Spanish would make it impossible for him to continue to work

in Antwerp. He emigrated, taking his daughter Margaretha and his Calvinist son-in-law Franciscus Raphelengius with him, and together they moved into Huis Assendelft on Breestraat.

Plantin stayed for only two years, transferring the Leiden business to his son-in-law as soon as he dared to return to Antwerp. The firm, known as the "Officina Plantiniana apud Raphelengiis", published work by Lipsius, Scaliger, Clusius, Vulcanius and Simon Stevin. The company's specialism was printing in Oriental languages. Raphelengius cut the letters himself and kept four presses running constantly. The French Ambassador in The Hague described the business, which existed until 1619, as "la plus belle imprimerie de ces pays"—"the finest printing establishment in this country".

Plantin's trainee, Lodewijk Elsevier, who came from Leuven, stayed longer in Leiden. He set up in business next to the university as a bookseller, bookbinder and auctioneer, besides which he also served as university beadle, a largely ceremonial function. After his death, his son Bonaventura inherited the shop and took over the business. The Elsevier family continued to be successful entrepreneurs in the city for generations, buying several buildings on Rapenburg which were soon rented out to booksellers. Justus Lievens, who had attended the Latin school with Rembrandt, also opened a shop there.

Depicting books and paper was a special skill which Rembrandt had mastered at an early age. His *Musical Company* (1626) not only shows a woman singing from a score, but also displays books and folios scattered carelessly around the floor. With their weathered vellum binding and rumpled paper, the books appear to serve here as *vanitas* symbols, emphasizing the vanity and transience of earthly life. Elsewhere, however—in the hands of the hermit St Jerome or the prophetess Hannah—books are generally emblems of erudition and piety.

A market had sprung up in Leiden for paintings that encouraged contemplation and reflected scholarly pursuits. The academic ideals of "study, the active life and the contemplative life" came to characterize the work of Leiden's painters. The painting that Rembrandt made in 1628 of a meditative St Paul, seated at his writing desk, is a miracle of light and serenity. The Apostle appears lost in thought, his head inclining forward. His outstretched left arm rests on the desk. Light streams in from above through a window, but there is additional illumination from a candle behind the book, the appearance of which is therefore reduced to dark contours. It is as if the book itself radiates light.

Studying, writing and collecting were the core activities at the university. Daniël Heinsius called the library "an arsenal of wisdom". But the university did not confine

Willem Isaacsz van Swanenburg, after Jan Cornelisz van 't Woudt, *Library of the University of Leiden*, 1610.

itself to collecting books, prints and paintings. In its botanical garden, the chief gardener gathered living and dead creatures as well as plants, seeds, *naturalia* and "curiosities" in order to demonstrate the astonishing wealth and diversity of God's Creation.

To enter the botanical garden, Rembrandt had to pass through two stone archways. The first one, on Rapenburg, led to a courtyard. On the left was the door to the university, where students and professors walked in and out, clad in their jet-black gowns. On the right was the door to Elsevier's bookshop and printing business. If Rembrandt walked straight on, he would come to the second archway, on the other side of which he would suddenly find himself in a green oasis.

In 1590, the university's board of governors had decided to allocate the empty courtyard behind the main building for use as a "herb garden". The board managed to secure the most famous botanist of his day, Carolus Clusius of Artois, whose real name was Charles de l'Écluse, to serve as the garden's director or *Horti praefectus*.

Clusius was ageing and had suffered a bad fall, dislocating his hip, just before coming to Leiden. On 19th October 1593, the sixty-seven-year-old disabled botanist

arrived on Rapenburg. He was incapable of carrying out any practical work in the garden. The problem was solved by appointing Dirk Ougaertszoon Cluyt, who went by the name of Clutius, as chief gardener. These gentlemen, C&C, turned out to be the perfect duo—one brain, the other hands.

Four quadrants were constructed in the botanical garden, with four times four rectangular flower boxes. This classic harmonic structure reflected Clusius's classification of the plant kingdom. The gardening grandees energetically set about acquiring plants and seeds from all over the world and planting them in the boxes.

Clusius had built up an excellent network of botanists throughout Europe. Moreover, he sought out ships' captains setting off on their eastern voyages and asked them to gather "seeds, fruit, bulbs, roots, herbs, flowers, gum, resins, creatures, items from the sea and suchlike, such as are found in those lands and are unfamiliar or unknown to us here". And they obliged.

In this way, Clusius was able to introduce hyacinths, anemones and horse chestnuts to Holland. His most spectacular find was the tulip, a flower that he had once seen in Lisbon and to which he had given the name *Draco arbor* in his book about the flora of Spain. In 1593, a Flemish diplomat from his circle of friends sent him some tulip bulbs. An Antwerp merchant had acquired them along with a cargo of cotton cloth from Constantinople, but mistook them for onions. He munched a few, roasted with vinegar and oil.

"He picked up the rest," wrote Clusius, "and tossed them into a pile of vegetable waste in his garden. A merchant from Mechelen named Georg Rye, who was very learned in the field of botany, happened by and saw them there. He salvaged them and planted them in his garden; and it was thanks to his actions that I was later able to see several new varieties."

The Turkish tulips that Clusius cultivated were both *praecoces* and *serotinae*, meaning early-flowering and late-flowering varieties. On his sowing experiments, he noted: "Seeds from the same fruit, collected personally by myself and planted in the soil at the same time in the autumn, produced a number of plants the following spring, which after five to ten years (for some develop faster than others) yielded white, mottled white, yellow, mottled yellow, red, mottled red, purple and mottled purple tulips."

The tulips would become a veritable rage. There was a frenzied rush to collect and trade the bulbs. In 1606, a visitor to the Leiden botanical garden saw a tulip that was valued at 150 guilders. Even a picture of that tulip went for sixteen guilders. It is hardly surprising that the botanical garden suffered several robberies targeting its tulips.

HORTI PUBLICI ACADEMIÆ LUGDUNO-BATAVÆ CUM AREOLIS ET PULVILLIS VERA DELINEATIO.

Willem Isaacsz van Swanenburg, after Jan Cornelisz van 't Woudt, *Botanical Gardens of the University of Leiden*, 1610.

On the frontispiece of Clusius's *Rariorum plantarum historia* (1601), Jacques de Gheyn II engraved, beside a portrait of the author, encircled by fruit spilling from a cornucopia, both a vase with flowering tulips and another with tulips that were wilting—to symbolize the ephemeral quality of nature. Until his death eight years later, Clusius—who stayed lame but lived to the ripe old age of eighty-three, surviving the younger Clutius—carried on working on his scientific treatises in Leiden.

In Rembrandt's day, his botanical garden had become a garden of miracles, attracting countless visitors from home and abroad. It had a tree that was so poisonous that anyone who chanced to sleep a night beneath it would never wake up. It had a parsley-like herb that prompted debate among scholars on whether to call it *casta* or *impudica*, modest or debauched. As soon as you touched it it would shrink and collapse, later to rear up again.

Rembrandt must have been enthralled by the garden, especially by its collection of curiosities. In 1600 work started on an *ambulacrum*—a covered gallery—on the

south side of the botanical garden. The theology professor, Gomarus, an inveterate grouch, protested about the new structure. He grumbled that the gallery would block the light coming into his house.

The *ambulacrum* was built in spite of these objections, and was filled with the most wonderful things from the book of nature: not neatly arranged in bookcases, but placed associatively around the space. Besides dried plants, seeds, drawings, books such as Pliny's *Natural History*, maps of the world and terrestrial globes, the items on display included animals—both living and stuffed. Stuffed crocodiles dangled from the ceiling—*Crocodilus maior* and *Crocodilus minor*—along with a whale's jawbone and the bumpy shield of a giant tortoise. A Brazilian parrot perched on a stick. It was adamantly mute. An eagle with a black-and-white tail was kept in a cage. After it died, it too was stuffed and returned to its cage, with an inviting sign beside it that said: "Open my cage."

It was a sublimely eclectic collection, including such items as "Indian bat, swordfish, rhinoceros rib, bill of a sea pig, bird from Brazil with horns on its wings and its head, elephant's foot, bird of paradise, phoenix feather, Indian spider, teeth of a seahorse and a sperm whale, Fruit known as Pineapple, large snakeskins, the skin of a mermaid, wondrous creature in a hen's egg, the tongue of an adder, a variety of shells and a 'dragon'."

The purpose of displaying all these curiosities and of investigating strange plants and animals was to gain a better understanding of the world and the cosmos and to show the beautiful, miraculous nature of Creation. The botanical garden gave a picture of the lost paradise, the Garden of Eden, while the *ambulacrum* highlighted some of the occupants of Noah's Ark.

On Maarsmansteeg, right next to the town hall, was a pharmacy run by Christiaen Porrett, whose collection had a range that rivalled that of the *ambulacrum*. The pharmacist was an amateur scientist who performed chemical experiments, pulverized powders and prepared unguents from flowers and herbs gathered in his own garden beyond the city walls. Besides medicines, he also sold pigments to painters and dyes for use in textiles.

Porrett laboured in his shop with mortar and pestle, jars and scales amid a wealth of shells, conches and stuffed animals, precious glass items, an ivory globe, outlandish stones and crystals from remote regions, ancient coins, curiosities such as "a peculiar leg, of a revolting shape" and diverse paintings, most of them landscapes. On 28th March 1628, after Porrett's death, the "Singular items or Curiosities and exquisite items that stimulate the senses" that he had collected throughout his life were sold at public auction in the inn De Drie Koningen.

One person who certainly attended that auction—about this there can be no doubt—was the young Rembrandt. He had developed a collector's appetite as a boy and he would have rushed to see if there was anything he could buy. The best evidence for this passion is the inventory of the paintings, art on paper, furniture and household goods to be found in his mansion on Sint-Antonisbreestraat in Amsterdam that was drawn up on 25th July 1656, ten days after Rembrandt's fiftieth birthday. The inventory was compiled at a tragic moment in the painter's life. Rembrandt had signed a writ of *cessio bonorum*, relinquishing all rights to his goods in favour of his creditors. He was bankrupt.

Of the 363 items listed in this inventory, it is those contained in the *Kunstkammer* of Rembrandt's house that most fire our imagination. That was where he kept not only his art books and folders with work by Lucas van Leyden, Raphael and Michelangelo, but a cabinet of curiosities including twee terrestrial globes, busts of Aristotle, Socrates and Homer, Nero and Caligula, a powder compact from the East Indies, a Japanese helmet, a pistol, a Turkish gunpowder flask, boxes of minerals, a large number of horns, forty-seven *naturalia* gathered from land and sea and "a drawer containing a bird of paradise and six fans".

Rembrandt must have seen most of the *naturalia* in his own collection in the botanical garden as a boy. He collected partly for purposes of trade—in Sint-Anthonisbreestraat in Amsterdam he sold work by himself and his pupils as well as by other artists—but mainly in order to depict them. We encounter Aristotle and the bust of Homer in his painting of 1653. One of his etchings shows a marbled cone shell, the *Conus marmoreus*. We also find two studies of a bird of paradise, made with the pen and paintbrush.

Clusius described the *Paradisea avis* in his *Exoticorum libri decem* ("Ten Books of Exotic Life Forms"), published in 1605. Legend had it that this was a bird with a long, colourful tail and without legs, which was therefore condemned to spend its entire life in flight without ever alighting on land. In reality, local huntsmen on Ambon cut off the legs of birds of paradise prior to stuffing them, as a remedy to limit decomposition. Eventually, having believed in the myth for some time, Clusius found proof that the bird of paradise did in fact have legs.

In Rembrandt's studies in pen and paintbrush, the birds do not have legs. His birds of paradise, even with folded wings, are doomed for ever to haunt the skies.

The collection in the *ambulacrum* supplemented the medical collection in the Bagijnhof chapel on the other side of Rapenburg. There too, young Rembrandt saw a multitude of marvels. In the one-time chapel of the Beguine nuns, since dispossessed, the university's board of governors had ordered the building of the

Dutch Republic's first anatomy theatre in 1593. Dissections were extremely rare events. They could only be performed in winter, since the cold weather slowed decomposition, and the anatomical subjects would always be executed criminals—criminals hailing from another city, to prevent anyone recognizing them—about whose souls no one need fret, since they were already beyond redemption.

The theatre consisted of a central rotating table surrounded on all sides by six tiers of seats that wound upward to a height of nine metres. In the first circle, the

Study of a bird of paradise in pen and brush, c.1639.

chancellor and the university senate, professors and other dignitaries took their seats. The second ring was for surgeons and students, while all the upper tiers were packed with buzzing crowds of excited locals, who had paid a few stivers to satisfy their "desire and eagerness to gaze upon and observe it".

An anatomy lesson was a solemn spectacle, a voyage of discovery towards a better knowledge of God. Hundreds of candles were lit, and fragrant herbs and sprigs of rosemary scattered across the floor. The body on the turntable was covered by a thin white sheet and black Leiden cloth. When the chief anatomist or *praelector* cautiously lifted the edge of the shroud and folded it back, taking care not to reveal the body in any "unwarranted degree of nudity", and made the first incision in the abdomen, exposing the glistening intestines, a deathly silence fell over the room.

A battery of skeletons was arrayed along the galleries: the bones of an adult woman, named as Schoon Janneken, who had been garrotted in Leiden in 1594 for her infamous crimes of theft, and those of "a fabulous bird whose excrement burned

Bartholomeus Willemsz Dolendo (possibly), after Jan Cornelisz van 't Woudt, *Anatomy Theatre of the University of Leiden*, 1609.

everything it touched". On the skeleton of a horse sat that of a French nobleman who had raped and murdered his sister.

The prepared specimens in the theatre were equally lugubrious: the bladder of a man that had taken in eight full tankards of water, a shirt knitted from long strings of intestines, and a woman's genitalia sporting excessively long hair. Also exhibited were a large Egyptian mummy in a sarcophagus, the shoulder blade of a beached whale found near Katwijk in 1600, and a head constructed from the cranium of a black man who had been killed in the siege of Haarlem.

The room's central displays were the skeletons of "Adam and Eve". Adam held a spade, to enable him to work by the sweat of his brow after his expulsion from Paradise. Eve was shown plucking the apple from the Tree of Knowledge after her seduction by the serpent winding around its trunk. As if the message was not clear enough, the other skeletons held flags in their bony hands with admonitory messages like "HOMO BULLA" ("Man is a bubble"), "NOSCE TE IPSUM" ("Know thyself") and "MEMENTO MORI" ("Remember that you will die").

In the print that Bartholomeus Dolendo made of the anatomy theatre in 1609, we see Professor Pieter Pauw, the very first *praelector*. Pauw was succeeded in 1617 by Otto Heurnius, the son of the physician and chancellor of the university Johannes Heurnius. Otto took his responsibilities very seriously: when his father died a painful death, he opened up the dead body and cut seven large, ash-grey stones from the kidneys, "each one the size and shape of a flat walnut". And displayed them in the anatomy theatre.

Rembrandt would undoubtedly have attended one of Heurnius's anatomy lessons, either among the tiers of local spectators, as a student, or as an aspiring painter, for whom an ability to depict the human anatomy with great precision was part of the training. Like Leonardo before him, he would have been eager to learn how the body worked: indeed, the young Leonardo is known to have exhumed dead bodies to examine them.

In any case, Rembrandt knew how things worked in the anatomy theatre when the Amsterdam Surgeons' Guild gave him the commission, in 1632, to paint *The Anatomy Lesson of Dr Nicolaes Tulp*. This "Dr Tulp" was Claes Pietersz, a Calvinist who had studied medicine in Leiden under Pieter Pauw in the years 1611–14. Pietersz was celebrated as a surgeon in Amsterdam and steadily built up a career as a local public administrator. He took the new surname of "Tulp" in 1622 following his appointment as a magistrate in Amsterdam. The name derived from the tulip on the front façade of his house—a reference to the flower that Carolus Clusius had cultivated in Leiden's botanical garden.

In his painting of the anatomy lesson, Rembrandt completely omitted the theatre and audience. Of the surroundings we see only a few contours, so that all attention focuses on what is happening on the dissecting table. He made a sketch of the scene in the anatomy theatre, but the composition was created in his studio, where he had Dr Tulp and the six surgeons of the guild pose before depicting them. Much later, in the eighteenth century, their names were inscribed in the anatomy book that one of them is holding.

With his dynamic composition and the use of colour and light, Rembrandt infused his group portrait with depth, vitality and drama. Each of the surgeons surrounding Tulp is shown in a different pose and looks in a slightly different direction—even though all are totally absorbed in the lesson. No two gowns are precisely the same shade of black, no two collars the same shade of white. According to a theory that was current in the seventeenth century, the "thickness of the air" varied from one point to the next. Rembrandt conveyed these differences through variations of colour, thus heightening the effect of depth. Light shines bright on the cheeks and lustreless on the grey body. The dead opened arm glistens blood-red and ghastly white.

A real anatomy lesson always started with an incision in the abdominal wall because of the rapid decomposition of the intestines. In this painting, however, the abdomen is still intact. Rembrandt chose to highlight a different aspect altogether. In the seventeenth century, two specific parts of the body were seen as distinguishing humans from animals: the brain and the hands. He opted to focus on the latter.

There is something odd about the hands of the *objectum anatomicum*. X-ray photographs reveal that Rembrandt initially painted a stump instead of the right hand. Had the criminal's hand been hacked off after an earlier conviction? Did Rembrandt decide, on second thought, that this image was unduly gruesome? Or did his clients insist on the change?

The left arm seems almost to have been painted separately. We know that a visitor to Rembrandt's house on 2nd October 1669, two days before the painter's death, came across "four flayed arms and legs dissected by Vesalius". The sixteenth-century Flemish physician Andreas Vesalius, the very first pathologist—and the man who had taught Pieter Pauw—was famous for his prepared body parts. Was the left arm that Rembrandt painted in his anatomy lesson not that of the body, but one of Vesalius's specimens?

There is an indirect allusion to Vesalius in Rembrandt's portrait of Dr Tulp. In his 1543 book on the workings of the human body, *De humani corporis fabrica libri*

septem ("On the Fabric of the Human Body in Seven Books"), Vesalius observes that the hand is the physician's primary instrument—and the portrait of the author depicts him grasping the arm and hand of a cadaver.

With the scissors in his right hand, Dr Tulp lifts the superficial and deep groups of the *flexor digitorum* muscles and tendons in the open arm—those which control the fingers. With his own left hand, Tulp shows the effect of that control: the thumb and index finger come together.

The miracle of science reveals the hand of God.

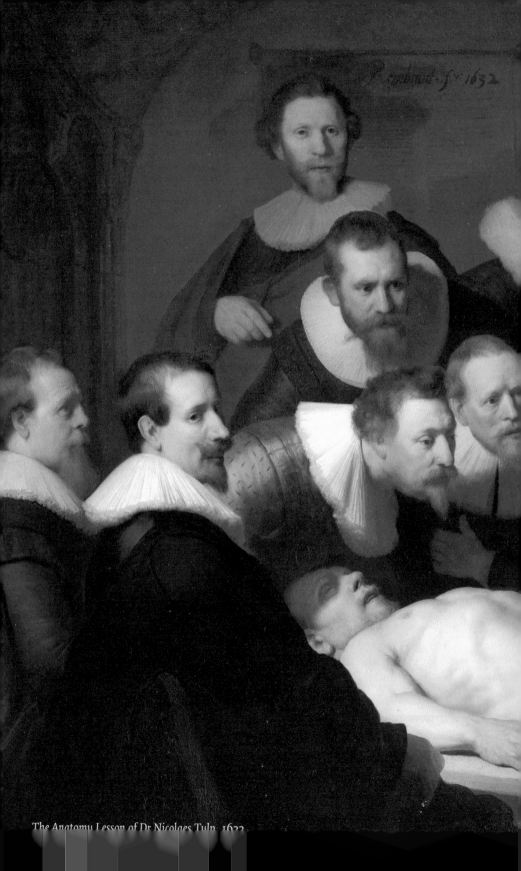

Self-portrait with Curly Hair and White Collar, 1628–32.

9

The Arminian redoubt

WHY DID REMBRANDT DROP OUT OF HIS COURSE AT LEIDEN UNIVERSITY? Was he a wayward young man who baulked at the discipline of academia? According to Orlers, his parents were compelled to remove him from university "since his natural inclinations were exclusively to the arts of Painting and Draughtsmanship".

It cannot be denied that Rembrandt was a rebel, but his decision to abandon his studies should also be seen in the context of wider historical events. In 1618, strict Calvinists known as Gomarists or Counter-Remonstrants seized power in the city, ousting the broader-minded Arminians or Remonstrants from positions in the town hall and banishing the spirit of Erasmus from what had been the bastion of liberty. That will have made it difficult for Rembrandt to continue his studies in the arts.

Rembrandt was raised in a Remonstrant family. He and his parents went to the Pieterskerk, which had been plucked bare by the depredations of the Iconoclasm, and heard the minister's voice and the psalms echoing through the hollow space between the columns. He would not have been allowed to sing in the choir, as the pupils of the Big School had once done every Sunday. Although the Van Rijn family attended Reformed Church services, his mother and her family, as well as his father's family, all remained Catholic. In any case, they were far from literalists.

The Van Rijn family moved in latitudinarian circles. The family's notary was Adriaen Claesz Paets, the leader of the Remonstrants. The membership list of the Remonstrant congregation, which would not be drawn up, for reasons of security, until the 1650s, included Elisabeth Simonsdr and her daughter Cornelia, the widow and daughter of Rembrandt's brother Adriaen. Rembrandt himself was never a registered member of either the Remonstrant or the Calvinist congregation—not in Leiden, nor later in Amsterdam.

He did not openly profess any specific denomination, doubtless seeking to avoid alienating potential clients, whatever their religious beliefs. He retained an air of neutrality. Indeed, he depicted himself in 1661 as St Paul, the Apostle who warned the early Christians about sectarian tendencies in his Epistles to the

Self-portrait as the Apostle Paul, 1661.

Corinthians. St Paul did not distinguish between winning the hearts of Jews, Christians, humanists and those of no faith at all. He wrote (1 Cor. 9:19): "For though I be free from all men, yet have I made myself servant unto all, that I might gain the more."

Yet the religious climate in which Rembrandt grew up was marked by growing intolerance. The seizure of power by the strict Counter-Remonstrants cut off the

path to the possible careers his parents had envisaged for him. With his religious background, he could bid farewell to any hopes of becoming a public administrator, an academic or a physician. Most undergraduates followed in their fathers' footsteps.

The best opportunities for acquiring a good position in society were in the largest faculty: theology. Rembrandt's magnificent paintings of biblical stories demonstrate his affinity with this branch of learning. However, following the power grab of the strict Calvinists, the study of theology must have lost its allure as a fount of knowledge. It was more like a desert.

The controversy that ultimately ripped apart the entire Dutch Republic found its origins on Rapenburg. It had started with a bold appointment. In 1603, the Amsterdam pastor Jacobus Arminius took up a chair in theology at Leiden University. His fellow professor, the Flemish-born Franciscus Gomarus, had expressed objections based on the newcomer's reputation for a lack of orthodoxy.

On 7th February 1604, Arminius chaired a debate on divine predestination in the university's auditorium. His liberal approach to the topic provoked Gomarus to react with a forceful denunciation. He organized an opposing debate, outside the university's schedule, in which he proclaimed the importance of strict orthodoxy. From that time onward, the two theologians engaged in an open polemic.

While Arminius reasoned that people were elected to salvation on the basis of their response in faith, Gomarus posited that the chosen received faith, and hence

Jacobus Arminius Franciscus Gomarus

God's grace. Arminius embraced the concept of free will, through which humans could earn themselves a place in heaven by doing good on earth. In the view of Gomarus, the faithful were accorded a place in heaven, a prospect reserved for very few following the Fall from grace in the Garden of Eden. Only God, he insisted, could determine the fate of a human being.

It was said that Arminius and Gomarus fought out their battle not only in the lecture halls, but also across the hedge that separated their gardens on Nonnensteeg and Achtergracht. Their neighbours were astonished, the legend goes, to hear the two theologians hurling curses at each other in Latin. The colourful story is easily refuted, if only for geographical reasons. It is true that Gomarus owned a building on the south side of Nonnensteeg—it was there that he quarrelled with the university's board of governors about the wall of the botanical garden that would

Salomon Savery (attrib.), *The Scales*, 1618.

block the light—but he rented that house out. Moreover, the gardens of the two scholars were not adjacent at all.

In reality, the dispute played out across the Rapenburg canal, where both professors resided in their elegant houses: Gomarus in a mansion now numbered 29–31 and Arminius (from 1608) on the other side, at number 48. The apocryphal story may have sprung from a misreading of two lines by the great Dutch poet Joost van den Vondel, in an anonymous satirical caption to the print *On the Balance of Holland*, which may be roughly rendered:

> Gommer and Armijn in court
> For the one true faith they fought.

The court referred to here is the Court of Holland. But the Dutch word *hof* means not only "court" but also "garden"—and it is possible that some misinterpretation could have led to the anecdote about the two professors shouting abuse at each other over the hedge.

Arminius died in 1609, but his death by no means buried the debate. On the contrary, a war of opposing pamphlets erupted between the Arminian Remonstrants and the Gomarist Counter-Remonstrants. In other Dutch cities, too, the issue of divine predestination provoked fierce debate. In 1610, dozens of Arminian preachers, led by Johannes Wtenbogaert, court preacher of Maurits in The Hague, drafted a petition to the States of Holland entitled the *Remonstrance*, setting out their positions in five articles. A year later, the Leiden church minister Festus Hommius drew up an opposing declaration affirming the beliefs of the Counter-Remonstrants in seven articles.

The Counter-Remonstrants were incensed that the Remonstrants had addressed their petition to secular rather than ecclesiastical authorities. Radical Calvinists regarded the Arminians' positions as amounting to crypto-Catholicism—heresy. The conflict led to a schism within the Reformed Church in Leiden—the two groups held separate council meetings—and between the Church and the city council. The *vroedschap* consisted largely of Remonstrants from well-to-do local families, while among the population at large, especially among the large immigrant community, the stricter Counter-Remonstrants were in the majority.

Religious controversy is the theme of a painting that Rembrandt made around 1628, *Two Old Men Disputing*. A man with a long white beard, clad in a light-blue robe, is stabbing with the index finger of his right hand at a line in the book lying on the lap of another elderly man. The book is brightly illuminated.

The Apostles Peter and Paul Disputing, 1628.

The men depicted here are far from random individuals: they are the Apostles Peter, the tonsured figure we see from behind, and the bearded Paul. Rembrandt based the composition on a print dating from 1527 by Lucas van Leyden, which likewise depicts Peter and Paul in earnest debate. In Lucas's print, it is Peter who points to the book rather than the writer and preacher Paul. Rembrandt's Apostles are not martyrs but intellectuals. In this painting, he did not furnish them with their customary attributes—Peter with the keys to heaven and Paul with the sword with which he was murdered—but only with books.

Might Rembrandt have had Gomarus and Arminius at the back of his mind when he depicted the disputing old men? In any case, he worked in a city awash with bearded religious pedants. After the Synod of Dort, academics at the University of Leiden set about preparing a new translation of the Bible, which would be the *Statenbijbel* ("States Bible"). Every word was weighed and pondered. Is Paul's pointing finger a covert allusion to the projected *Statenbijbel*?

The Leiden controversy spread across the map of the Dutch Republic like a giant ink blot. Prince Maurits decided in the summer of 1617 to side with the Counter-Remonstrants. That was striking, since he had previously confessed to a total ignorance of theology; indeed, he was quoted as saying that he did not know "whether predestination was green or blue".

All the evidence suggests that Maurits's choice was a pragmatic one. To preserve the unity of the state and to strengthen his own position, he adopted a more orthodox position than his father, who had tried to uphold the principle of freedom of religion until his death in 1584. Maurits thumped the hilt of his sword and said: "With this I will defend the religion."

In siding with the Calvinists, Maurits found himself diametrically opposed to the legal adviser to the States General, the 'Land's Advocate' Johan van Oldenbarnevelt, the most powerful man in the Dutch Republic. On 5th August 1617, Van Oldenbarnevelt issued a "strong resolution" that gave city councils the authority to hire mercenaries to restore peace and order.

When Maurits had first entered the political arena, at nineteen years of age, he and the Advocate established a fine rapport. They complemented each other: the wily politician who planned ahead and dared to take risks, and the prince who showed himself an able military leader at a young age, with a shrewd ability to strike at the right time. Together they formed an ideal combination of ingenuity and strength.

Their relationship deteriorated, however, when Van Oldenbarnevelt sent Maurits to the south, much against the prince's wishes, to take the "pirate nest"

of Dunkirk. The long expedition almost cost the prince his life, when Spanish troops cut him off and he was compelled to engage them in what became the Battle of Nieuwpoort in 1600. He barely managed to snatch victory from the jaws of defeat.

The relationship plunged to new depths after Van Oldenbarnevelt concluded a truce with the Spanish in 1609 to protect the cities of Holland from any further damage to trade and to contain the mounting costs of the war. Maurits fiercely opposed the truce. He feared that the Spanish would lick their wounds and then strike back with even greater ferocity. What he wanted most of all, however, was to maintain his position and income as a general. To carry on fighting.

The truce with the Spanish had the effect of turning the Republic in on itself, which at length triggered a new internal struggle. Resentments grew between the dominant province of Holland and the other provinces, and deep chasms opened up in matters of politics and religion. The *egalité* that William of Orange had tried his best to achieve was strained past breaking point and was being fought out in the streets.

On 20th September 1617, Leiden's Remonstrant city council responded to Van Oldenbarnevelt's "strong resolution" by hiring 200 mercenaries, who went about brutally suppressing dissent. It proved counterproductive. On 4th October, in the wake of the commemoration of the relief of Leiden, riots erupted. Rough-and-ready youths from Walenwijk threw stones at the town hall, and mercenaries chased the stone-throwers through the alleys on either side of Breestraat, trampling on innocent passers-by as they went. One old man was struck on the head with a halberd.

The city council was forced to call the civic militia to arms by way of reinforcements. Throughout the city, people shuttered their windows and barred their doors. The uproar would have penetrated the walls of the classroom where eleven-year-old Rembrandt sat studying, but he would not have joined in. He was not a street urchin and was certainly not given to throwing stones.

Fearful of the restive populace, the city council took action the next day, 5th October, to seal off Breestraat on both sides of the town hall. Two barricades of tall oak stakes were erected, capped with spikes that locals were soon calling "Oldenbarnevelt's teeth". The wooden structure itself was dubbed "the Arminian redoubt", and later—after it had been torn down—a pamphlet distributed by the orthodox Counter-Remonstrants would personify it as "the Arminian tyrant" in lines that can be roughly rendered:

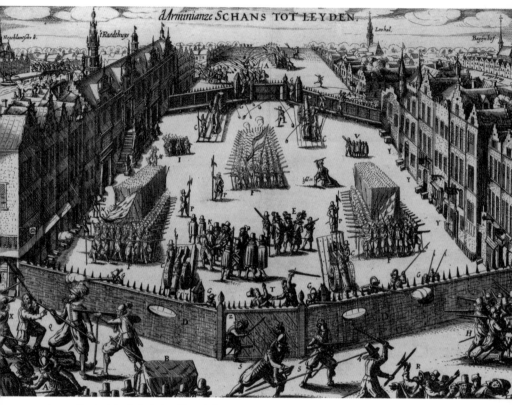

Anon., *The Arminian Redoubt in Leiden*, 1618.

> The Arminian tyrant
> Wrought havoc in this Land;
> But now is he brought low,
> His people no more are cowed.

Almost a year later, in the summer of 1618, Maurits decided to intervene. He dismissed all the mercenaries and disposed of his political opponents. He appointed new officials to executive positions. On 29th August he had Van Oldenbarnevelt arrested on charges of high treason, along with the Pensionary of Rotterdam, the liberal jurist Hugo Grotius, and the Remonstrant Pensionary of Leiden, Rombout Hogerbeets. Grotius and Hogerbeets were sentenced to "eternal imprisonment" by a bench of twenty-four judges. They were locked up at Loevestein Castle, from which the scholar Grotius escaped in a chest of books on 22nd March 1621. Hogerbeets was eventually released

by the new stadtholder, Frederik Hendrik, in August 1625, following the death of Maurits.

Van Oldenbarnevelt met with a grimmer fate. After nine months in prison, the seventy-two-year-old advocate was brought before a court presided over by Reinier Pauw, the Calvinist burgomaster of Amsterdam, and sentenced to death. Van Oldenbarnevelt refused to request clemency, which he saw as an implicit acknowledgement of guilt. On 13th May 1619 he was beheaded on the scaffold at the Binnenhof in The Hague. To the crowds that had flocked to the scene, he declared: "Men, do not believe that I am a traitor to my country. I acted piously and with sincerity, as a good patriot, and that is how I shall die."

While Van Oldenbarnevelt was being held in captivity, Maurits had been going from city to city to dismiss the mercenaries and to put in place a new Calvinist order. On 23rd October 1618, he and his troops entered Leiden. The Arminian redoubt was quickly dismantled and with the looming threat of the stadtholder's presence, twenty-two members of the advisory *vroedschap* were replaced, along with all the magistrates and three of the four burgomasters.

With the aid of Jacob van Brouchoven, a strict Calvinist jurist who had hitherto adopted a minority orthodox position in Leiden city council, Maurits purged the city council of all its Remonstrant members. Van Brouchoven took his seat in the court that sentenced Van Oldenbarnevelt to death and would conduct a true reign of terror as a magistrate in Leiden. "First the tyranny of King Philip, now that of King Brouchoven," wrote the great poet Vondel.

In November 1618, a synod was convened in Dort to resolve the ecclesiastical dispute. Church ministers from all parts of the Dutch Republic, along with delegates from other countries, flocked to Dordrecht. The orthodox Counter-Remonstrants easily outnumbered their opponents, and succeeded in adopting a motion condemning the Arminian position. At the end of the synod, six months later, the Canons of Dort were added to the Dutch articles of faith and the Heidelberg Catechism. Any preacher who refused to sign was dismissed. Many were banished or obliged to go into exile.

One of the refugees was Johannes Wtenbogaert, who, as court preacher of Maurits in The Hague, had fallen into disfavour since submitting the *Remonstrance*. After the arrest of his good friends Van Oldenbarnevelt and Grotius, he went into hiding. On 24th May 1619, eleven days after the execution of Oldenbarnevelt, he was banished and his property seized. Wtenbogaert fled to Rouen by way of Antwerp. He stayed away until after the death of Maurits in 1625. He then found a hiding place in Rotterdam until he was able to quietly move back to The Hague.

Rembrandt knew Wtenbogaert not only by reputation, but also through the latter's nephew and godson Joannes, who came to study in Leiden in 1626. Joannes went to live on Nieuwsteeg, lodging with a former deputy headmaster of the Latin school, Hendrik Swaerdecroon, whose brother-in-law was married to a cousin of Rembrandt's mother. Though only distant cousins, they must have felt a strong sense of kinship. Swaerdecroon had resigned his position at the school on a point of principle: he refused to sign the new oath of office that was prescribed by the Synod of Dort.

On 13th April 1633, Rembrandt painted Wtenbogaert's portrait. We know the exact date, because of an entry in the Remonstrant preacher's diary: "April 13, painted by Rembrandt for Abraham Anthonissen." Abraham Anthonisz Recht was a wealthy, assertive Remonstrant who had commissioned the artist to produce a portrait of his spiritual leader.

Rembrandt clearly had warm feelings for Wtenbogaert, judging by the unpretentious, amiable way he has depicted him. The portrait radiates the message: "This is a fine human being." He is shown hand on heart, skullcap on his head, with a folio propped up on a stand on the table, probably one in which the preacher had entrusted his reflections to paper.

Two years later, Rembrandt produced another portrait of Wtenbogaert, this time an etching. Beneath the print, which shows the preacher in a study crammed full of papers and vellum, his right hand placed defiantly on his side, Hugo Grotius inscribed some lines of verse in Latin, with the following message:

> By the pious and the army, of this man much was spoken,
> But what he preached, Dort's ministers abhorred.
> He was most sorely tried by time but never broken:
> Behold, The Hague, Wtenbogaert to his home is now restored.

Nowhere in Holland, after the Synod of Dort, were the Remonstrants persecuted for so long and with such ferocity as in Leiden. In Maurits's clean sweep of the city government, the old sheriff, although a life appointee, was dismissed and replaced by a man who embarked on a fanatical, implacable rout of the Remonstrants: Willem de Bondt.

The new sheriff came from a family of good standing and had excellent ties with the local élite. He was the son of Gerardus Bontius, the first professor of medicine to be appointed to the University of Leiden, who also served two terms as vice-chancellor.

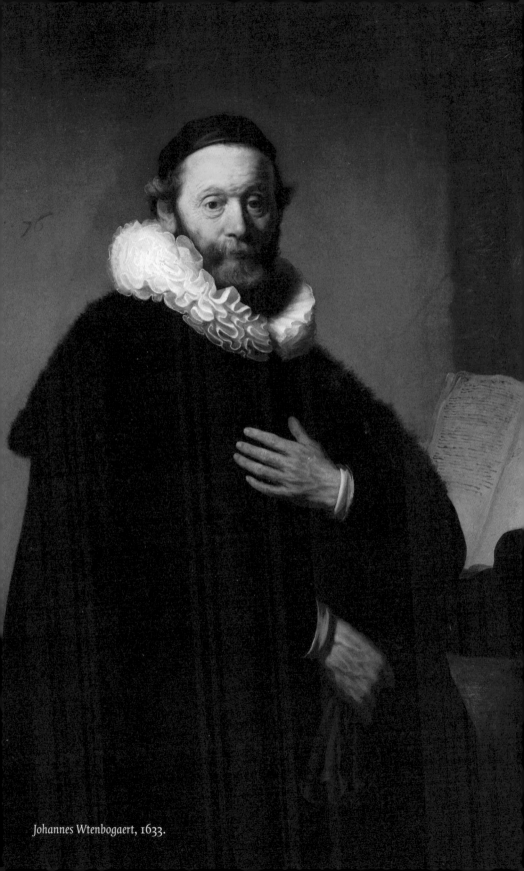

Johannes Wtenbogaert, 1633.

Willem de Bondt's ascent to a professorship in law led to membership of the city's advisory council or *vroedschap* and thence to his appointment as sheriff. It placed him in a pivotal role. He was head of police, patron of the university, and in charge of administering the law. In accepting this position, financial considerations would have come into play: De Bondt received a sum of money for each arrest, and when a convict's property was seized he was entitled to a share of the proceeds.

Petrus Scriverius was convicted of writing a caption to a portrait print of the imprisoned Remonstrant leader Hoogerbeets. Sheriff De Bondt imposed a fine of 200 guilders, but Scriverius refused to pay. When the bailiff came to collect the money, Scriverius took the man into his study and showed him his library, saying: "These books taught me how to tell justice from injustice: these caused the offence, so let the fine too be taken from them."

De Bondt himself did not lead a blameless life. On the contrary, he was accused of corruption, intemperate drinking and neglect of his official duties. He was unfussy about marital fidelity—in the Leiden bars he haunted, he would bellow to all and sundry that his wife Maria was happy to have the organist of the Hooglandse Kerk play upon her—and lax in his attendance at Sunday services.

On New Year's Day 1634, De Bondt and his officers attacked a group of Remonstrants. Two weeks later, his small dog Tyter died under suspicious circumstances. Man and dog (Dutch *hond*) had been inseparable companions. Vondel wrote a few lines of verse that translate roughly as:

> Tyter was his master's joy.
> Where'er he went, where'er was found
> Tyter was never without his Bondt.

Suspecting foul play, the sheriff enlisted the help of the well-known professor Adriaen van Valckenburgh to perform an autopsy on the dog. Had Tyter been strangled or poisoned? De Bondt then gave his dead companion a ceremonial funeral. The lifeless body was carried solemnly to its grave, followed by an odd procession of professors, dignitaries, the little dogs Vorst and Spier and the dog belonging to Professor Schrevel—all draped in mourning garb. At the funeral feast that was hosted after the ceremony, the local Calvinist élite came to pay their respects, including the feared magistrate Van Brouchoven.

The interment of Tyter provoked a flurry of scorn and mockery throughout Holland. Vondel penned his satirical poem, "Funeral of the *Hond* of Sheriff Bont," and Jan Miense Molenaer produced two paintings depicting Tyter's sickbed and

his funeral. The Arminians were outraged: a sheriff who treated them like dogs, but buried his dog as if it were his own child. Rembrandt had already moved to Amsterdam by the time of the canine committal, but even there the events in Leiden were the talk of the town.

Notwithstanding the fun people had with their jests about the "renowned hound", there was nothing funny about the religious persecution in Leiden. After 1574, when Catholics were prohibited from celebrating Mass in public and their churches and religious houses were confiscated, a similar ban followed for Remonstrants in 1619: henceforth, they had to congregate in secret. Each time they met they risked arrest, a fine, a beating or banishment from the city. When Remonstrants went to listen to a preacher's sermon in a field or in the nearby village of Warmond, Calvinist ruffians would ambush them on their way home, pelting stones at them from the embankments.

On 21st April 1619, the Knotters, a wealthy family of cloth merchants who had paintings by Lucas van Leyden and his teacher Cornelis Engebrechtsz hanging on the wall, offered the Remonstrants some space in a back room of one of their houses on Rapenburg—present-day numbers 45–47, once part of the Roma convent. During their service, the rabble lobbed stones at the windows, smashing them. The preacher was pelted with stones and filth as he fled. When the mob caught up with him, they tossed him into the ditch behind the house. The contents of the house were strewn across the cobblestones of Rapenburg.

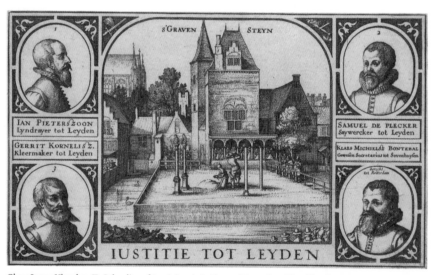

Claes Jansz Visscher II, *Beheading of Arminians in Leiden and Rotterdam* (detail), 1623.

The magistrate did not merely turn a blind eye to this terror, but condoned it quite openly. Stone-throwers and plunderers were acquitted and Remonstrant gatherings prohibited on pain of a 200-guilder fine. The Remonstrants themselves were blamed for the events, like Paul in Thessalonica. In the Acts of the Apostles (17: 5–8), the Apostle himself is accused of causing a riot, rather than the rioters, whose rampage is described in the text: "But the Jews which believed not, moved with envy, took unto them certain lewd fellows of the baser sort, and gathered a company, and set all the city on an uproar, and assaulted the house of Jason, and sought to bring them out to the people."

Three men of Leiden met a far worse fate. These were the "Arminian traitors" who had conspired with the sons of Johan van Oldenbarnevelt in a plot against the life of Prince Maurits. On 21st June 1623, Jan Pietersz, rope-maker, Gerrit Kornelisz, tailor, and Samuel de Plecker, *saai* cloth-worker, were beheaded at the square known as Schoonverdriet near Gravensteen. The rope-maker went first. He shook hands with the preacher who had prayed for him before the executioner pulled a red cap down over his eyes, told him to kneel down "and chopped off his head, in a slightly sideways direction".

Did Rembrandt go and watch the execution? The beheading of Leiden's Remonstrants took place just a stone's throw from the studio of the first master to whom he was apprenticed.

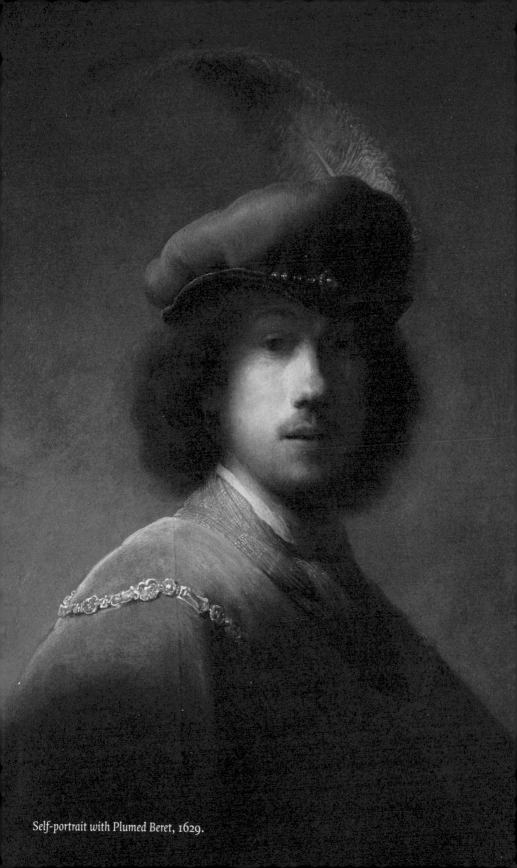

Self-portrait with Plumed Beret, 1629.

The ghost of Lucas

"IN THE BEGINNING WAS THE WORD, AND THE WORD WAS WITH GOD, and the Word was God," states the Gospel according to St John. But Rembrandt's gospel was not the word but the image. What did the boy see that made him decide, apparently quite abruptly and without prior warning, to become a painter? Something must have made an enormous impression on him. Could it have been, perhaps, the most beautiful and most famous painting in the city?

In the mayor's chamber in the town hall hung the painting *The Last Judgement*, a triptych by the sixteenth-century master Lucas van Leyden. During the market that was held as part of the annual celebrations of the relief of Leiden on 3rd October, the town hall opened its doors to the public. Crowds of visitors would converge on the triptych to gaze at it.

According to Karel van Mander, the "sublime and glorious painting" by Master Lucas was hung well above eye level; so Rembrandt would have acquired a cramp in his neck from staring up at the images of heaven and hell. His gaze would have been sucked inward, into the cloud-filled depths of the painting, and together with the *figure piccole*, the tiny, hazy figures of dead souls, over the horizon. The space in the painting seemed endless; all was air and light. Heaven was a vision in light pink, blue and gold.

Besides the sensation of space, the sight of the nudes would have struck Rembrandt like a bolt of lightning. Lucas had emphasized the physicality of the dead souls: he painted them naked, muscular, curvaceous and fleshy. Tangible. The nudes were painted in "sweet flesh tints".

Even more exciting than staring at the pious dream-lift of angels in heaven was the image of hell, where the dead souls of sinners, as described in the Book of Revelation, are cast into the "lake of fire". Lucas had gone to town on his devils, with their goats' heads, sharp claws and bat wings. One monster is screeching, a fat tit with a nipple like a gherkin dangling on its belly. Another sticks out its tongue—in the place where its genitals should have been, an inversion known as *fellatio reversibile*. Defecating, screaming and roaring with laughter, the demons

prod the dead souls with their pitchforks and heave them into the blazing maw of hell.

The moral was unequivocal: no one could escape the Last Judgement. Two priests, identifiable by their tonsures, are tossed into the scorching flames. High-born or high-ranking in earthly life: it all counted for nothing. Yet the moral is not without its light-hearted side. One angel laughs mischievously as she places her arm around the bare buttocks of a salvaged soul.

Sometimes the wings of the triptych were closed, revealing the rear panel paintings of Peter and Paul against the background of an earthly landscape. The saints are conversing, one bearing the keys to the gates of heaven, the other armed with his attributes of book and sword. Karel van Mander eulogized Lucas's pictures of the two Apostles, ranking them among the great triumphs of art.

It was a miracle that the work still existed. The children of the wealthy local timber merchant Claes Dircksz van Swieten had commissioned The Last Judgement from the artist on 26th August 1526 in honour of their father's memory. Lucas had accepted the commission to paint this "memorial retable" for the sum of thirty-five Flemish pounds. Upon completion, the triptych was to be hung above the Van Swieten family tomb in the Pieterskerk.

Four decades after the triptych had been borne aloft to the church in a solemn procession through the city, the Iconoclasm erupted. Legend has it that the "icono-clastic mob" took down the altarpiece and carried it out of the Pieterskerk with a view to destroying it outside. At this, it is said, one of the burgomasters purchased the painting from the rabble and moved it out of harm's way. It is a fine story. However, the triptych, which was painted on panels and encased in heavy wooden frames, weighed a good 400 kilos: even the iconoclasts might have found their knees buckling beneath such a load.

Somehow, in any case, the Van Swieten family managed to save The Last Judgement. It was transferred to St James's Hospital. In 1572, amid the threat of renewed unrest, it was moved again: this time to St Catherine's Hospital. Five years later, after Leiden's Protestant city council had ordered the churches to be stripped of images and painted, the triptych was moved to a permanent place of safety.

This resting place was the burgomaster's chamber in the town hall, where Isaac Claesz van Swanenburg installed Lucas's work with the consent of the Van Swieten family. However, under pressure from the Calvinist authorities, the painter-magistrate was compelled to paint over the Holy Father and his colourful aura and to replace him with the word "Yahweh". Not until the twentieth century, during

restoration work on The Last Judgement, was the figure of God rediscovered and carefully restored to his rightful place, high up in the heavens.

In the burgomaster's chamber, the triptych attracted considerable attention from local townspeople and foreign visitors. In 1602, the Habsburg Emperor Rudolf II, an avid art lover and collector, tried his best to buy the memorial retable. Rudolf sent an envoy to The Hague, prompting Prince Maurits and the States General to urgently petition Leiden city council to agree to the sale.

So eager was Rudolf to acquire The Last Judgement that he was said to have offered a sum of money in gold ducats sufficient to cover the entire surface of the triptych. A vast fortune. Nonetheless, the emperor's request was politely, proudly, declined. The city did not wish to let the painting go, wrote Van Mander, "whatever great sums of money were offered for it".

Rembrandt was undoubtedly transfixed by the beauty of The Last Judgement. Furthermore, he concluded from the stories told of Lucas van Leyden that for a fine painter, the prospect of a golden future beckoned.

A book of portraits of famous Dutch people contained a print by Hieronymus Cock, Lucae Leidano pictori, with as its caption a little Latin poem by Dominicus

Lucas van Leyden, triptych with The Last Judgement, c.1526–27.

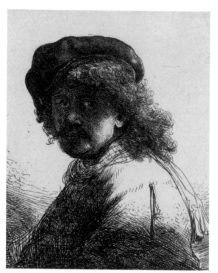

Self-portrait in a Cap and Scarf, 1633.

Reproduction of an engraving of a self-portrait by Lucas van Leyden, c.1872.

Lampsonius. The final lines may be rendered: "Let our poem at least spread far and wide / the glory of your name and your city of Leiden."

If Rembrandt could display talent and willpower, he too could become a famous artist. His desire to become a painter rather than a Church minister, physician or scholar, in line with his parents' plans for him, was not a bohemian whim but a serious professional ambition. The ghost of Lucas challenged him.

A print made of Lucas's self-portrait in 1620, which circulated in Leiden, bore the following inscription: "Portrait of Lucas van Leyden, the incomparable painter and printmaker, at fifteen years of age, made by his own hand."

When Rembrandt was fifteen, he would have seen Lucas van Leyden as a shining example. "Among the many gifted, subtle minds in our art of painting who excelled from earliest childhood," wrote Karel van Mander in his *Schilder-Boeck* (1604), which describes the life and work of over 250 painters and explains contemporary art theory, "I know not one who was [his] equal with the brush and burin in his hand, and who appears to have been born with consummate skill as a painter and draughtsman."

Lucas—who bore the same name as that of the guild's patron saint, and must have seemed to Rembrandt the painter *par excellence*—was described by Van Mander as not just naturally gifted, but also as one who had been fanatically devoted to his art from an early age. "His marbles and toys were the artist's tools, such as charcoal,

chalk, pen, paintbrush, burin and so forth. His mother often tried to stop him from drawing at night, not so much because of the cost of candlelight but from fear that by constantly brooding and foregoing sleep, he would enfeeble or harm his young, fragile body. He never stopped depicting all manner of things from life—heads, hands, feet, buildings, landscapes, and all kinds of materials, since that too gave him pleasure."

Lucas van Leyden practised his profession with unflagging dedication. He worked long hours, was constantly sketching from nature and live models, even in the evening, by candlelight. To Rembrandt, the message was clear: to fulfil his own ambition, he must do the same: study with relentless commitment and become proficient in his chosen craft as soon as possible.

In 1629, Rembrandt would paint himself as Leiden's greatest painter. He sported a cap with a long feather, like the one worn by Master Lucas in one of his famous prints. The feather was a *vanitas* symbol. The man who wore it was not just flaunting his feathers, but acknowledging that, however brilliant he might be, the feather might be swept away by the wind at any moment.

Like life itself.

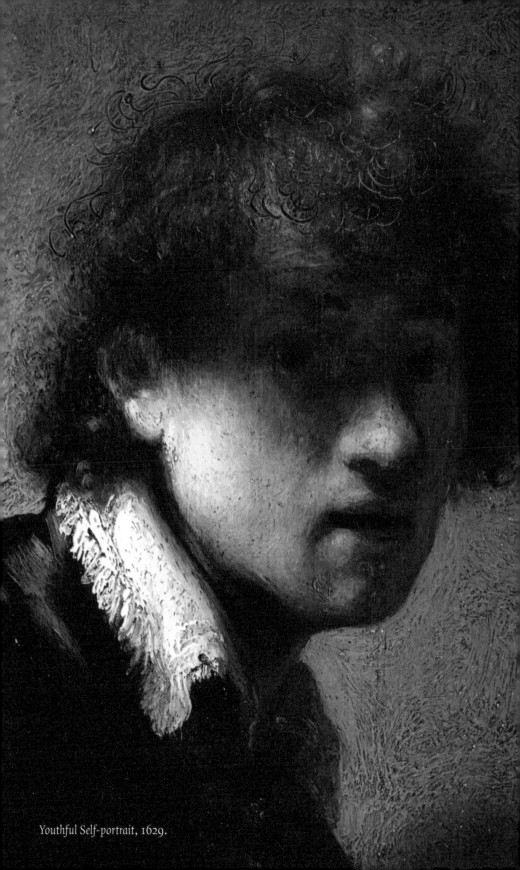

Youthful Self-portrait, 1629.

Little Naples
on Langebrug

REMBRANDT'S FIRST TEACHER WAS JACOB ISAACSZ VAN SWANENBURG, who came from a well-known Leiden family of public administrators, merchants and artisans. Jacob was the eldest son of Isaac, the city's omnipresent painter, who was known as Master Nicolai. The paterfamilias himself had been trained by his uncle, Pieter Cornelisz Kunst, and Aertgen van Leyden. His later teacher was Frans Floris, the most important painter in Antwerp.

In 1569, Master Nicolai had married the daughter of a prosperous cloth merchant, Marytge Dedel, who was ten years his junior. Two years later, immediately after the birth of their eldest son, Jacob, he purchased a building overlooking the New Rhine, on the site of what is now number 45. It stood between the mansions of the fabulously wealthy brewer Van Heemskerck, on the corner of the alley, and that of a surgeon. A little farther down the road lived Petrus Scriverius, a close family friend.

After Leiden had joined the side of the Dutch Revolt in 1572, several new appointments were made in the city council. Van Heemskerck, a prominent Calvinist, became one of the new burgomasters, as did Joost Willemsz Dedel, Master Nicolai's father-in-law.

Master Nicolai was evidently viewed as an unimpeachable adherent of the new doctrine. Even so, like the Catholic *glippers* who had slipped out of the city and forfeited their houses and property as a result, since they were viewed as traitors, he had stayed away from the city during the siege of Leiden. He spent that period in Hamburg.

As son-in-law of the well-known cloth merchant, Master Nicolai may possibly have acted as a kind of agent for him. In Hamburg the red cloth from Leiden was dyed black and sold for the city's far more expensive black cloth, a ruse that badly damaged Leiden's reputation. Perhaps he had returned from a journey to address a commercial problem of this kind to find the Spanish troops suddenly surrounding

Isaac Claesz van Swanenburg, *Self-portrait*, 1568.

the walls, and was unable to get back into Leiden safely. He was not dogmatic in political or religious matters, but was rather a skilful pragmatist. He moved in Remonstrant circles without ever breaking off contact with Catholic family members.

Master Nicolai had a successful career and was appointed as a magistrate in 1576. Between 1596 and 1607 he served several terms as burgomaster. A few months

after the relief of Leiden, he was called on to design part of the decorations in the procession to mark the inauguration of Leiden University. This was the first in a long series of commissions: designs for stained-glass windows in churches and images of the cloth trade for the Saaihal. For three whole decades, not a single artistic commission was granted without this administrative and artistic jack-of-all-trades being involved in it in some way or other.

In his house on the New Rhine, Master Nicolai trained three of his sons for a future in the studio: Jacob, Claes and Willem. Other sons followed their father's career in public administration. One succeeded Jan van Hout as town clerk after the latter's death in 1609. The most brilliant son was the youngest, Willem: he became a superb printmaker, producing beautiful engravings depicting the anatomy theatre, the library, the fencing school and the university's botanical garden. Willem's promising career was cut short by his premature death in 1612 at just thirty-two years of age. Claes, a "righteous Remonstrant", was a respectable painter of unremarkable work.

As Master Nicolai's eldest son, Jacob van Swanenburg would have been destined to continue the family tradition. He brought his period of training in his father's studio to a close with a trip to Italy to study the paintings of Leonardo, Raphael and Titian in the original. He left for the south around 1591, when he would have been maybe twenty years of age. But to the astonishment of his father, Jacob did not come back. He would not return to Leiden for twenty-four years.

Jacob was bewitched by what he saw in Italy. He went to Venice, moved in painters' circles in Rome, and then went still farther south. His travels ended in Naples, when a woman captured his heart. He fell in love with Margaretha Cordone, the daughter of a grocer and merchant in Oriental goods. To marry her, he returned to the bosom of the Mother Church. Seven children were born to the couple, three of whom survived to adulthood.

Jacob had not sought his parents' consent for the marriage. They did not hear about it until afterwards. When his father and mother had the notary draw up their wills on 28th January 1610—Master Nicolai was ill and feared for his life—the document stated that Jacob was "abroad and married in Italy". Alone among the children, he was excluded from the inheritance. For his father, it must have been a bitter disappointment that his son had not wanted to follow in his footsteps, marrying into a well-to-do family and making a career for himself in Leiden.

Jacob would never see his father again. Master Nicolai was troubled by a bladder stone in 1614 and suffered severe pain, "caused by passing water". The family chronicle recorded that the ageing Van Swanenburg was afflicted by attacks of

fever for several weeks. On 10th March 1614, he fell into a sleep from which he failed to awake. He breathed his last breath and "gave up the Ghost in the gentlest of ways".

Had the news of his father's death reached Jacob? Was that why he returned to his native city? All we know is that he had run into trouble in Naples before then. He clashed with the Inquisition in 1608, after he had hung a painting of a witches' sabbath at his stall within the grounds of the Church of Santa Maria della Carita. Jacob was questioned but not convicted. He managed to escape prosecution by offering the feeble excuse that he had only hung the painting up to let it dry. Possibly the ground had become too hot under his feet.

Jacob decided to leave his wife and three young children with his parents-in-law and return to Leiden. On 21st December 1615, he knocked on the front door of his parental home on New Rhine. The Van Swanenburg family welcomed the prodigal son back into the fold. Jacob found the city of his birth to be a congenial place. He put his affairs in order, taking over a year to do so, and left for Naples on 4th April 1617 to fetch his wife and children.

On 6th January 1618, Jacob returned to Leiden, having crossed and recrossed the Alps in a journey that took a little over two months, with his wife Margaretha and their children Maria (aged fifteen), Silvester (ten) and Catherina (four). The family moved into a building on Langebrug, present-day number 89, diagonally opposite Wolsteeg, a road that ended, fifty metres farther, across from the steps of the town hall on Breestraat: a few hundred metres, as the crow flies, from the house overlooking the New Rhine in which he had been born.

The road now called Langebrug—"Long Bridge"—had been a canal known in the Early Middle Ages as Voldersgracht ("Fullers' Canal"), because this was where the cleansing or "fulling" of woven materials took place. The mush of uric acid, soil and soap with which fabrics were "felted" went straight into the canal. It emitted a noxious stench, and fulling was eventually banished to the outskirts of the city. In the seventeenth century the Voldersgracht was covered in stages with stone vaults, eventually becoming one long bridge—which is how the street where Master Jacob lived acquired its name. The stone vaults were safer for pedestrians, whether or not in an inebriated state. The artist Aertgen van Leyden, who had taught Jacob's father, had been relieving himself in the Voldersgracht in 1564, having had rather too much to drink, when he lost his balance, toppled into the water and drowned.

Around 1620, when Rembrandt arrived at the painters' workshop as a young trainee, the residents of Langebrug were a miscellaneous bunch. They included

The Slaughtered Ox, 1655.

many small businessmen and artisans. No really wealthy people—they lived in the great mansions on Breestraat or Rapenburg—but neither was there any real poverty.

There was a constant toing-and-froing in that section of the narrow street, especially with maidservants and other women who were off to the tripe hall or Penshal to purchase bacon, blood pudding, sausage or tripe. There were two entrances to the Penshal market: one on Breestraat, the other on Langebrug,

diagonally opposite the Van Swanenburg residence. The latter was called the "Sheep Gate": its stone arch, dating from 1607, displays an image of a ram holding Leiden's coat of arms.

The Penshal was not an actual hall but a small square with covered colonnades on either side. It had once hosted a haberdashery market, but now it was the place where offal such as liver, kidneys, brains and lungs were arrayed on stone tables beneath the arcades, carved and sold. There were only two approved sites for the sale of meat in Leiden. Beef was sold at the meat market in the town hall, while pork and offal were traded in the Penshal. This facilitated good hygienic practices and produced clarity for those charged with levying excise duties.

While the meat trade at the town hall was conducted by men, it was women who sold low-quality offal at the Penshal. These market women—the "bacon or tripe wives"—mainly catered for the poorer sections of the local community. Rembrandt would have seen slaughtered cows dangling in the indoor meat market in a splayed posture resembling the upside-down crucifixion of the Apostle Peter, the carcass sliced open. Did he shudder at the sight? In 1655, he depicted the cruel beauty of a crucified ox, in an image that would in later centuries serve as a source of inspiration to Chaim Soutine and Francis Bacon.

We do not know why Rembrandt's parents chose to apprentice him to Jacob van Swanenburg. One might have thought Joris van Schooten, Leiden's most highly esteemed and experienced master painter at the time, would have been a more obvious choice. Simon van Leeuwen wrote in his brief history of Leiden (*Korte besgryving van het Lugdunum Batavorum nu Leyden*, 1672) that Van Schooten was in fact Rembrandt's first teacher, but there is no corroborating evidence for this.

Father and mother Van Rijn moved in the same non-dogmatic circles as the Van Swanenburg family, whose influence was sharply curtailed after the 1618 purge of the local executive. Even so, Rembrandt's parents would have hoped that a scion of that family might be able to introduce their son into the world of city magistrates, patrons and art collectors. Perhaps the story of Jacob's long sojourn in Italy also had a certain appeal. He was the only painter in Leiden who boasted foreign experience of this kind.

Art historians have endlessly insisted that Jacob van Swanenburg did not exert a shred of influence on his brilliant pupil. But are they right? According to Orlers, who himself owned a "magical piece" by Master Jacob, Rembrandt developed his skills so rapidly with Van Swanenburg "that art lovers were quite amazed, and that it was abundantly plain that he would mature with the passage of time into an outstanding Painter".

At first sight, few resemblances suggest themselves between the work of the fifty-year-old Jacob and that of the young Rembrandt. Not much of Master Jacob's work has survived: we have a stiff *View of St Peter's Square in Rome* and a handful of apocalyptic horror scenes. A *Temptation of St Anthony* is attributed to Jacob—the subject of the first painting we know by Michelangelo, along with *The Rape of Proserpine* and several scenes from Dante's *Inferno*.

When Rembrandt entered the studio on Langebrug, around 1622, Master Jacob had just finished painting the underworld on a panel measuring 1 x 1.25 metres. A spectacular piece. Pluto, lord of the underworld, steers his chariot through billowing dark clouds. The sky is ablaze: the night is on fire. Damned souls are trying in vain to evade their fate, as Charon scoops them up into his ferry boat across the River Styx. They are skewered and gobbled up by devils with wings and grotesque heads. Portrayed in the enormous, gaping jaws of a monster are a number of detestable sins. The woman who is pulling out her tongue represents bearing false witness. The man stuffing himself with food symbolizes gluttony.

What possible link suggests itself with the work of the young Rembrandt? The relationship is invisible. It is easy to understand, however, why Master Jacob's

Jacob Isaacz van Swanenburg, *The Underworld with Charon's Boat*, c.1620.

Man Drawing from a Plaster Model, 1639–43.

influence is so hard to demonstrate. As an apprentice, Rembrandt had come to lay the foundations for his career as an artist. These foundations would later be painted over—quite literally—with the passage of time.

The boy had to make endless sketches, by daylight and candlelight, of plaster busts, feet and hands, and anatomical prints to master the art of depicting the human body. He will have had the occasional opportunity to draw from a live model, to strengthen his grasp of perspective. He had to practise the rendering of materials—depicting the folds in a woollen cloak, for instance. Again and again. All those initial efforts from the days of his apprenticeship have been lost. They were rarely made on paper, but mostly on a blank slate or *tabula rasa*—drawings that were subsequently erased for all eternity.

Rembrandt learnt to distinguish between different pigments, from white lead to chimney-black or bone-black—obtained from charring animal bones in the fire for hours—and from vermilion to Spanish green, and was taught how to pulverize pigments on the grindstone and mix them with linseed oil. He had to continue crushing the pigments until they became a wonderfully smooth dye, sometimes thin, sometimes thick and creamy, giving off a pungent aroma. He had to clean paintbrushes—coarse, bristly ones made of ox hair, and the very finest ones consisting of just one or two tail-hairs from a marten—and prepare his master's palette.

He also learnt how to prepare Master Jacob's oak panels: cracks in the panel had to be filled in, and the surface made non-absorbent, by using a brush to apply an initial primer of glue, followed by a layer of glue-chalk gesso. This smoothed out the knots and irregularities and stopped the oil seeping into the wood. Next came a sanding procedure, creating a smooth surface on which the master would apply an underpainting of the scene in "dead colour". Only then would Van Swanenburg paint the different sections of his composition on the panel, moving from the background to the foreground.

As part of his daily routine, Rembrandt became versed in the complex grammar of form, light, colour and space. The pupil would often stand beside his teacher, literally copying his movements. He also studied theory. The most important text was Karel van Mander's didactic poem on the art of painting, *Den Grondt der Edel vrij Schilderconst* ("The Foundations of the Noble and Free Art of Painting"), part of his *Schilder-Boeck*, which was written in rhyming verse to make it easier to recite and to commit to memory.

It will have been some time before Rembrandt was allowed to apply the initial design for a painting himself. Or to make a copy of one of the master's works, which meant first copying it as precisely as possible and then personalizing it with minor alterations. Working on an *Inferno* would have shown him how difficult that was: painting fire. Karel van Mander has a special word of praise, when discussing the topics of reflection, shimmer and lustre, for painters who are able to depict convincingly the rage of Vulcan. His words may be roughly rendered as follows:

> He exercises imperious rule over art
> Who figures well with colours Vulcan's wrath
> And the awful misery of his realm.

Jacob van Swanenburg had learnt the art of painting dark-flaming underworlds in Italy. At the end of the sixteenth century, when he had left Leiden and journeyed first to Rome, then Naples, he found himself in a land that was fascinated by dramatic nocturnal scenes. He was not the only artist to draw inspiration from Italy in this area: countless foreign painters came to steal the fire of the night there, including Adam Elsheimer from Frankfurt, Peter Paul Rubens from Antwerp and Gerard van Honthorst of Utrecht, who became known as Gerardo della Notte— "Gerard of the Night".

When Van Swanenburg and his wife were living and working in Naples, the famous Michelangelo Merisi da Caravaggio, who was seen as a magician who could conjure with light, stayed there for some time. Caravaggio was the master of chiaroscuro, the sharp contrasts between light and dark that give his paintings such a dramatic impact. Later, after his return to Leiden, Master Jacob would undoubtedly have told his pupil about Caravaggio. It was like a spark in a barrel of gunpowder.

There was something else about Caravaggio's work that must have fascinated Rembrandt, besides his chiaroscuro: his realism. For the Italians it was a shock to see the lifelike quality of the figures in his paintings. They looked as if they were about to step right out of the canvas. The angel caressing Matthew's hand (in *Matthew and the Angel*), in what was almost a loving embrace with the Evangelist, caused a scandal in Rome. The cardinal of San Luigi dei Francesi forced Caravaggio to rework the painting in 1602. But even the new version, which still hangs in the Contarelli chapel of the Church of San Luigi dei Francesi in Rome, stirred consternation because of the realism and humanity with which the angel and the ageing, ungainly Matthew were painted.

Karel van Mander, who had the honour of being the first to publish a biographical sketch on Caravaggio, pronounced the indecorous work a disgrace. He scoffed that the Italian master simply painted what he saw in the natural world—an accomplishment in which Rembrandt would later indeed take pride. The word *edel*—"noble"—in the title of Van Mander's *Den Grondt der Edel vrij Schilderconst*, from which Rembrandt recited lines as a pupil, reflected the writer's underlying moral purpose.

Besides teaching the technique of painting, the book also included moral exhortations for aspiring young painters. They must take care to maintain an unblemished reputation at all times, in their work and their life. That could certainly not be said of Caravaggio, who was embroiled in a series of scandals and brawls, and who had been obliged to flee from Rome in 1606 to escape a murder charge.

Rejecting the popular image of artists—"Hoe schilder, hoe wilder"—Van Mander instead urged the opposite: "Hoe schilder, hoe stiller" ("The truer the painter, the quieter he is").

Master Jacob pointed the way to Rembrandt. Studying with the Van Swanenburg family brought Rembrandt into contact with other painters in a natural way. Otto van Veen had been trained by Master Nicolai, after which he served an apprenticeship with Peter Paul Rubens. In his turn, the astute, successful artist from Antwerp travelled to Leiden to ask Willem van Swanenburg to make engravings after his paintings. In a sense, then, Rembrandt and Rubens might be seen as cousins from the same family of painters.

The influence of his first, eccentric master on the young Rembrandt is perhaps a little hard to demonstrate. But Jacob undoubtedly contributed to the formation of his student's emotional life. In the Van Swanenburg and Van Heemskerck family chronicle we read, following Jacob's death on 16th October 1638, that he was a gifted painter of works of great artistic quality, and a man of "a very fine character and disposition".

With his tales of Rome and Naples and his blistering images of the underworld, the amiable Master Jacob must have fired Rembrandt's imagination. Master Jacob and his wife communicated in Italian. It is an intriguing thought that the boy studying his craft in the Langebrug workshop did not draw models only from plaster busts, but that Maria, his master's daughter, an Italian girl aged seventeen, may also have caught his eye.

Paint would not have been the only smell to have met Rembrandt's nostrils in the studio. Might Margaretha have sometimes had a pasta sauce bubbling away on the fire? The cookery book for the Dutch housewife written in 1612 by Antonius Magirus, based on the work of Bartolomeo Scappi—the personal chef to Pope Pius IV and the "Michelangelo of the Italian kitchen"—includes a recipe for *hutspot* that would have appealed to locals. This same cookery book also has a recipe for *mostaccioli*, Neapolitan pastries. Magirus warmly advocates the use of Parmesan cheese, garlic and truffles. If Margaretha was able to obtain these ingredients, which would not have been easy in Leiden, she would certainly have used them.

Rembrandt served his first apprenticeship in Little Naples on Langebrug.

The Sacrifice of Isaac (detail), 1635.

12

Innocence Slain

AFTER THREE YEARS—ROUGHLY FROM 1622 TO 1625—IN MASTER JACOB'S studio, Rembrandt was an accomplished draughtsman who was proficient at mixing pigments and oil to make paint, priming the surface of a panel and "laying in" a painting, one layer at a time. According to Orlers, art connoisseurs in Leiden were confounded by his progress and could see that he was destined for greatness. But he still had a long way to go.

Rembrandt wanted to become a history painter. In the hierarchy of visual arts, the history painter occupied the highest-ranking position because he had to be able to depict biblical, mythical and secular "histories" with the aid of light and colour, perspective and composition. He had to be adept at painting a range of subjects: portraits and tronies, animals, objects, draperies, landscapes and—above all—human figures in diverse poses and in different relationships to one another. A history painter was a divine director-cum-choreographer.

To redeem the promise of his artistic prowess, he had to widen his outlook, deepen his knowledge and refine his taste. In 1625, his father agreed to allow the young man to continue his training with Pieter Lastman, the best history painter in the Dutch Republic. Vondel compared Lastman to Rubens, calling him "the Apelles of Amsterdam", after the divine painter of antiquity.

For Rembrandt, who had just turned eighteen, it meant his first real entrance into an arena outside Leiden. He had undoubtedly accompanied his father on a trip by carriage to The Hague, or gone with his mother on a visit to her ancestral town of Katwijk. The Hague and the seaside were relatively easy to reach: the return journey took just a few hours.

Travelling to Amsterdam, however, meant going by sailing vessel, on a journey that would take the entire day. And if he was unlucky, if the wind shifted or a gale blew up, it might take an additional day. The ferry service went three times a day: the first boat left at 6 a.m., when the city gates opened. It departed from the quayside of the Old Rhine canal in front of the poorhouse bakery, and travelled via Kaag and Braassem. After that the journey led close to the wind across the lake of Haarlemmermeer.

Haarlemmermeer is no longer a lake today. The hydraulic engineer Jan Adriaensz Leeghwater had already—back in 1641—submitted impoldering plans, which involved the use of 200 drainage mills, but two centuries would elapse before the land was reclaimed. In Rembrandt's day a huge expanse of water stretched between Leiden, Haarlem and Amsterdam where conditions could quickly turn lethal. On 26th May 1573, this tempestuous lake had witnessed a sea battle in which Spanish ships led by Admiral Boussu sank part of the Dutch Sea Beggars' fleet and routed the rest. In a storm, the water took such great bites out of the embankments—in 1611 the villages of Nieuwerkerk and Rietdijk were submerged as a result—that the Haarlemmermeer was known as "the water wolf".

Did Rembrandt hold on tightly to the stay as the wind rose, the churning waves spewed white foam and the roaring water crashed across the bows? Did he grip his cap to stop it from being blown off his head? If so, he would have looked just like that single passenger who stares straight out at us, with an expression of eerie calm, in the middle of his own painting of *Christ in the Storm on the Sea of Galilee* (1633): "And there arose a great storm of wind, and the waves beat into the ship, so that it was now full. / And he was in the hinder part of the ship, asleep on a pillow: and they awake him, and say unto him, Master, carest thou not that we perish? / And he arose, and rebuked the wind, and said unto the sea, Peace, be still. And the wind ceased, and there was a great calm." (Mark 4: 37–39)

The arrival in Amsterdam must have had an air of magic about it. As the boat sailed across the IJ towards the harbour, its boom stretched out wide, the west wind propelling it forward, the silhouette of the city would have appeared to fill the entire horizon. Church towers pierced the clouds and a forest of masts gradually came into focus. Hundreds of ships lay moored in rows, one behind the other, on the quayside of Damrak, surrounded by men busily loading and unloading their cargo.

The ferry pressed on, into the canals, which "swarmed" with small vessels, as noted in the seventeenth-century *Beschryvinge van Amsterdam*. The warehouses were taller and the shadows they cast in the canals blacker and deeper than the young Rembrandt would have seen before. Everything was larger and more congested. Even for a self-assured young painter from Holland's second-largest city, Amsterdam must have been an astounding sight. A city into which one might vanish for good.

The French philosopher René Descartes marvelled at the anonymity of life in the Dutch Republic: "In what other country can one enjoy such complete liberty?" Descartes lived in several Dutch cities, including Leiden and Amsterdam, from

Christ in the Storm on the Sea of Galilee, 1633.

which he wrote in a letter of 1630: "in this great city where I am, containing not a single man except me who doesn't pursue a career in trade, everyone is so attentive to his own profit, that I could live here all my life without ever being noticed by a soul".

Rembrandt's first and second teachers must have known one another, if only by reputation. They had a good deal in common: both were Catholic, both had spent some of their formative years in Italy. Pieter Lastman came from an affluent Amsterdam family. His father was a messenger and his mother an assessor and dealer in second-hand goods. She possessed such a shrewd head for business that there was ample money to fund her sons' education. One trained as a sail-maker, one as an engraver, a third as a goldsmith. Pieter became a painter.

After his apprenticeship with Gerrit Pietersz in Haarlem, Lastman had journeyed to Italy. He departed in the summer of 1602, staying away for almost five years. In Venice he copied paintings by the Italian masters, and in Rome he frequented the same circles as Caravaggio and Adam Elsheimer. Together with his Amsterdam friend Jan Pynas, Pieter rose early to watch the sun rise over the Eternal City and to see the golden morning light play over the ruins on the Palatine Hill. He must have started to feel like an Italian—Italian enough, in any case, to sign his paintings "Pietro Lastman".

Returning to Amsterdam in 1607, he had moved in with his mother. His father had died while he was away. A year later, his mother took possession of a building on Sint Anthonisbreestraat ("Breestraat" for short), number 59, which was spacious enough for Pieter to set up his studio there. It was a strategic location. Within a short space of time, Breestraat between the old St Anthony's Gate and the newer gate on the east side of the city became the beating heart of the art trade.

It was not only wealthy local burghers who gravitated to the new, spacious houses; the mansions also attracted immigrants from other parts of the world: Flemish cloth merchants, Germans, French people and Sephardic Jews, some of whom employed Moorish servants. In 1625, the art dealer Hendrick Uylenburgh, whose father was the painter at the court of the Polish king in Cracow, took possession of a house on Breestraat. He found himself at the centre of an artists' colony that included the painter brothers Jan and Jacob Pynas, Jan Tengnagel, the Remonstrant painter François Venant, the portraitist Thomas de Keyser—and Pieter Lastman.

When Rembrandt arrived at Lastman's studio on Breestraat, there was a colourful painting on the easel in which at least twenty-five figures crowded around

Pieter Lastman, *Coriolanus and the Roman Envoy*, 1625.

an ancient warlord sporting a laurel wreath: *Coriolanus and the Roman Envoy*. Gnaeus Marcius Coriolanus was a Roman general who defected to the Volsci. As army commander he conquered one city after another, until he came to the city where he had been born. The Romans sent his mother and wife to beseech him not to attack Rome. He initially refused their entreaties, but eventually relented. The painting depicts the women's supplication.

In Lastman's studio, numerous colourful small and medium-sized paintings stood leaning against the walls, waiting for buyers. One was *The Baptism of the Eunuch*, which depicts a scene from Acts 8: 26–40: an angel appears to the deacon Philip and tells him to depart in the direction of Gaza. There he sees a chariot riding, carrying the chief treasurer of Ethiopia, "a eunuch", who is reading the Old Testament Book of Isaiah. Philip then hears the words: "Go near, and join thyself to this chariot."

The deacon complies, and then asks the Ethiopian if he understands what he is reading. He proceeds to explain the text, which so convinces the eunuch that he immediately asks to be baptized. Rembrandt must have been familiar with this curious, exotic conversion tale, but he now saw for the first time what a black man actually looked like.

Rembrandt must have been dazzled by his master's erudition. Lastman's paintings attested to a wide-ranging, sophisticated knowledge of literature, art, architecture and history. He derived the scene with the women kneeling before Coriolanus from Livy. The story of Balaam and the ass, which had previously been depicted almost exclusively in engravings, comes from the Book of Numbers. Every splash of paint was inspired by a book.

Training with Lastman meant hours of painstaking study. Rembrandt was no longer required to perform menial tasks in the studio, as he had done for Master Jacob in Leiden. He could set to work straight away copying his master's works, in red chalk on paper—which was exactly how Lastman laid in his own compositions.

Rembrandt may possibly have produced some fully fledged copies in oil. If so, they have not been preserved—or have never been recognized as such. It was not customary for an assistant to display his own style. Customers came to Lastman's workshop to see the master's own hand, even if the work they were shown was made by his pupil.

In painting, as in classical poetry and rhetoric—which Rembrandt had studied at the Latin school—*imitatio* was not disparaged but respected as a way of honouring tradition. Borrowing or collecting themes, motifs or characters was not seen as intellectual theft, but as elegant allusions to admired predecessors.

Thus the sweet angel who breathes inspiration into the Evangelist Matthew in Caravaggio's painting in the Contarelli chapel in the Church of San Luigi dei Francesi in Rome ended up (by way of a copy by Adam Elsheimer) in a painting by Lastman—later to fly into Rembrandt's *Sacrifice of Abraham* in 1635. Just in time to grasp Abraham's arm and to save the life of his son, Isaac.

Rembrandt did more than execute copies in Lastman's studio. He was driven by a keen sense of rivalry. That compulsion characterized his single-mindedness, although his desire to excel was also part of the tradition within which he was trained. Samuel van Hoogstraten stated baldly, in his *Inleyding tot de hooge schoole der schilderkonst* ("Introduction to the Academy of Painting"), that what had driven Raphael to vie with and eventually surpass Michelangelo was a combination of envy and ambition. "Let your rivalrous spirit be ignited," he counselled young painters.

Remarkably, Rembrandt stayed only about six months in Amsterdam. Did he tire of it so soon? Probably it was a matter of finances. If we infer the apprenticeship fee from the sum that Rembrandt himself would demand four years later from his pupil Isaac Jouderville, his father was paying Lastman around fifty guilders every

six months. This would have included the expenses incurred for materials in the workshop, but not the cost of board and lodging.

Perhaps he and his father made a joint assessment: would paying for additional training, at that stage, be a profitable investment? They decided it would not. But he was not eligible to set up in Amsterdam as an independent artist. To join the Painters' Guild, he would need to have proved his worth with an Amsterdam master for three years. Since Leiden no longer had a St Luke's Guild—it had not been reinstated after the relief of Leiden in 1574—there was nothing to prevent Rembrandt starting out there as a painter "alone and for himself", as Orlers put it. In his native city, he immediately became a big fish in a small pond.

Rembrandt returned at a dark moment in time. Leiden was in the throes of the Black Death. In the last few months of 1624, so many bodies piled up that throughout Holland, as we read in the Van Heemskerck and Van Swanenburg chronicle, the name of Leiden struck terror into people's hearts. If someone visiting another town let slip that he came from Leiden, he soon found everyone giving him a wide berth. Rembrandt's sister Machtelt may have been one of the last victims of the epidemic. She was buried in the family grave at the Pieterskerk on 6th September 1625. Had Rembrandt rushed home in order to attend her funeral?

Once he had settled back into Leiden, he took Pieter Lastman's colourful compositions and reworked them in his own style. You might say that he took them apart and then reassembled them. In his own *Balaam and the Ass* he surpassed Lastman by enlivening the story and conveying the figures' emotions in their faces. From the outset, the pupil showed himself to be a better storyteller than his master.

The prophet Balaam is summoned by the Moabite king, Balak, who wants him to curse the Israelites who have entered his realm on their flight from Egypt. When the prophet mounts his ass to go to King Balak, God's angel blocks his path three times. Through a miracle, the ass can see the angel but Balaam cannot. The ass keeps trying to go around the angel; each time the prophet strikes the ass with his stick. After the third time, God causes the ass to speak: "What have I done unto thee?" Then Balaam sees the angel and realizes the error of his ways.

Rembrandt rotated his panel by ninety degrees and presented the story of Balaam and the ass in a vertical rather than horizontal format. He added depth and movement to the scene by depicting the prophet, the ass and the angel behind and above one another rather than side by side in a line. In Lastman's painting Balaam and the angel are frozen in their poses, whereas in Rembrandt's they swirl around one another. Balaam is beating the ass on its head with grim determination. In Lastman's the ass's mouth is open; in Rembrandt's it is speaking.

Balaam and the Ass, 1626.

Pieter Lastman, *Balaam and the Ass*, c.1620.

We know from a 1641 letter from the Parisian art dealer Claude Vignon that Rembrandt sold *Balaam and the Ass* to the art lover Alphonse Lopez, secretary to the King of France. Lopez came to The Hague and Amsterdam to conduct negotiations on behalf of Louis XIII regarding the procurement of munition, cannons and ships and broke his journey in Leiden, halfway between the two cities. The letter proves that Rembrandt did not necessarily need a clearly defined commission to start on a work. He felt free in his choice of subject, although he initially took his lead from Lastman's history paintings.

Nonetheless, Lastman was not the only influence on Rembrandt's work. His development was closely followed by a small group of art lovers—the same connoisseurs who had been so astonished by his progress with Master Jacob. One was Pieter Schrijver, known as "Petrus Scriverius". His circle of friends included the Van Swanenburgs and Schrevelius, the headmaster of the Latin school. Scriverius was a passionate Remonstrant, whose beliefs repeatedly got him into hot water with the sheriff, De Bondt.

The probate inventory of his estate, drawn up in 1663, includes "two fine large paintings by Rembrandt". These may have been two of his earliest independent works: *The Stoning of St Stephen* (1625) and the painting that is known by the nondescript title *Leiden History Painting* (1626). The two are roughly the same

The Stoning of St Stephen, 1625.

size, and both convey a message that accords with Scriverius's uncompromising views.

This scholar may very well have served as adviser to the young Rembrandt. He certainly had the library, the knowledge and the fervour to perform such a role, and did not shy away from giving well-defined commissions to young painters. A surviving letter from the painter Cornelis Saftleven, written just after his fourteenth birthday and dated 16th April 1621, has a detailed design on the back for a painting that Scriverius had ordered from the boy. It was a parody of the Synod of Dort, portraying the preachers and theologians who took part in it as a parliament of dozy owls presided over by a rooster in a stable (this is a visual pun on the Dutch word *oproerkraaier*, literally "the rooster that crows riot", meaning "agitator" or "ringleader"). A drawing of a calf hangs on the wall—a playful allusion to the name Calvin.

Might Scriverius have given Rembrandt instructions in much the same way? In any case, *The Stoning of St Stephen* is also a variation on a painting by Pieter Lastman with the same subject. Rembrandt could find the story of Stephen in the seventh chapter of the Acts of the Apostles, on the same open page as the story of the baptism of the eunuch. Stephen was the first Christian martyr. As one of Christ's disciples, he was falsely accused of blasphemy. In his own defence, he gave a sermon

Copy after Pieter Lastman, *The Stoning of St Stephen.*

in Jerusalem that incensed the judges—so much so that he was stoned to death outside the city walls, in the presence of the Pharisee Saul of Tarsus.

The Stoning of St Stephen by Pieter Lastman has been lost, but the composition is still known because a drawing was made of it. Rembrandt accentuates the drama of the scene more than his mentor. He shifts Saul to the background and introduces a watching horseman, who casts a pitch-black shadow over much of the painting. Furthermore, rather than depicting a single executioner throwing stones, Rembrandt surrounds Stephen with a mob of stone-throwers. Behind the deacon, a boy weeps tears of anguish at the flagrant injustice. He has Rembrandt's face.

Lastman was a Catholic, for whom the portrayal of Stephen's martyrdom was an age-old image of papist iconography. In the Dutch Republic, however, art also served as a weapon between the warring Protestant factions—Remonstrants and Counter-Remonstrants. Well-known biblical stories were given fresh interpretations. After the Counter-Remonstrant coup and the Synod of Dort, the Remonstrants saw themselves as martyrs who were unjustly accused of blasphemy. Is Rembrandt referring, in his *Stoning of St Stephen*, to the urchins who threw stones at the Remonstrants?

We are often in the dark when we try to interpret a seventeenth-century artwork. Many allusions and suggestions that Rembrandt's contemporaries would have automatically registered and understood are lost on us today. At the same time, we are sometimes inclined to ascribe meanings that may never have been intended. Sometimes, a plethora of interpretations can do more to obscure than illuminate the true significance of a painting.

This seems to apply in the case of Rembrandt's *Leiden History Painting* (1626). It is quite possible that this was the other "fine painting" that was owned by Scriverius. But this does nothing to clarify its subject matter. Over the past several decades,

The Leiden History Painting, 1626.

as many as fifteen different interpretations have been published by learned art historians claiming to have unlocked the mysteries of this enigmatic painting.

What do we see in the *Leiden History Painting*? A soldier kneels before an emperor who stands on a platform, holding up his sceptre. Grouped around the emperor are an army general holding a map scroll, a priest, a bearded man clad in a fur-trimmed cloak and a respectably dressed citizen. Weapons lie at their feet. A whole army is arrayed behind the kneeling soldier. Another soldier holds up his hands to the emperor, palms facing forward, while a third, his index and middle finger forming a "V", appears to be swearing an oath. The surrender, entreaty or petition to the ruler—we are already indulging in the business of interpretation—is set against the background of a city, a palace or a temple. A column in the distance is surmounted by a sculpture of a lamb.

Is this Saul arming David? The judgement of Brutus? The clemency of Titus? The magnanimity of Alexander? The surrender of the German cities to Charles v? Or the arraignment of Piso? I would not venture to say. The art historians do venture to say, but they contradict each other.

Two interpretations posit an intriguing connection with the contemporary political conditions in which Rembrandt produced his history painting. The first of these—the most recent theory—is that the painting depicts "the magnanimity

of Emperor Ferdinand II". In 1618 the Thirty Years War had broken out after an incident known as the "Defenestration of Prague": a group of furious Protestant noblemen had grabbed two Catholic government officials and their secretary, manhandled them into the air, "rapiers and cloaks and all", and tossed them out of the window of Prague Castle.

The attack was intended as a warning to the representatives of the Habsburg emperor, who sought to establish the absolute power of the Holy Roman Empire, thus curtailing the existing rights of the nobles, burghers and peasants and imposing restrictions on the freedom of religion. The conflict that erupted—which consumed Central Europe, claimed millions of victims and precipitated flows of refugees across the continent—was not unlike the beginning of the Dutch Revolt against King Philip II of Spain, the other branch of the Habsburg dynasty.

When the devout Catholic Archduke Ferdinand II was crowned emperor in 1619, the Protestant Elector Palatine Frederick V, grandson of William of Orange, proclaimed himself King of Bohemia. German princes were obliged to choose sides, and that is when the war began in earnest. Maurits of Nassau sent money and troops to support his cousin Frederick.

This support did not sway the battle in his favour. The Bohemian rebels, under their commander-in-chief Christiaan von Anhalt, suffered a crushing defeat at the hands of the Bavarian general Johan Tserclaes, Count of Tilly, at the Battle of the White Mountain in 1620. The clash had lasted just two hours. Von Anhalt's son, whose name was also Christiaan, had fought bravely but was taken captive. The commander-in-chief fled, full of remorse at his role. Christiaan Junior, who kept a diary during his time in captivity that has been preserved, also came to rue his actions. Father and son professed their loyalty to Ferdinand II, who showed mercy and accepted them back into the fold.

The Protestants had lost one battle after another, and in 1622 the forces of the Elector Palatine were routed with the aid of Spanish troops. Frederick was forced to abandon his palace at Heidelberg and fled to the Dutch Republic, where he would live out the rest of his days in exile. He and his wife and children initially moved into the former home of Johan van Oldenbarnevelt on Kneuterdijk. Frederick was known as the "Winter King" because he had only been king for one winter.

The events surrounding the Winter King were followed closely in Holland. Pamphlets were published on Frederick's marriage to the "Queen of Hearts", the nickname bestowed upon Elizabeth Stuart, the beautiful daughter of King James I of England. The wedding had taken place on St Valentine's Day, 1613, amid great

pomp and ceremony. Meanwhile, the episode of the defenestration was related by Jacques Hoefnagel, a cousin of Constantijn Huygens, who had been in Prague at the time. Maurits's help to his cousin was also remarked upon and reported.

If the History Painting depicts the young Von Anhalt professing his allegiance to Ferdinand II, Rembrandt was poking fun at Maurits and his cousin, the Winter King. All their unbending Calvinism and bellicosity had yielded nothing but the humiliation of bending their knee before a Catholic emperor.

Mockery like that would have been very much in the spirit of Petrus Scriverius. But there is another interpretation of the painting that fits: might Rembrandt have been depicting "Palamedes before Agamemnon"? Palamedes was a virtuous, contemplative Greek hero who proposed a truce during the siege of Troy. He was wrongly accused of having accepted a Trojan bribe. Odysseus planted money and a forged letter in Palamedes' tent. On the basis of this trumped-up evidence, Palamedes was sentenced to death by the Greek king, Agamemnon.

This story had only become widely known shortly before Rembrandt produced his painting. It is not in Homer's Iliad, only in Virgil's Aeneid. Even so, it was painfully topical. For Joost van den Vondel had chosen it as the theme of a play, entitled Palamedes or Innocence Slain.

Holland's most illustrious poet, a Mennonite who converted to Catholicism, did not mince words in his poetry or plays. In a poem about the issue of predestination, "Decretum Horrible", Vondel calls Calvin "an aberration, a calumniator, and a child devil". In 1625 he wrote an allegorical indictment of the political assassination of the land's advocate Johan van Oldenbarnevelt and the unconscionable role played by Maurits. It was incendiary material, fraught with danger.

On the advice of the Amsterdam magistrate Albert Burgh, Vondel had searched for a story from antiquity that would reflect the themes of the day. Vondel's friend Johannes Meursius, a self-important but extremely erudite Remonstrant professor of history and classics at Leiden University, suggested the story of Palamedes. Meursius had tutored Oldenbarnevelt's sons, Reinier and Willem, and accompanied them on a grand tour of Europe. He had witnessed with sorrow the beheading of the old advocate, and a few years later of his two sons, who were found guilty of conspiring to assassinate Maurits.

According to his friend and biographer Geeraert Brandt, Vondel was sitting in his house in Amsterdam on 23rd April 1625, putting the last touches to his play, when his wife stood at the bottom of the stairs with a message from The Hague.

"Husband!" she cried, "the prince lies on his deathbed!"

"Let him die," Vondel called back. "I'm just now seeing him off."

In Vondel's play, the characters of Palamedes and Agamemnon clearly stood for Van Oldenbarnevelt and Prince Maurits. The last words of Palamedes echo almost exactly those of the advocate mounting the scaffold in The Hague. They may be rendered:

> Standing before the public gaze, head held high:
> Oh men, he said, that your true souls ne'er believed
> The charges of treason, which are false and quite contrived—
> That was my dearest wish. My duty I have done—
> Acted with candour, piety and truth,
> And die, as I lived, a sincere Greek.

The play caused a scandal. Vondel had to go into hiding, reappearing only after he had received assurances that Amsterdam city council would not hand him over to the Court of The Hague. He was let off with a mild punishment: a 300-guilder fine, which was paid by Burgh. "A flogging with a foxtail," joked the locals.

Might Scriverius have sent Rembrandt a copy of the play? *Innocence Slain* was immediately banned, but it was distributed secretly and reprinted multiple times. Scriverius knew Vondel well. In the *liber amicorum* of the Leiden man, Vondel wrote a poem signed "P.v.K."—the initials of his pseudonym, Palamedes van Keulen.

Would Rembrandt not have seen any danger in carrying out the idea proposed by Scriverius? Did he shrug off fears of a flogging, albeit with only a foxtail? It is fair to assume that the highly charged political-religious situation, the devastating war in Europe and the Protestant conflict that was tearing apart the Dutch Republic, the city and even his own family, was reflected in his work. But exactly how—that remains unclear.

All we can say with confidence is that Rembrandt largely based the composition of his history painting on a work by his teacher Lastman: *Coriolanus and the Roman Envoy*. In that painting, too, we see an imperial figure on a high podium, with soldiers in the background whose spears and halberd pierce the sky. The shoes worn by the emperor in Rembrandt and by Coriolanus in Lastman are the same. Had Rembrandt been tasked with adding those blue-and-gold sandals to his master's painting? And did he use them again in his own painting a year later?

For the painting's powerful impact, it is unimportant. What we see here is an artist flexing his muscles: Rembrandt, twenty years of age and bursting with ambition, shows the full range of what he has to offer. He goes to town in the rendering

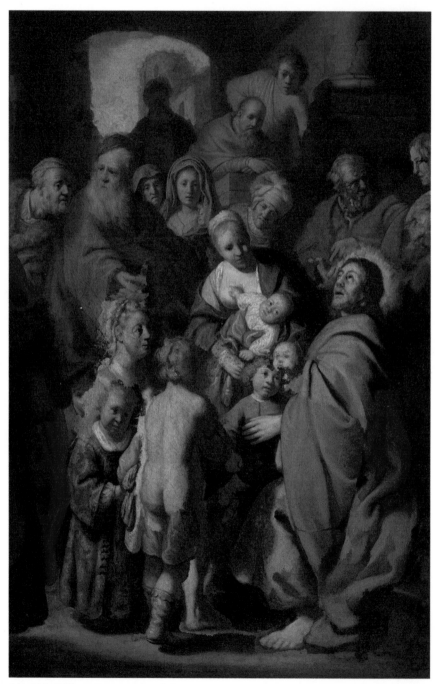

Suffer Little Children to Come unto Me, c.1628.

of materials, the play of light on the general's brocade cloak and the smooth, gleaming shield with its halo of sunbeams.

Right next to the corpulent councillor with the fur-trimmed cloak, behind and to the side of the emperor's sceptre, Rembrandt himself pops up: a boy with a full head of curls. Since he wanted to depict the play of light in the boy's hair, he turned the brush around and again used its wooden tip to scratch the curls into the wet paint, exposing the dead colour beneath.

Rembrandt must have found it frustrating to be compelled to leave the vibrant, cosmopolitan city of Amsterdam so soon and return to his native Leiden. It has always been assumed that he painted his first independent history paintings in Leiden, and that he did not continue to travel back and forth between the two cities for a time. The argument goes that it would have been difficult to transport the panels on which he painted—all his early work was executed on oak panels, with the exception of three *tronies* on gilded copperplates.

A recent discovery sheds new light on this matter. In May 2014, the art dealer Jan Six—a descendant of the Amsterdam patrician Jan Six, who was Rembrandt's friend and the subject of a magnificent portrait by the artist—discovered a hitherto unknown painting by the young Rembrandt at Lempertz auction house in Cologne. Lempertz's auction catalogue lists, as lot 1174: "Niederländischer Meister Mitte 17. Jahrhundert, *Lasset die Kinder zu mir kommen*. Öl auf Leinwand (doubliert)" ("Dutch master, mid-17th century, *Suffer Little Children to Come unto Me*. Oil on canvas (lined)"). The dimensions were given as "103.5 x 86" (cm). Six gained the backing of an investor, and together they acquired the work for 1.3 million euros.

Sometimes the material itself tells a story. This large work was not painted on a panel, but on linen. Rembrandt could easily have rolled up the canvas and taken it along with him on the ferry boat back and forth across the Haarlemmermeer. He may have worked on it alternately in Leiden and Amsterdam. In all probability this painting remained unfinished. That was something that Rembrandt allowed to happen throughout his life. Houbraken lamented that "much of the work is only half finished".

The painting depicts a scene from the Gospel of St Matthew: "Suffer little children to come unto me". When Jesus arrives in Judea, children are brought to him from all sides so that he may place his hand on their heads and pray with them. At first, the disciples try to block their path. But Jesus says: "Suffer little children, and forbid them not, to come unto me: for of such is the kingdom of heaven." (Matthew 19:13–14)

The theme never lost its fascination for Rembrandt. In his *Hundred Guilder Print* of 1648—so named because Rembrandt had to pay 100 guilders to buy back a copy of his own etching after his bankruptcy and the forced sale of his property—he depicts not only the episode of Peter keeping the women and their children away from Jesus, but all the stories in Matthew 19. Thus he shows the dispute with the Pharisees, the healing of the sick, and the young man who is told to give his riches to the poor if he wants to enter the kingdom of heaven.

In his painting with the "little children"—similarly to *The Stoning of St Stephen* and the *Leiden History Painting*—Rembrandt used his teacher's colourful palette, with combinations in soft yellow and light blue, pink and mauve, olive-green and ochre. He also borrowed a figure from Lastman's painting *St John the Baptist Preaching* (1627). The dark silhouette of this figure, who has his back to us, adds depth and contrast to the composition.

An even more intriguing aspect of the painting as found by Jan Six was the way it had been treated. It was soon discovered that much of the image had been painted over at some point in the intervening centuries: the nude little boy, who stands with his buttocks towards us, was given some breeches. Christ's purple cloak was painted red. Behind Christ stood a single disciple, arms crossed, but in the original we find three disciples engaged in a debate—including bald-headed Peter.

Why were these changes made? They must have been driven by prudishness and religious rigidity. Erasing the debating disciples banished the unwelcome idea that God's laws could conceivably be debated—as in the fierce dispute about pre-destination between the Remonstrants and Counter-Remonstrants.

The most wonderful parts of the painting had remained intact all those centuries. Among the bustle of parents and children, we see the woman who has been identified for centuries as Rembrandt's mother. The resemblance with the little prints that he made of her in 1628 is striking.

And then, the most beautiful thing of all. Right at the top, elevated above Christ and the children, a boy hoists himself up with his hands to be able to look over the heads. A figure serving as "bait" to guide the viewer's gaze, precisely as Rembrandt had learnt from Van Mander's *Schilder-Boeck*. Chubby face, surprised round eyes and a head of curls. Full of curiosity, he looks at us.

Wondering what is to come.

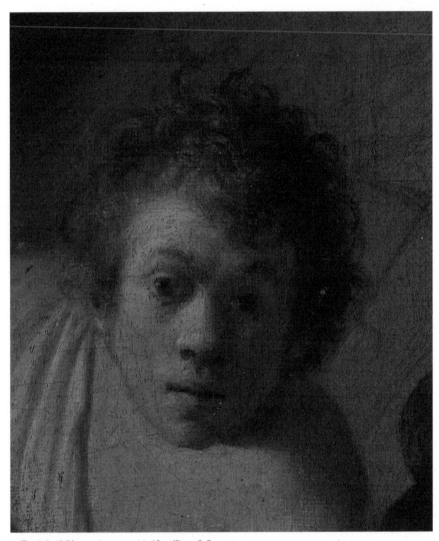

Suffer Little Children to Come unto Me (detail), *c.*1628.

Jan Lievens, *Portrait of Rembrandt van Rijn*, c.1628.

13

Two noble young
painters of Leiden

IT IS AN IRRESISTIBLE IMAGE: TWO YOUNG BOYS FROM A PROVINCIAL town in Holland who team up and determine to conquer the world, recognizing the spark of genius not only in themselves but also in each other. They are totally absorbed with one another, Rembrandt van Rijn and Jan Lievens. They constitute a mythical duo of painters like Peter Paul Rubens and Jan Brueghel the Elder—and, many centuries later, Vincent van Gogh and Paul Gauguin.

Michel de Montaigne wrote, in his wonderful essay of 1580, of a friendship in which "[our souls] mingle and melt into one piece, with so universal a mixture that there is left no more sign of the seam by which they were first conjoined".

At the end of the 1620s, even art connoisseurs found the work by Rembrandt and Lievens hard to tell apart. The 1632 inventory of the household effects of Stadtholder Frederik Hendrik included "a painting depicting Simeon in the temple, with Christ in his arms", with the note "made by Rembrandt or by Jan Lievensz". Rembrandt's *Minerva* and his *Proserpine* were both wrongly attributed to Lievens. In the eyes of the outside world, for a brief period of time, they merged into a single painter.

Montaigne described true friendship as without self-interest, but that did not apply here. The two friends from Leiden sought to benefit from each other's talents: Rembrandt from Lievens's technique and zest for experiment, and Lievens from Rembrandt's intellect, knowledge and capacity for empathy. Besides mutual affection and appreciation, the two were driven even more by an urge to compete: that rivalry "that has brought forth so many glorious masters in the arts", according to Van Hoogstraten. Their work was in part a product of constant creative competition.

When did Rembrandt first meet Jan Lievens? Leiden was tiny, certainly if you moved in the same circles. They must have met when very young. Jan's elder

brother Justus was exactly the same age as Rembrandt and in the same class at the Latin school. Was Rembrandt as much of a bookworm as Justus? Did it start with their friendship, after which he became acquainted with the rest of the Lievens family?

The Lievens family lived close to the school, in Pieterskerk-Choorsteeg. The street was full of activity. The narrow alley led between the church and the town hall, the divine temple and its secular counterpart. Diagonally opposite them lived Jan Jansz Orlers. He watched Jan grow up, and it is thanks to him that we know some fine anecdotes from his boyhood. The section devoted to the life of Lievens in Orlers's *Beschrijvinge der Stadt Leyden* is much longer than the one on Rembrandt.

Jan's father, Lieven Hendrixcz, had fled from Ghent in 1584 after his native city had been conquered by the Duke of Parma. He came to Leiden, where he was able to find work as a skilled embroiderer and later as a milliner and merchant. It was there that he met his wife, Machtelt Jansdr van Noortsant. They married in 1605 and were blessed with a large family: four sons followed by four daughters.

Justus was the eldest. He loved books and was always studying. He attended the Latin school and then enrolled at the university, on 26th October 1622. After graduation he married a girl who would be Jan Steen's aunt, and set up a bookshop on Rapenburg.

Jan was the second son, born on 24th October 1607. According to Orlers, Jan had such a passion for art that his father apprenticed him to Joris van Schooten when he was just eight years old. At that point, Rembrandt had just been admitted to the Latin school. Jan was fanatical about painting and would not let anyone or anything distract him from it. When rioting erupted around the town hall between the mercenaries and Calvinist ruffians on 4th October 1618, and everyone was shuttering their windows and bolting their doors, the boy just carried on with his work, unperturbed. He was copying a few prints by "Witty Willem", the nickname of the etcher Willem Buytewech. In the words of Orlers, he "placed his love of Art on a higher plane than all the tumult in the world".

Jan's gift for painting was soon noticed. Artists were astonished at what he could accomplish at such a young age. His copies of work by contemporary masters were indistinguishable from the originals and were sold as authentic paintings to unsuspecting buyers abroad. At fourteen, he made a portrait of his mother that dumbfounded one of his neighbours, who thought it magnificent and a very fine likeness. It was Jan Lievens, rather than Rembrandt, who was seen as a child prodigy.

The two produced a prolific output of "diverse paintings and copies, which continue to be held in high regard today". The emphasis that Orlers placed on the great value of Lievens's paintings in his revised edition of his *Beschrijvinge der Stadt Leyden* was not entirely devoid of self-interest. When his book was published, he owned as many as ten of them—and their value would certainly not have suffered from his panegyrics.

Jan had already completed his training as a painter when Rembrandt had yet to begin. When Rembrandt started as a pupil in Jacob van Swanenburg's workshop on Langebrug, Jan, who was one year younger, was at work just around the corner—no more than fifty paces away—busily copying fabulous portraits and paintings while also designing his own work. Rembrandt must have admired him immensely. And envied him.

Rembrandt's very first little paintings, images of the five senses on five separate small oak panels, were probably made in Master Jacob's workshop. They are tentatively dated to 1624. An X-ray of the one depicting *Sight* reveals that Rembrandt painted it over the image of a female nude. Was this a discarded painting by Master Jacob or one by his young friend?

It might have been Jan Lievens who gave Rembrandt the idea of depicting the five senses. His friend had chosen that exact subject, albeit on one larger, horizontal panel, representing the taste of wine, the aroma of tobacco, the touch of a woman's bosom, the sound of the lute and a bespectacled man ogling the woman's full breasts. Lievens's painting had been purchased by Adriaen Claesz van Leeuwen, the wealthy owner of the brewery Het Lam, who in turn was married to Maria van Swanenburg, from the well-known family of painters and magistrates. There you have it: the universe of Leiden in a nutshell.

The senses were a popular subject among painters in the seventeenth century. Such images were part of the effort to fathom the inner depths of a human being, not only through reason—certainly important in the university city of Leiden—but also by exploring the senses. It was as if people felt a new, pressing need to taste, feel, smell, hear and see with more intensity and sharpness than ever before—there was an opening-up to the world.

Four of the five senses depicted by Rembrandt have survived. The search for *Taste* is still ongoing. In *Touch* a stone-cutter uses his chisel to remove an imaginary stone from the head of a groaning man. A quack using smelling salts to revive someone who has fainted is the subject of *Smell*. And in the painting depicting *Hearing*, we see three men singing together from a score; by the looks of it they are as out of tune as crows.

The Operation, c.1624–25. The Spectacles Vendor, c.1624–25.

Sight was the most important sense—not only for painters. People became ever more adept at polishing glasses for microscopes, telescopes and spectacles. In Rembrandt's image of *Sight*, we see a hawker in an Oriental costume with puffed sleeves, a turban and an earring. A purse dangles at his hip. In front of his belly he has flipped open a small wooden chest in which spectacles, lenses and accessories such as cords and fabric bags are laid out. An old woman is trying on a pince-nez. Smirking, the vendor offers a second one to an old man.

"Selling someone a pair of spectacles" was an expression meaning tricking someone, or making a fool of them. Every viewer from Rembrandt's time would immediately have seen that this corpulent, grinning salesman, with his theatrical purple stage costume, bulging purse and sparkling earring, was a swindler.

The vendor has already put the pince-nez on the old woman's nose. Her expression speaks volumes. Tiny, squinting eyes: she can't see a thing. When the salesman offers a pince-nez to the old man, the prospective customer points at the tip of his bulbous, purple nose. Is he supposed to put it there? He is being "led by the nose"—an expression that in Dutch has more to do with trickery than coercion.

Even certain details of the small paintings can be linked to work by Lievens. The man selling spectacles appears to be wearing the purple suit with openwork

The Three Singers, c.1624–25.

The Unconscious Patient, c.1624–25.

puffed sleeves from the drinker in Lievens's *Five Senses*. In any case, the wooden poses and arm gestures of Rembrandt's figures are remarkably similar to the backgammon-players in a painting by Lievens.

Rembrandt was not yet Rembrandt when he set about depicting the five senses. Like Lievens, he was searching assiduously for ways of rendering light in his little panel paintings. The coarse brushstrokes should not be seen as foreshadowing the fabled rough style of his late period. Here, it is awkwardness plain and simple. In 1624, Lievens was in every respect streets ahead of his friend. And that would remain the case for some time.

When Rembrandt returned from Amsterdam—we assume in the autumn of 1625—after his brief apprenticeship with Lastman, with whom Lievens had studied from 1618 to 1620, he set up in Leiden as an independent painter.

Ever since 1897, when a Dutch translation was published of the Latin text of Constantijn Huygens's memoirs of his early years, in which he emphatically described Rembrandt and Lievens as "two noble young painters of Leiden", it has been assumed that the two shared a single studio. It would not have been customary to set up a workshop together. On the contrary: most painters' guilds forbade it, to prevent unfair competition. In Leiden, however, there was no longer a St Luke's Guild after the Relief, so sharing was not ruled out.

Where might that workshop have been? There are two serious possibilities: at one of their two homes. According to Orlers, Jan Lievens worked at his parents' house from his earliest childhood. His mother had died in 1622, his father remarried and became a tax farmer. That meant that he purchased from the city council the right to collect certain taxes. The accounts show that in 1623 he paid 1,160 guilders for the rights to collect the excise duties for firewood and another 1,430 guilders for those relating to vinegar. If he collected more than he had paid to the treasury, he made a profit. If he collected less, he would suffer a loss.

Initially he prospered. In 1635, however, everything would collapse. Jan's father purchased the rights to collect the city's milling tax for the huge sum of 103,800 guilders. That year, Leiden was hit by the worst-ever epidemic of the Plague. The Black Death claimed 15,000 victims, wiping out one-third of the city's population. Trade came to a standstill. Lievens went bankrupt and was left with debts of 60,000 guilders, an astronomical sum for the time.

In the late 1620s, however, prospects still looked good. Jan Lievens was still living at home with his father, in a house that was full of children from the new blended family. The house may conceivably have been spacious enough to accommodate a workshop for two, but it seems rather unlikely.

Arnold Houbraken writes that after returning to Leiden from Amsterdam, Rembrandt continued working on his art, "diligently and with great zeal on his own at his Parents' house". Houbraken's anecdotes should be approached with caution: he sometimes mangles the facts. In this case, however, there appears to be little reason to doubt his words. Why would he not simply have relayed what he knew from contemporary accounts?

Even so, the phrase "at his Parents' house" admits of another interpretation. The house on Weddesteeg was not large and was already packed with relatives and the miller's assistants. But Rembrandt need not stay at home in order to be in his father's house. For his father had had five houses built on Galgewater, right around the corner from Weddesteeg. It was just a minute's walk across the little courtyard and along the alley that had been constructed especially to connect the houses.

Did Rembrandt set up his studio in a front room of one of his father's houses? If so, it would have yielded an advantage for a painter: the rooms were north-facing, providing the best light. It was partly a quest for north light that drove Rembrandt's pupil Gerrit Dou, who grew up just around the corner on Kort Rapenburg, to leave his father's house for a building where he could live and work on Galgewater. Dou would never move house again.

Whether Lievens came to work on Galgewater, we do not know. It seems quite likely. All we know for sure is that the distance between the alleys Pieterskerk-Choorsteeg and Weddesteeg is so small that even two separate studios would not have prevented the two painters from cooperating closely on a daily basis.

There were obvious advantages to such a partnership. Rembrandt and Lievens may have made joint purchases of panels and paint. Dendrochronological research reveals that some of their panels were sawn from the same tree. These would have been ordered from the same carpenter, sawn to size, no more than one centimetre thick, from one of the huge Baltic oaks—as thick as a man—that were unloaded from ships at the main carpenter's yard on the other side of the water.

Paint was expensive. The artists purchased pigments from the pharmacy and oil pressed from linseed from a miller friend. Paint took hours to make, toiling over a grindstone, and had a short shelf life. The artists improvised tubes (metal tubes did not yet exist) from knotted pig bladders, submerged in oil. The perishability of the expensive paint also sometimes influenced the artists' decisions in the painting process: Rembrandt and Lievens would occasionally prepare just one or two, or possibly three, colours to begin with. These they would apply to the relevant portions of the panel before proceeding to the next colour.

Their work fizzed with experimental fervour. They proved alchemists in the mixing of paint and were constantly searching for techniques to achieve dramatic effects. It was once again Lievens who took the initiative. "Jan Lievens was a true adept at working miracles in the blending of paints, varnishes and oils," wrote Van Hoogstraten—and he must have heard this from Rembrandt himself.

Rembrandt collected all sorts of paraphernalia for his work. He went in search of weaponry and suits of armour. He purchased turbans, berets, items of jewellery, garments and fabrics—and both young men would use them. Father Lievens may have helped to make or alter costumes that looked as if they had been plucked from a work by Lucas van Leyden or one of the medieval masters. The painters shared their costumes and props. Thus, the shield that Rembrandt used in his *Leiden History Painting*, with a metal tip in the middle of the sun from which radiate wavy beams, turns up in Lievens's work—and is later recycled in a painting by Rembrandt's pupil Gerrit Dou.

Besides props and costumes, they also shared models. We find several characters, including an elderly man with a beard and an elderly woman, recurring frequently in the work of both Rembrandt and Lievens. Were these people neighbours? Family members? Sometimes they may have plucked someone from the street. They might press a gift of alms into a beggar's hand and then get him to sit

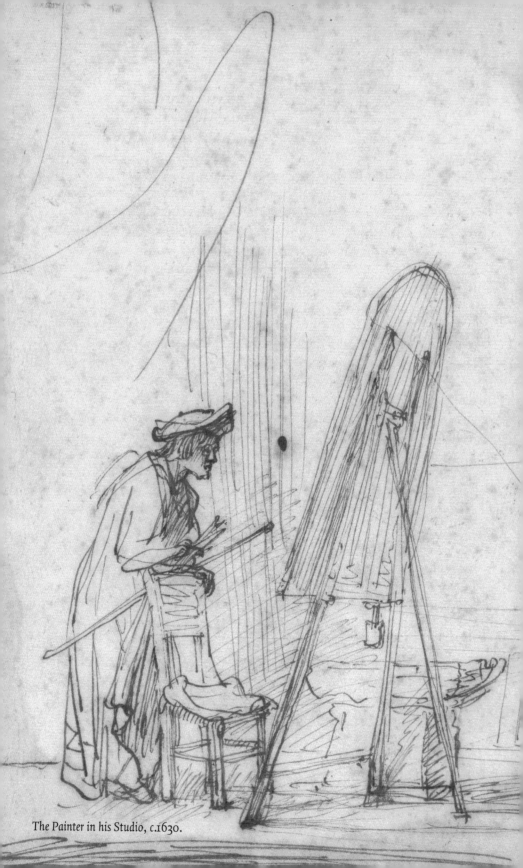

The Painter in his Studio, c.1630.

motionless in a specific pose in the armchair in the studio, while the two men made their sketches. Not infrequently, such sketches were used as the basis for a painting.

They used each other and themselves as models. Lievens made a portrait of Rembrandt, and Rembrandt drew Lievens from life in the studio. He is easily recognizable by his long face, angular jaw and slight build—Huygens called him "an inconsequential little tree trunk". He is depicted resting his elbows on the back of the chair in front of his easel, palette in his right hand, maulstick in his left. Jan has briefly risen to gaze at the painting on which he is working from a distance. He looks and ponders. How to proceed?

As they developed their own styles, the young men gradually shuffled off the ties that held them to Pieter Lastman. In 1626, in painting his *Tobit and Anna with the Kid*, Rembrandt was still using the multicoloured palette of his Amsterdam teacher. The painting epitomizes his ability to render fabrics and other materials, from the torn cloak of the aged Tobit to the rough coat of the little kid under Anna's arm.

This painting depicts a scene from the Apocryphal Book of Tobit and illustrates the ordeal in which Tobit's faith is tested. The affluent, devout Tobit lives in exile in Assyria. His property is seized because he is living in accordance with Jewish law. The ultimate test is yet to come. Tobit goes blind after a sparrow has defecated in his eye. Since he is now unable to work, his wife Anna does so instead. She earns a living by spinning and weaving—an allusion that will not have been lost on the people from the cloth centre of Leiden.

One day, Anna comes home from work with a kid that she has been given in addition to her wages. Tobit accuses his wife of having stolen the animal, but discovers that his accusation is false. In Rembrandt's painting, the sightless whites of his eyes weep bitter tears. Tobit folds his hands in remorse and begs his wife's forgiveness.

Rembrandt based the composition on an engraving by Jan van de Velde after Willem Buytewech. In that image, too, Anna holds the little kid under her arm and leans over towards her blind husband. "Witty Willem" had previously depicted a different scene from the story: Anna's outrage at the false accusation. Rembrandt chose to show the old man begging for forgiveness.

Rembrandt derived the hand-wringing gesture—in which the fingers are very oddly entwined—from a print by Willem van Swanenburg after Abraham Bloemaert's *The Penitent St Peter*. The Latin caption to that print, on Peter and his remorse at the betrayal of Christ, was by Petrus Scriverius. It is signed "P.S. extempore".

Tobit and Anna with the Kid, 1626.

Starting with his *Flight into Egypt* (1627), Rembrandt went in search of new paths to the light. He no longer sought to infuse drama into his scenes by using contrasting colours. Instead, he gravitated towards what Van Hoogstraten calls "congenial colours"—subtle shades of white lead, ochre, brown and black—and sharp contrasts between light and dark. In the *Flight into Egypt*, Joseph (in whom we recognize a Leiden beggar), as well as Mary and her infant, seated on the donkey, stand out against the blackness of the night.

The protagonist of the painting *Parable of the Rich Man* cups his hand protectively around the flickering candle, which casts a strange light on the folios and ledgers all around him. The coins on the table glitter: "Thou fool, this night thy soul shall be required of thee: then whose shall those things be, which thou hast provided?" (Luke 12:20). No pile of bonds is high enough to prevent the fool's life-candle from being extinguished.

In *Christ in Emmaus*, Rembrandt conceals the light source behind the figures, leaving much of the scene immersed in blackness. A silhouette stands out against a golden glow. Even without being able to see his face, we know him at a glance from his profile, hair and beard. Furthermore, the expression on the face of a guest at the inn in Emmaus leaves us in no doubt: he stares with a mixture of awe and veneration at the figure of Christ. Here we have a painting as a hall of mirrors.

A more secular shadow play is conjured up in the painting *La Main chaude*. A man with a large hat holds a candlestick. His hat casts a jagged shadow on the floor. A group of boys are playing the game of "hot cockles". One boy has to shut his eyes, place his open hand, palm uppermost, behind his back and guess who strikes his hand or his buttocks. Rembrandt shows the boy sneaking a look, turning his face to the light. He is cheating.

The attribution of this work to Rembrandt—like his earliest genre paintings depicting the senses—has been challenged. Might these reservations have been subconsciously prompted by the subject's sheer banality? Was it regarded as a little unseemly, perhaps, that a genius might produce a humorous genre piece? If so, it is a baseless view. Why should Rembrandt leave banal subjects to banal painters? We may recall that the Leiden artist Jan Steen, who tackled such scenes with gusto, was one of the cleverest and most ingenious painters of his day.

La Main chaude gives us a fleeting illusion of being in the company of his friends, as they play a game in the waning light. The same applies to Rembrandt's *The Music Party*, in which he includes the figure of Jan Lievens playing the harp. Why might the young men not have amused themselves in this way in the evening?

Rembrandt loved to dress up; he posed in all sorts of costumes in his self-por-traits. It is quite possible that he had his friends act out scenes from his paintings.

At the same time, we must not interpret the work too literally. In the past, The Music Party has often been described as a portrait of Rembrandt's family making music together, with the painter playing the harp and his sister Lijsbeth singing from her book. However, although Rembrandt's mother may have posed as a model for the old woman, this is very far from an innocent domestic scene.

The painting is crammed with symbolic allusions. The figures' Oriental attire, the red shoes of the young woman, her swelling breasts beneath the satin suggest the atmosphere of a harem. The playing of the strings, the wielding of the bow—they conjure up erotic acts. The little painting hanging on the rear wall points in the same direction. The angel gives Lot an opportunity to take his family and flee from Sodom, the city of sin, before it is engulfed by flames. This is a brothel scene—an admonition to resist the temptations of the flesh.

The Music Party belongs in the category of genre paintings of merry companies that were made by Caravaggio and by his Dutch admirers Gerard van Honthorst and Hendrik ter Brugghen. Lievens was already emulating the Caravaggists two years before Rembrandt, exploring the possibilities of chiaroscuro and choosing with care the right subject to reflect that influence.

In 1624, Lievens produced two paintings of a boy blowing hot coals in a brazier. He was showing off. The ancient historian Pliny the Elder had described the painter Antiphilus of Alexandria triumphing over his rival Apelles with a painting depicting just this subject. To flaunt his knowledge, Jan—who, unlike his brothers and Rembrandt, had not attended the Latin school—signed the works "J. Livius". For his painting of the boy with the red-hot coals Lievens stole light, just as Prometheus stole the fire from the gods.

How should they paint? The two young men deliberated endlessly on this subject. Samuel van Hoogstraten relates in his 1678 Inleyding tot de hooge schoole der schilderkonst the captivating story of a "painting contest" between three landscape painters who had workshops in Leiden in the mid 1620s: François van Knibbergen, Jan van Goyen and Jan Porcellis, "the Phoenix of the Sea". If this artistic competition ever in fact took place, we can be sure that Rembrandt and Jan Lievens would have been right at the front, watching. A likelier explanation, however, is that the story should be read as an allegory, like Pliny's narrative on the contest between Antiphilus and Apelles. It was a way of conveying the rivalry between painters and their aston-ishing capacity to deceive the eye in a single exciting story.

The Music Party, 1626.

According to Van Hoogstraten, the three Leiden painters agreed to paint within a single day—"one shining of the sun"—a panel painting with a landscape so realistic that viewers could imagine strolling into it. The winner would gain a vast sum of money and eternal fame. On the day of the contest, they feverishly set to work.

Knibbergen started to paint as if writing a story. He plonked down the horizon with a single flourish of the paintbrush, after which—according to Van Hoogstraten's over-elaborate account—he dashed trees, mountains and waterfalls from his brush as "letters from a copyist's pen". He wielded his brush in a confident, airy style. The thin clouds floated from his hand, and the cliffs and crumbling ground were born from his paint.

Jan Lievens, *The Four Elements: Fire, c.1624.*

Jan van Goyen—who was ten years older than Rembrandt, had grown up on Langebrug and had also been trained by a member of the Van Swanenburg family—"soused" his entire panel, "here light, there dark". In the rough under-layer, Van Goyen went about looking for "drolleries", which he seemed to conjure up effortlessly with a plethora of tiny brushstrokes. The painter saw things that lay concealed "in a chaos of paint". His eye reliably guided his hand and intellect, so that the viewer would see a perfect painting even before comprehending what Van Goyen was aiming at.

Porcellis almost drove the spectators mad, because he endlessly delayed getting down to work. He hedged, hesitated, lingered. But then it happened: it became clear that Porcellis had created the painting in his head before he had even dipped his brush in the paint. Once he started, the work was rapidly completed. He won the contest, his one-day painting being judged the most lifelike of the three.

Rembrandt derived elements from all three of these contestants. He was a "writing" painter like Knibbergen, wielding his brush as if writing a poem: he infused his work with meaning elegantly, but also with intensity and drama. Rembrandt was not averse to painting wet-in-wet like Van Goyen, to create a swirling effect. And he embraced the Porcellis method: first developing the painting in his mind, completing the invention and only then starting to paint. That was the subject of his marvellous panel painting of the artist in his studio, standing at a distance from his work on the easel and gazing at it.

Rembrandt the inventor.

Not long afterwards, someone visited Leiden who would have greatly appreciated Rembrandt's little painting of *inventio*: Constantijn Huygens, the poet-diplomat and secretary to Stadtholder Frederik Hendrik. Huygens thought it vitally important to be able to converse with great expertise on matters of art—as indeed was customary in the highest circles. In the late 1620s, he made the rounds of the most interesting artists in the Dutch Republic, often travelling with his brother Maurits.

We know of this visit because in 1629—Huygens was then just thirty-three years old—he recorded some memories of his youth, devoting one magnificent passage to Rembrandt and Lievens. The circumstances in which Huygens wrote this memoir were noteworthy: he was in Frederik Hendrik's retinue on the occasion of the siege of Den Bosch. As the cannons bellowed, Huygens sat down and entrusted his memoirs to paper, calmly and in an even hand.

Constantijn was the son of Christiaan Huygens, secretary to William of Orange. He was already fluent in five languages as a young boy and wrote metrical poetry

in Latin, which was also the language in which he recorded his memoirs. The youth did not hesitate to correct his erudite father, when the occasion arose. "When Father himself tried to make a Latin distich, the rascal observed in a couplet that if great poets take many liberties in the metre, Father is certainly a great poet."

In the autobiography of his youth, Huygens describes the upbringing and education that enabled him to develop into a Renaissance man. His memoirs are superbly written: eloquent and erudite and more than a little self-important. Had he already mentioned that besides his consummate abilities in draughtsmanship, design and invention, his lute-playing was divine?

Huygens had been raised for a future at court. He received the finest possible education, was introduced into all the right circles around Europe and enjoyed a rigorous training in the arts, so that he would never be at a loss for words in a conversation with art connoisseurs. Furthermore, he and his brother Maurits had had lessons in draughtsmanship so as to become well versed in the basic principles of art from their own experience.

His tutor and mentor was Johan Dedel, a relative of Isaac van Swanenburg's wife. Perhaps it was Dedel who first told Huygens about Rembrandt. Although the news might have reached him through a variety of channels. Huygens was a former student of the university, he was on terms of friendship with the erudite poet and university librarian Daniël Heinsius as well as with father and son De Gheyn, and the Wtenbogaert family too were among his circle of acquaintances. He had excellent connections who could always be relied upon to tell him where he needed to go.

In 1625, after Prince Maurits had died and been succeeded by his half-brother, Frederik Hendrik, Huygens was appointed as the stadtholder's secretary. Besides advising in affairs of state, his remit also included mediating in the court's artistic commissions. He held the key to the prince's treasury. For Rembrandt and Lievens, his visit was a momentous occasion on which much might depend.

In his memoirs, Huygens sang the praises of the young painters in the tradition of classical rhetoric. "Even if I say they are the only ones who can equal those great artists I have already praised as the wonders of mortal men, I would still be selling them short. And if I say that it won't be long before they surpass those whom I have already designated as men of genius, then I wouldn't be adding anything to the expectations of the most distinguished authorities based on their extraordinary debut."

The explanation he gives for their talents also appears to have been drawn from a handbook of rhetoric. He was struck by their extreme youth. "Both are still

Jan Lievens, *Portrait of Constantijn Huygens*, c.1628–c.1629.

beardless, and, judging by their faces, more children than young men." He praised
them both as naturally gifted. They were developing without regard for birth. He
pointed out that Lievens was the son of an ordinary burgher, a needle-worker, and
the other the son of a miller, "although he was decidedly not baked from the same
dough".

"Whose mouth would not fall open," demanded Huygens, "were he to see two such miracles of talent and skill rise from the furrows behind such ploughs?"

Their teachers were barely known outside the common classes, asserted Huygens. "Due to their parents' modest circumstances, the boys were compelled to take teachers whose fees were low. Were these teachers to be confronted with their pupils today, they would feel just as abashed as those who first instructed Virgil in poetry, Cicero in oratory and Archimedes in mathematics."

This was pure chutzpah. Huygens was only too well acquainted with the reputation of the Van Swanenburg family, partly through his tutor Dedel, and he respected Pieter Lastman, who was certainly no obscure, cheap or vulgar master. No, Huygens was not so concerned here with the facts. He wanted to prove that he was not dealing here with well-trained craftsmen, but with "absolute geniuses".

Besides these bombastic fusillades, Huygens also gave a meticulous account of the differences between the two artists:

Impromptu, I venture to say that Rembrandt surpasses Lievens in aptness and liveliness of emotions. On the other hand, Lievens excels in grandeur of invention and audacity of subjects and forms. Everything that his young mind strives to achieve must be majestic and sublime. Rather than adhering to the true size of the subject, he prefers to make his image in a larger format. Rembrandt, in contrast, is pleased to concentrate with supreme dedication on a small painting, and achieves in the small scale a result for which one may search in vain in the largest paintings of others.

Here, Huygens hits the nail on the head. That is all the more remarkable when you think that no one before him had published a single word about the two young painters. Panel size was indeed an important issue. Quantity is also a quality. Huygens's observation that Rembrandt was capable of telling a complex story in a small panel painting was astute: his comments apply just as well to the mysterious self-portrait with dark eyes, *The Painter in his Studio*, as they do to *David before Saul with the Head of Goliath*.

This small panel painting from 1627, scarcely larger than an iPad, looks like a sketch in paint. It may be a preparatory study for a larger painting that was never made. Just as Lastman's *Coriolanus* had served as an example for *The Leiden History Painting*—the army tent, the motley crowd, with spears poking into the sky, and the horseman in the left foreground are clearly derived from it.

But Rembrandt injected new significance into the figures. David killed Goliath with a single well-aimed shot from his sling, "[so] that the stone sunk into his forehead". Then the shepherd's son chopped off the head of the Philistine giant with his own sword. In the small panel painting he gives Goliath's head to King Saul, the powerful king with his small lackeys, to whose throne David would later ascend.

Rembrandt's horseman, the richly dressed young man in the vivid blue cloak and a turban on his head, must be Jonathan. Saul's son forged a lifelong friendship with David. In 1 Samuel 18:1 we read: "And it came to pass… that the soul of Jonathan was knit with the soul of David, and Jonathan loved him as his own soul." Rembrandt's small painting shows their first meeting.

Constantijn Huygens foresaw a bright future for the two painter friends: Rembrandt as a history painter of small-scale panel paintings, the other as a maker

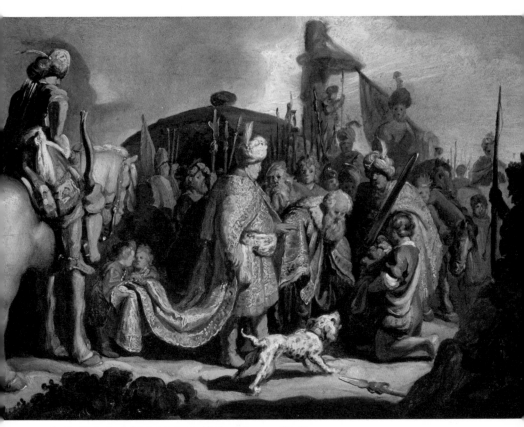

David with the Head of Goliath before Saul (1 Samuel 17:57–58), 1627.

of life-sized portraits. The stadtholder's secretary recalled that after an occasion on which he had visited Lievens together with his brother Maurits, Lievens had been possessed with a passionate desire to paint his portrait. Lievens's anxious desire to ingratiate himself with Huygens gives the account a slightly poignant air:

> His yearning was so unquenchable that he turned up just a few days later, saying that since that first moment he had been unable to sleep at night and had been so befuddled in the daytime as to be unable to work. So persistently had my image remained in his mind that he was unable to wait any longer to satisfy his enthusiasm. The effect of his imagination was all the more remarkable, because he was generally reluctant to ask someone to pose for a portrait, and could be persuaded to do so only with difficulty.

Huygens praised the portrait that Lievens had painted of him and had high expectations of the boy's career. He considered that, quite aside from his enthusiasm, Lievens displayed keen insight, "more mature than that of an adult man". His only objection—unsurprisingly for the vain secretary to the prince—was that he found Lievens too unbending and self-assured. He could not abide criticism of any kind. "That bad quality, damaging at any age, is simply ruinous in youth. For just a small quantity of sourdough makes the whole dough go sour."

Huygens saw Rembrandt as the more gifted of the two, that much was clear. To highlight the sure hand and vitality in the work of the miller's son, he described— again with a tremendous sense of pathos—the painting that was set up on the easel in the studio at the time of his visit: *Judas, Repentant, Returning the Pieces of Silver*.

The paint was still wet; it was not yet finished. Rembrandt would carry on working on it for a whole year to get the composition right. He made numerous drawings to try out the characters' poses. He depicted the moment at which Judas comes to the temple to return the pieces of silver he had accepted for betraying Christ, "saying, I have sinned in that I have betrayed the innocent blood. And they said, What is that to us? see thou to that." (Matthew 27:3–4)

Judas throws the coins on the floor of the temple and sinks to his knees, hands folded. His hand-wringing has an extra bitter association, since after his visit to the temple, the Bible relates that Judas hangs himself. Again, Rembrandt derived the pose from Van Swanenburg's print after Bloemaert's *The Penitent St Peter*.

Three Scribes, preparatory drawing for Judas Returning the Thirty Pieces of Silver, 1629.

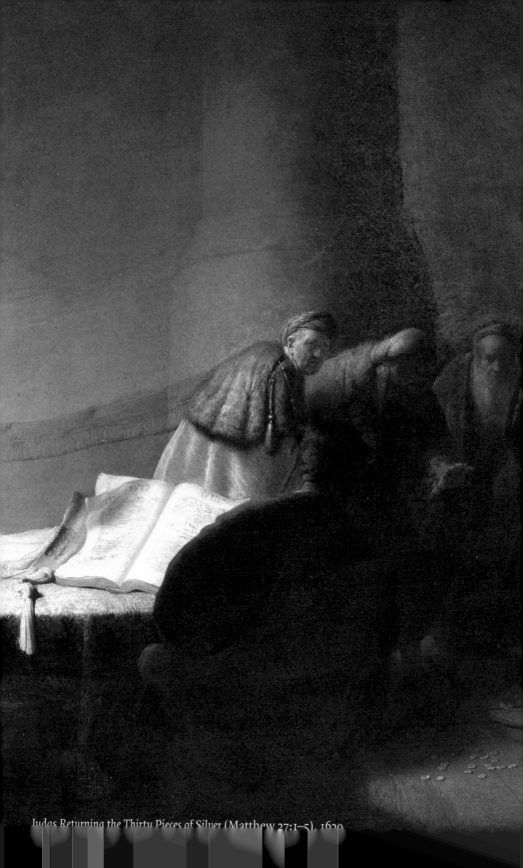

Judas Returning the Thirty Pieces of Silver (Matthew 27:1–5), 1629

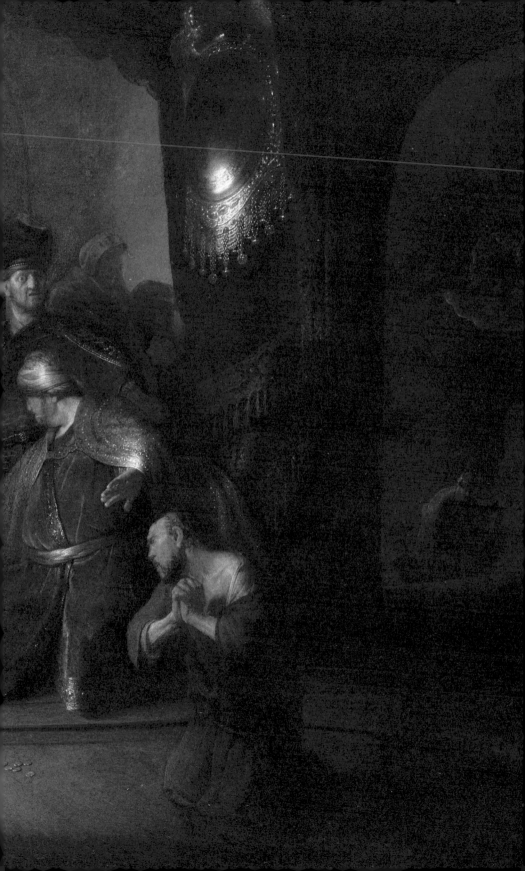

Huygens wrote:

The gesture of that one figure of Judas, reduced to despair (not to mention all the other impressive figures in this one painting), that one frenzied figure of Judas who shouts, begs for forgiveness, but who no longer has any hope and in whose face all traces of hope have been erased; a wild look in his eyes, his hair torn out, his clothes ripped, arms twisted, hands clenched so tight they are bleeding; in a blind impulse, he has fallen to his knees, his entire body contorted into pitiful hideousness.

Huygens compared this history painting by the young Rembrandt to "all the beauty that has been created down the ages". And that comparison to Protogenes, Apelles and Parrhasius, the divine painters of antiquity, worked out to the advantage of the young miller's son from Leiden.

Huygens had only one point of criticism regarding "the famous young men". He could not understand that they did not take a long break for a study trip around Italy, the "promised land" of art:

That is of course the one morsel of folly in young men who are otherwise so brilliant. If someone could get that into their young heads, truly, he would be adding the only missing element for the consummation of their artistic powers. How glad I would be if they could make the acquaintance of a Raphael and a Michelangelo and take the trouble to feast their eyes on the creations of so many giant minds! How fast they would be able to do all that better and give the Italians reasons to journey to their own Holland.

The boys answered Huygens that they were in the full bloom of their life and had to take advantage of it. They did not want to waste any time on foreign journeys. Anyway, they said, "if you want to see the best Italian paintings, in the genre that is nowadays best loved and most collected among kings and princes north of the Alps, you must look outside Italy. What you find there with great difficulty, scattered here and there, you can see here in abundance, to the point of saturation."

Were they right? Both Rembrandt and Lievens devoted intensive study to the prints of the Italian masters and the work of the Caravaggists. In the stories, lessons and examples of their teachers Jacob van Swanenburg—in whose house Italian was spoken—and "Pietro Lastman" they had, in a sense, already been to Italy.

"To what extent this excuse is valid, I shall not venture to say," wrote Huygens. However, he did feel compelled to declare that he had never before witnessed such dedication and tenacity as he saw in these painters. "For they truly make the most of their time. This is all that matters to them."

The memories related by Constantijn Huygens enable us to spend a brief space of time in the direct vicinity of Rembrandt and Lievens. We can feel the feverish excitement, the burning ambition on their beardless faces. The place smelt of paint and stank of sweat.

"The most remarkable thing of all", noted Huygens, "is that they dismiss even the most innocent pleasures of youth as a waste of time. They are so indifferent to such things that you might think you were dealing with old men, who are weary of life and have long left all those trivialities behind them."

In reality, everything had yet to begin.

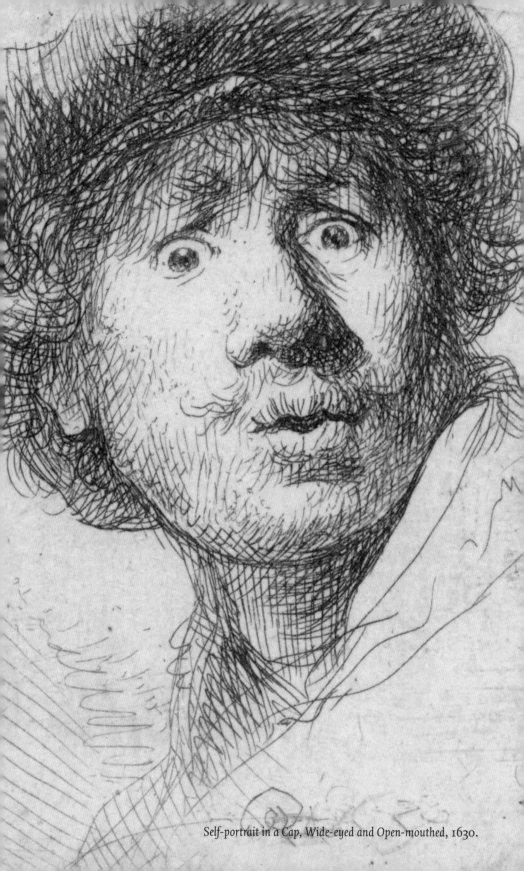

Self-portrait in a Cap, Wide-eyed and Open-mouthed, 1630.

14

The first heretic in the art of painting

ONE DAY, AN ART LOVER OF REMBRANDT'S ACQUAINTANCE SUGGESTED that he offer a painting he had just completed to an affluent gentleman in The Hague. Following the advice, the artist set off on foot, the little panel under his arm. The gentleman purchased the painting for 100 guilders. Rembrandt was so delighted that he rushed off home to tell his parents as fast as possible.

With his new riches, walking suddenly seemed too prosaic a mode of transport to the young artist, who leapt aboard a carriage back to Leiden instead. Halfway between the two cities, the coachman briefly halted to feed the horses. All the passengers dismounted to have a drink. Except for Rembrandt. He stayed behind, alone, keeping guard over his money. As the trough was being taken away and the coachman was returning with the other travellers, the horses bolted.

"Without paying the least heed to the pulling of the reins," wrote Arnold Houbraken in his lives of the Dutch artists (*De Grote Schouwburg der Nederlandse kunstschilders en schilderessen*), "they galloped off with Rembrandt until they were within Leiden's city walls, where they stopped in front of their customary inn. The astonished onlookers asked Rembrandt what had happened. But he shrugged and dashed off to his parents, bearing his prize."

Houbraken's anecdotes should be regarded as charming fictions. The painter-biographer told this story primarily to show that Rembrandt was parsimonious and fixated on money from an early age: "He was extremely pleased at having been transported to Leiden without having to pay, and even faster than usual."

Whatever the case may be, Houbraken's story does suggest that after the visit of Constantijn Huygens, who introduced him to connoisseurs and collectors in The Hague, and to the courtly circles surrounding Frederik Hendrik and his wife Amalia van Solms, Rembrandt had "piles of work".

In addition to his contact with the prince's secretary, there was another impor-
tant reason for his success in the late 1620s: Rembrandt had started making etch-
ings. Unlike paintings, etchings could be reproduced. He sold them to dealers who
took them to art fairs all over Europe. Rembrandt's fame soon spread with the
speed of a team of bolting horses.

We do not know who taught him the art of etching. Since his etchings can
scarcely be compared to those of other artists and he soon developed an entirely
individual, painterly style, he must have been self-taught. "The extremely bizarre
method that Rembrandt contrived for the etching," wrote Baldinucci in his *Vita di
Reimbrond Vanrein*, "which he alone practised, which was neither applied by others
nor seen elsewhere... entailed the use of streaks and little dashes and irregular
lines, without contours, to evoke an intense, powerful chiaroscuro."

That Rembrandt developed a unique signature mode of etching, and that his
character drove him constantly to experiment, is not to downplay other sources
of inspiration. His first important influence was Lucas van Leyden, whose fame,
well beyond his native city, was based on his marvellous etchings. As a boy,
Rembrandt must have heard tell of the meeting between Lucas and Albrecht Dürer
in Antwerp. One summer's day in 1521 they signed each other's portraits and
exchanged a few prints.

Rembrandt would continue to collect work by Lucas throughout his life. The
prints were rare and expensive, but the price did not deter him. One print in par-
ticular was in great demand: a 1520 *Uylenspiegel*, an etching of a family of beggars
who trek from one city to the next, the children in straw baskets on their parents'
backs. The father plays the bagpipes, the mother goes barefoot. Rembrandt paid
200 guilders for a print. For such a sum you might have rented a canal-house for
a whole year.

In 1633, Rembrandt depicted himself in an etching in exactly the same way as
Lucas: with a scarf and beret, the left shoulder turned forward and the eyes meeting
the viewer's gaze sideways, producing a slightly distrustful expression. Here he
posed as the hero of his boyhood days. Rembrandt would continue to use the
beret—a fashionable accessory in Lucas's day—as a trademark. It worked: his
pupils took to wearing berets, and depicted their master and each other wearing
them. The beret became the artist's headgear par excellence.

Jacob van Swanenburg had shown Rembrandt the engravings by his brother
Willem after the work of Rubens, Bloemaert and other masters. And Pieter Lastman,
who is not known to have made any etchings, may nonetheless have provided both
Rembrandt and Jan Lievens with some useful instruction, given that Lastman

himself had studied under the first Netherlandish specialist in the art of etching, Gerrit Pietersz Sweelinck.

Before work could begin, it was important to study the subject attentively. To make a good etching required considerable technical expertise. The process can be broken down into several stages. First, a copperplate was heated and coated with a thin layer of wax. In this "etching ground" the artist could draw the design with a needle. The copperplate would then be dipped in a bath of acid. Wherever the etching needle had exposed the copper, the acid would "bite" the lines into the metal. Then the wax was removed, the copperplate inked all over and the ink wiped off the surface, leaving only the ink in the grooves. A slightly moistened sheet of paper would be placed on the inked plate, and the two would be put through a printing press together. Et *voilà*! Your etching would appear, printed in reverse image on the paper.

In the very first etching that we know by Rembrandt, he does not yet display any of his "bizarre" qualities. In 1626, he and Jan Lievens both produced etchings for the Haarlem printer I.P. Berendrecht. The printer would have given the young men prepared plates and carried out the remaining process himself after the designs were finished. Lievens produced an etching of John the Evangelist on the Greek island of Patmos. Rembrandt made a *Circumcision*. It is to be hoped that the *mohel* whose task it was to circumcise the infant had a surer hand than the young artist

The Circumcision, 1624–28. The Circumcision: small plate, 1628–32.

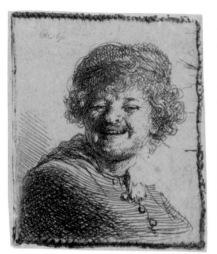

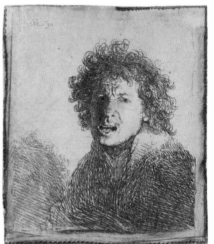

Self-portrait in a Cap, Laughing, 1630. *Self-portrait, Open-mouthed, as if Shouting, 1630.*

Sheet of studies: self-portrait, a few beggars, heads of an old man and a woman etc., 1630–34.

who depicted him. Excruciating. Just compare this etching with a *Circumcision* made four years later: a world of difference.

From the late 1620s onward, Rembrandt appears to have had his own personal etching press. From then on, we find works preserved in different "states"—that is, prints in different stages of development. They clearly show how obsessively focused Rembrandt was on practising his technique.

If a design was unsuccessful, he rotated the plate ninety degrees and made something else in the remaining space. He applied incisions and strokes of varying depths. Sometimes he cut off part of the plate and carried on with just that piece. Most of the prints he made were tiny and fiddly, but he would occasionally use a larger plate and wield his needle with vigorous strokes, as if making a drawing. He also experimented by immersing the plate in an acid bath in between times, thus interrupting the process. Later on, he would not only draw in the wax with a needle, but scratch his design directly into the etching plate with a burin or "drypoint".

His subjects were extremely varied, but one stood out above all else: images of himself. When he chose himself as his model, he could make all sorts of strange faces in the mirror to see how different emotions, moods and temperaments were expressed in the face. He undoubtedly told Samuel van Hoogstraten what the latter quotes in his *Inleyding tot de hooge schoole der schilderkonst*: the best place to depict passions was in front of the mirror, "so as to be both performer and spectator at the same time".

"There's no art to find the mind's construction in the face" says King Duncan (*Macbeth*, Act I, scene iv), but Rembrandt clearly took a different view. He portrayed himself in diverse moods: flabbergasted, with pouting lips, wide-eyed, head back and chin raised; angry, staring right at us, lips tightly shut in fury and dark-flaming eyes, with wild, tangled hair; grinning, or rather smirking, the cheeks of his round face raised, teeth bared and lips slightly parted, eyes squeezed to slits; suffering: open-mouthed, shouting in pain and frustration.

These *passiones animi* served as artistic experiments. They were a kind of auto-biography, but were destined for the market. He signed his self-portraits on the plate "RHL 1630". It was an ingenious way of establishing his reputation: Rembrandt used his etchings in much the same way as we now use Facebook and Instagram. He sent his "selfies" off into the world, and before long everyone would recognize him. Interestingly, he never sought to make himself more attractive than he was.

Sometimes it seems as if he deliberately downplayed his appearance. Or possibly that he wanted to emphasize the painterly qualities of his etchings by making his hair even messier and more tangled than it was in real life. Baldinucci pointed out

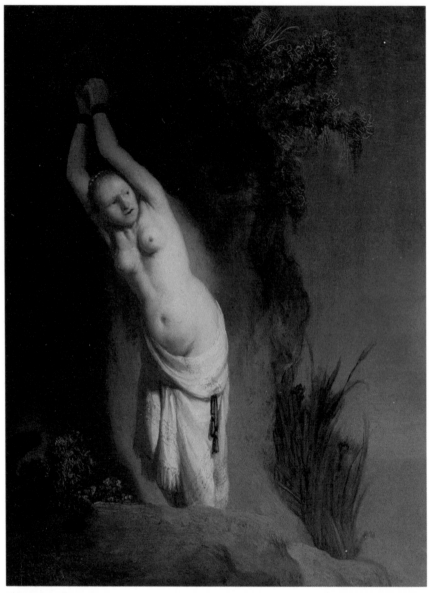

Andromeda, c.1630.

that Rembrandt even scribbled his signature half illegibly: "He signed his prints with disagreeably written, slapdash, misshapen letters."

It is precisely that looseness, bravura and ostensible nonchalance that give his etchings their enormous appeal. Rembrandt paid no heed to prevailing fashions

or ideals of beauty. He play-acted and posed in front of the mirror, but also depicted quite honestly and informally the figure he saw there—and in this way etched a fascinating, complex new image of himself as an artist and as a human being. Sometimes he seemed to find it easier to show his emotions through his art than in real life.

In the same year that he depicted his surprised, grinning and angry *tronies*, Rembrandt had an opportunity to paint the naked truth. His first female nude was Andromeda—a woman of legendary beauty. Queen Cassiopeia boasted that her daughter was more beautiful than the Nereids. To punish the mother's pride, Andromeda was chained naked to the rocks to be sacrificed to a sea monster. When the Greek hero Perseus, who was speeding through the skies on his winged horse Pegasus, saw her standing there, he was smitten. He killed the monster and released the young woman from her chains.

In Ovid's *Metamorphoses* Andromeda is "a marble statue", a ravishing beauty who sets Perseus' heart on fire. Not in Rembrandt's painting. He did not paint a sensual, idealized lover but a woman of flesh and blood. The chains cut into her skin, the muscles in her neck and chest are taut, her belly is distended. Her fear is terrifying—and it is not a pretty sight.

Rembrandt's realism must have been a shock. In the Calvinist world of Leiden, it was far from customary to have models pose nude, let alone to depict them thus. Rembrandt disdained custom. Was he out to shock? In any case, he did not shrink from depicting indecorous subjects indecorously. His nude was really naked.

When selecting models for a nymph or bather, he did not choose graceful young girls but older women. Judging from their appearance, Rembrandt might have plucked them from one of the brothels in Sliksteeg. According to the Amsterdam bookseller and poetaster Andries Pels, Rembrandt "chose no Greek Venus as his model but rather a washerwoman, or a treader of peat from the barn". Pels carped at her flabby breasts, the pinch marks from the corset on her stomach and the imprint of garters on her legs.

In his 1681 *Gebruik en misbruik des toneels* ("Uses and Abuses of the Stage"), Pels articulated the incredulity that many of Rembrandt's contemporaries must have felt. He could not believe that a brilliantly gifted painter had strayed wantonly and "ostentatiously" from the path of righteousness, choosing to be "the first heretic in the art of painting".

Rembrandt's female nudes were "too pitiful for words", thought Houbraken, but he also told an anecdote which shows that in his teaching practice Rembrandt certainly kept an eye on prevailing standards of decorum. What was still

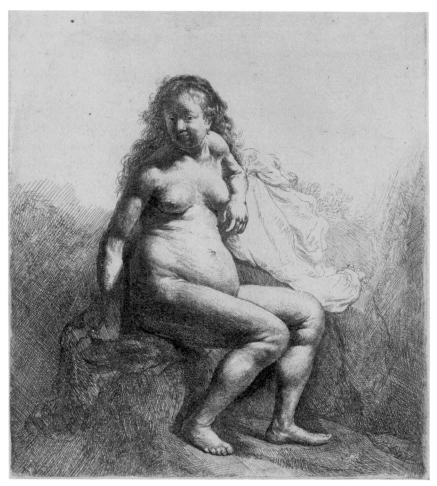

Nude Woman, Seated on a Mound, 1629–30.

unthinkable in Leiden, he put into practice in the more tolerant milieu of Amsterdam: drawing and painting from live models with his pupils.

On a hot summer's day, one of his pupils was busily painting a female nude model in a specially partitioned room. Because of the heat, the apprentice too "stripped to full nudity". His fellow students peeped through a crack to see what the two were getting up to. Then the master arrived. He in turn looked through the crack, and heard one of them say: "We are just like Adam and Eve in Paradise, for both of us are naked."

At this, Rembrandt thumped on the door with his maulstick and cried: "Since you are naked, you must leave Paradise!"

Adam and Eve hastened to leave, pursued by an irate Rembrandt aiming blows at them with his stick. Upon leaving the building, they just managed to put on enough clothes to avoid appearing naked in the street.

Rembrandt would train pupils for thirty-five years, building up an excellent reputation as a strict but fair taskmaster. His first pupil arrived on 14th February 1628: it was Gerrit Dou, fifteen years of age. Rembrandt himself was only twenty-one. Gerrit grew up just around the corner from him on Kort Rapenburg, where his father, a stained-glass artist, ran a successful business making church windows. When it became clear that the boy was a talented draughtsman, his father apprenticed him first to the engraver Bartholomeus Dolendo and then to the stained-glass artist Pieter Couwenhoorn, a friend of Scriverius and the drawing master of Constantijn Huygens's son Christiaan.

After his apprenticeship, Gerrit started working for his father. Such were his gifts that he was soon bringing in a lot of money for the business. Even so, his behaviour struck terror into the heart of his ageing father, wrote Orlers in his chronicle of the city. For Gerrit would nonchalantly climb up ladders to install new windows or to repair old ones, without the slightest concern for his safety. His father was afraid that this daredevil attitude would lead to a tragic end. He decided to send him off to train with the nearest painter instead.

Under Rembrandt, Gerrit Dou became the sorcerer's apprentice. Almost immediately he proved capable of copying his master's compositions down to the smallest detail. Was it Dou who painted the copy of his master's *Self-portrait with Gorget*, which now hangs in the Mauritshuis in The Hague and was long believed to be the original? For Rembrandt, his pupil must have been a blessing. Besides receiving the tuition fees, he also made money from the sale of Gerrit's work.

The boy worked with the concentration, patience and precision of a watchmaker. He evolved more and more as a *feinschilder*—the term for a Dutch artist in this period who painted usually small, meticulously rendered images. Meanwhile, his master was moving in the opposite direction in the 1630s: working in an ever looser, more impasto style, with broad brushstrokes. In small panel paintings, Dou performed miracles using a brush consisting of a single tail-hair from a marten.

Rembrandt's second pupil was another local boy: sixteen-year-old Isaack Jouderville. His father (also named Isaack) hailed from Metz and had come to Holland in 1607 as a soldier in the States army. Two years later, at the beginning of the Twelve Years' Truce, he leased the Leiden inn De Drie Haringen, on the

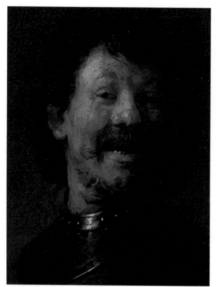 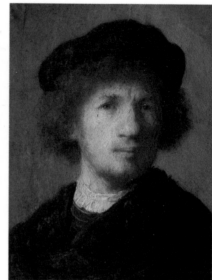

The Laughing Man, c.1629–30. *Self-portrait in a Cap, 1630.*

corner of Noordeinde and Kort Rapenburg—diagonally opposite the Dou family. When Prince Maurits came to Leiden in 1618 to change the composition of the city council, his retinue took lodgings with Jouderville.

Isaack's parents moved in artists' circles. They had a harpsichord in the inn and traded in paintings—a common way for innkeepers to eke out their income. His brother Jacob became a bookseller, his sister Magdalena married a painter. When Isaack was seventeen, both his parents died within a short space of time: his father in November 1629, his mother Magdalena a month later.

It was around this time that Isaack came to Rembrandt as his new apprentice. His guardians paid fifty guilders every six months in tuition fees—a hefty sum, certainly considering that it did not include board and lodging or the cost of materials. This indicates how seriously Rembrandt was already being taken as a painter and teacher.

We know the exact figures for Jouderville's apprenticeship because documents preserved in the archives of Leiden's "Orphans' Chamber" record, down to a stiver, Isaack's expenditure on meat, butter and cheese, and on having his breeches mended. The documents also include a pile of receipts, one of which dates from the end of 1631, when Rembrandt issued a financial statement for the previous two years: "I assert that I received 200 guilders since the death of Machdaeleena Joddervyle for instructing her son Isack in the art of painting. Rembrant Harmensz van Ryn."

Old Woman at Prayer, 1629–30.

Two self-portraits of Jouderville are known: a serious one and a smiling one. This suggests that he followed his master's tactics in depicting emotions in front of the mirror. There was someone else who made copies of Rembrandt's work, beside his pupils Dou and Jouderville: Jan Gillisz van Vliet, the son of a Leiden grain merchant who lived in a house overlooking the New Rhine, close to the Van Swanenburg family and Petrus Scriverius.

Jan Gillesz did for Rembrandt what Willem van Swanenburg had done for Rubens: he made prints after his paintings. They were reproduced in large numbers, and ten have been preserved. Prints made it possible for art lovers to glimpse Rembrandt's paintings, which, once sold, disappeared for good behind their owners' front doors.

Rembrandt's workshop was doing good business. One painting after another was being laid in. Etchings rolled off the press. Clients and connoisseurs frequently dropped in to see what new work was hanging on the wall or to place an order. In a painting that has been attributed to Dou, we see an artist in a studio that may well have been Rembrandt's. His metal shield with the sunbeam design lies in a corner. Behind the painter a fashionably dressed gentleman appears on the threshold: an art connoisseur.

The only little paintings that Rembrandt made on three gilded copperplates, all the same size, must have been intended for visitors of this kind—to give them something to talk about and a selection from which to choose. There is no common theme among the facial types or *tronies* depicted on the gilded plates: a laughing soldier, a self-portrait and an old woman at prayer. Rather, the connection is precisely the differences between them. The soldier is painted in wide, coarse brushstrokes, the self-portrait in softer, more fluid strokes and the old woman in delicate, cautious, meticulous little strokes.

At the Latin school, Rembrandt had learnt that Virgil employed three different narrative styles in his epic poem the *Aeneid*. The three types of linguistic expression

or *genera dicendi* were the *stilus humilis*, *mediocris* and *gravis*: approximately, the plain, medium and sublime style. Rembrandt showed the ease with which he was able to apply these styles in his paintings: the soldier was painted in the *stilus humilis*, the self-portrait in the *stilus mediocris* and the old woman in the *stilus gravis*.

In executing commissions and finding the right composition, he worked in a spirit of ever fiercer rivalry with Jan Lievens. In 1630 there was a small contest to find the best composition of *The Raising of Lazarus*. Rembrandt went first. In his painting, Christ raises his right hand above the grave of Lazarus, whose body had been buried four days ago; "by this time he stinketh", we read in John 11:39. Lazarus rises from the grave, his features ashen, frail and hollow-cheeked. His sister Martha leaps forward into the light from sheer astonishment.

Then it was the turn of Lievens. He depicted Christ standing on a podium, his hands devoutly folded, his gaze turning upward in a beam of light that reaches to the heavens. In the grave, far beneath him, we see only two hands poking out. "Lazarus come out!" The sister gapes in amazement. Lievens made an etching based on the painting in 1631.

Rembrandt produced a sketch in red chalk that largely corresponds to Lievens's composition. He then reworked that drawing into an *Entombment of Christ*: probably by way of preparation for the series of Passion scenes that the stadtholder, Frederik Hendrik, had commissioned from him. The drawing is dated "1630". Lievens's etching dates from the following year. Gary Schwartz thinks that Rembrandt antedated the drawing, to record that he, rather than Lievens, had conceived the original idea for the composition.

Would Rembrandt have felt any need to practise such a deceit? Whatever the case may be, with the etching that he then made of *The Raising of Lazarus*, the final move in the contest, he carried the day. The work was just a little larger than his rival's and was rounded at the top—exactly the shape that was needed for the court's Passion paintings. Furthermore, it is the shape of the painting that Lievens is executing in Rembrandt's drawing of him. They kept an eagle eye on each other's work.

Now he showed Christ diagonally from the back. The viewer's gaze follows the line of his arm upward to his hand. Now, the head of Lazarus ascends into the bright light. The bystanders lend extra dramatic force to the resurrection. The man opposite Christ mirrors the hand gesture, the thrust of Martha's head suggests a forward leap. And a man behind Christ wrings his hands, just like Judas in the painting by Rembrandt for which Huygens had such boundless admiration.

The 1656 inventory of Rembrandt's property includes both a *Raising of Lazarus* by himself and one by Jan Lievens. Did he keep the two as a vivid memento of their contest?

Rembrandt did extremely well out of the introduction to the court that was engineered by Huygens. Together, Stadtholder Prince Frederik Hendrik and Amalia van Solms ordered a total of thirteen paintings from him. The 1632 inventory of their property includes *Simeon in the Temple*, "made by Rembrandt or Jan Lievens", *Minerva in her Study*, *The Rape of Proserpine* and *Andromeda*. In 1633, Rembrandt painted the portrait of Amalia, a profile as on a coin—that was to serve as the pendant to the portrait that Gerrit van Honthorst made of Frederik Hendrik.

As early as 1629, probably right after Huygens's visit to Leiden, the stadtholder purchased two paintings by Rembrandt—a self-portrait with a gold chain and an old woman with a veil—and two by Lievens. It should be noted that the attributions to Rembrandt have been questioned: the self-portrait may be a studio copy by Jouderville and the "old woman with a great shawl" is believed by some experts to have been made by Lievens.

Frederik Hendrik gave the paintings to Sir Robert Kerr, Lord Ancrum, as a gift to King Charles I of England. Kerr had been sent to The Hague as an envoy after the eldest son of the Winter King, the Elector Palatine Frederick v, had been killed in a tragic accident. The Winter King was married to Elizabeth Stuart, a sister of Charles I. In other words, the king has lost his nephew, and the pictures by the noble young painters were presented to him as a small token of comfort.

The young prince had drowned when he and his father sailed from Spaarnwoude to Amsterdam to go and see the treasures of the Silver Fleet that Piet Hein had seized as booty from the Spanish in the Battle in the Bay of Matanzas, present-day Cuba. It was a foggy day, and the ship carrying the Winter King and his son to Amsterdam collided with a fishing boat. Fire broke out and the panicking passengers jumped into the water. A servant barely managed to save the Winter King's life. His son drowned.

In the summer of 1631, Rembrandt and Lievens were each commissioned to make portraits of one of the Winter King's other sons. The young princes were then living in Leiden, in the Prinsenhof, on the corner of Rapenburg and Langebrug. In 1628 they enrolled at the university. The two painters each produced a *portrait historié*, depicting the princes in the form of a biblical and historical figure respectively. Rembrandt painted Prince Rupert in Oriental costume with his teacher—we do not know his identity—in the manner of *Eli Teaching Samuel* (1 Samuel 1:24). Lievens portrayed Karl Ludwig, dressed in a classical, gold satin

cloak, with his teacher Wolrad von Plessen as *Aristotle Teaching the Young Alexander the Great*.

The evidence strongly suggests that Rembrandt did not complete his *portrait historié* himself. The detailed execution of the velvety cloak and the almost polished face of the young prince point to the hand of Gerrit Dou. X-ray photographs reveal that the teacher's frowning forehead was initially more brightly illuminated and that less attention was paid to his pupil's face. Did Rembrandt's client want it to be the other way around? It is striking: in the painting that depicts education, Rembrandt allowed his best pupil to add the finishing touches.

All these commissions arose from that first studio visit by Constantijn Huygens. However, there was someone else who was extremely important for Rembrandt. It was one of the "most excellent friends" of the brothers Constantijn and Maurits Huygens: Jacques de Gheyn III, who was known as Jacob, the son of the extremely affluent and highly esteemed court painter Jacques de Gheyn II. As a result of his father's success, Jacob grew up in luxury. He proved to have a great talent for etching. "He made an overwhelming impression," wrote Huygens, "arousing expectations that the whole of Italy might envy."

We do not know whether De Gheyn Junior introduced the Huygens brothers to Rembrandt; perhaps it was vice versa. In any case, Jacob visited Rembrandt's studio in the late 1620s and managed to procure two paintings there. The inventory

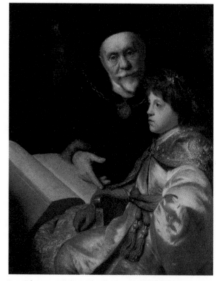

Prince Rupert of the Palatinate and his Tutor as Eli and Samuel, c.1629–30.

Jan Lievens, *Prince Charles Louis with his Tutor,* 1631.

accompanying De Gheyn's last will and testament included a painting with this description: "two old men sit debating, one with a large book on his lap illuminated by sunlight". Even the notary was struck by the play of light in Rembrandt's painting of Peter and Paul engaged in a dispute.

The other painting in the will—both works were bequeathed to De Gheyn's nephew Joannes Wtenbogaert—was described as "an old sleeping man, sitting by a fire, his hand pressed to his chest". The flames cause shadows and shimmering shapes to appear and disappear on the wall. Rembrandt's black-in-black in the background is superb.

Every seventeenth-century viewer would immediately have understood which sin Rembrandt was depicting in that painting: it was "sloth", or idleness. It just so happens that Huygens, a true moralist who never ceased to emphasize, when relating his childhood memories, how important it was for a young man to lead a pious, virtuous and industrious life, whipped himself up into a frenzy of indignation about this indolent artist.

Jacob did not have to work for a living, and so he did not. "That someone who was evidently born in the Netherlands that he might be for all eternity a pearl in the crown of his fatherland", grumbled Huygens in his memoirs, "could so bury his talent and sink into a fruitless, dishonourable idleness."

His lackadaisical friend threw such criticism to the wind. On one of the rare occasions on which he did finish something, he made an etching that might have been entitled "In Praise of Idleness". A young man has pulled the hood of his cloak down over his eyes and sits, deep in delicious sleep, surrounded by clouds of opium fumes. Beneath the print is a French quatrain praising sleep as the beneficent state that levels shepherd and king ("Le bouvier & le Roy"), while mellowing and calming a mournful soul.

The print must have driven Huygens to despair. "Yet I do not relinquish hope that you, most magnificent of my friends, will turn once more to the seedbed where slumber the germs of fame, I refer to your brilliant talents."

It is not inconceivable that Huygens may have taken Rembrandt aside and urged him to adopt some strong-arm measures to jolt Jacob out of his torpor. The idler's fate could easily be foreseen, if he failed to mend his ways: slumped and snoring in his chair, in grimy clothes and reduced to penury. His life, like the little fire in the painting, was emitting its final flicker. The painting may well have been intended as a satire.

In Rembrandt's Leiden years, he had been on excellent terms with Huygens. But the moralism of the prince's secretary, as well as his uncompromising views

of the role and style that he expected the painter to adhere to, would strain their relations. And eventually sour them.

The first sign that all was not well can be seen in the satirical poems that Huygens wrote in 1633. Rembrandt had painted his brother Maurits and Jacob de Gheyn in two friendship portraits. Outbursts of mischievous humour? Or did Constantijn really dislike the portraits? He wrote that the "skilful painter" had looked "askance" at his subjects and the portrait of De Gheyn was a poor likeness. Roughly rendered into English:

> Whose face is this? Anyone who buys it
> Can say it's his but none that the features fit.
> Or:
> Rembrandt's hand, De Gheyn's picture.
> Marvel, reader, none of De Gheyn's features.

Huygens may have become irritated at the way in which Rembrandt's art was developing. He had foreseen a great future for the artist: as a history painter at court, the same kind of role that Rubens played in Antwerp. For Lievens he had in mind a more modest role as a portraitist. However, in the early 1630s, when he was spending more and more time in Amsterdam, it was in fact Rembrandt who made more of a name for himself as a portrait painter.

Huygens ordered two paintings from Rembrandt at the same time—both destined for the stadtholder. They were a *Raising of the Cross* and a *Descent from the Cross*. They were to be based on the paintings of these classical devout themes by Peter Paul Rubens. It was no easy task for Rembrandt to surpass the works painted in 1610 and 1612, which hung in the St Walburgis Church in Antwerp—if only because Rubens's paintings were twenty-five times bigger than the modest-sized panels that Huygens had ordered from Rembrandt for the stadtholder's quarters in the Binnenhof.

In 1633, Rembrandt delivered the two piercingly realistic paintings, in which he did not shrink from according a prominent role to himself. In the *Raising of the Cross* the painter, wearing his blue beret, stands beside the nailed, bleeding feet of Christ.

Why would Rembrandt have done this? To start with, it was a way of placing himself on the wall of Frederik Hendrik's gallery. He could be certain that he would be recognized there by the most powerful figures at court, wealthy art lovers and potential clients.

Portrait of Maurits Huygens, 1632. Portrait of Jacques de Gheyn III, 1632.

His motives go further than that, however. It appears to be a confession. As if the painter were declaring, as in a poem that was well known at the time, "He Bore our Griefs" by Jacob Revius (1630), that he shared in the responsibility for the death of Christ: "No, it was not the Jews who crucified you, Lord Jesus," wrote Revius. And a few lines further on: "I am the one, O Lord, who brought you there."

In the *Descent from the Cross*, one of those who helps cautiously to take Christ's body down from the cross has the face of Rembrandt. He holds his cheek tenderly against the abdomen of the leaden corpse. Here, the painter plays a supportive rather than a guilty role. In both cases, he displays his personal involvement. In his world, Christ's Passion was a living event. Faith and life were inextricably intertwined.

Satisfied with the result, the stadtholder ordered three new paintings, to depict the Ascension, Entombment and Resurrection of Christ. But with this commission, something strange happened. Rembrandt took an astonishing six years to complete the paintings. He also grumbled about the size of the fee and the time it took for him to be paid, all of which aroused the irritation of Constantijn Huygens.

Did Rembrandt obstinately take his time, thinking and experimenting as long as he wanted until he was satisfied? Did he consider the prince's commission less important than the lucrative portraits of burghers that he was producing in his new city of Amsterdam? It was not until 1639, when he had bought an extravagant

house in Anthonisbreestraat—now the Rembrandt House—and needed money, that he sent them to the court in The Hague. The paint was still wet.

The financial negotiations and the foot-dragging were a painful issue for Rembrandt but a blessing for his biographer: because of them, we have seven letters from Rembrandt to Constantijn Huygens, from early 1636 to the end of 1639. They are the only letters from him that have come down to us. Notwithstanding their businesslike subject matter, he reveals his character in just a few words.

On 12th January 1639, Rembrandt reported that *The Entombment of Christ* and *The Resurrection of Christ* had been completed with the aid of "studious diligence". The *Ascension* was yet to be finished. It had taken so long, wrote Rembrandt, because he was straining after the "greatest and most natural moving quality".

What did those words mean? Did Rembrandt seek to depict the most natural movements? It is certainly true: the men guarding the grave tumble off in all directions in terror and astonishment when an angel lifts the lid of the sarcophagus and Christ rises from inside.

Or did he mean it figuratively? Did he seek to move the emotions of the viewer? In my view, that seems also to be true.

Although Rembrandt eventually succeeded masterfully in moving everyone, with his discourteous behaviour he had blotted his copybook with Constantijn Huygens. The relations between the painter and the powerful secretary never really recovered.

For Rembrandt, the Passion series had become his own Via Dolorosa.

Raising of the Cross, 1645.

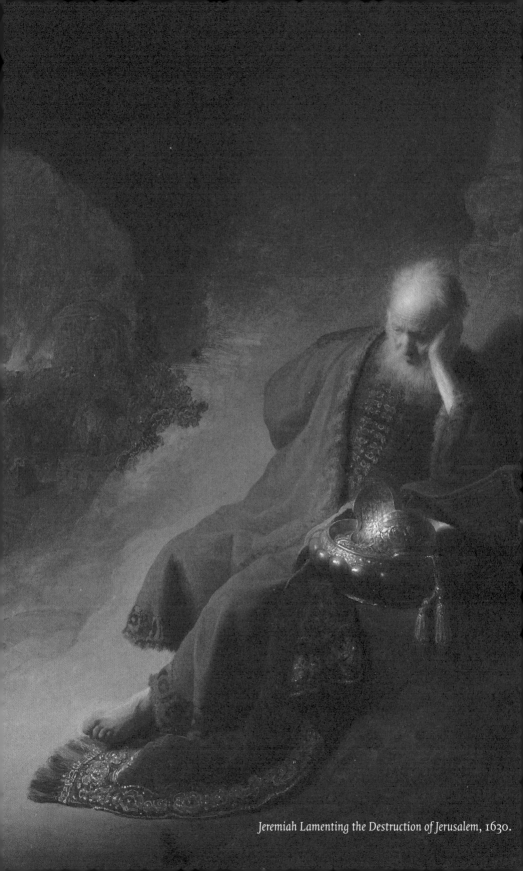

Jeremiah Lamenting the Destruction of Jerusalem, 1630.

15

Eyes shut

ON 27TH APRIL 1630, REMBRANDT'S FATHER HARMEN WAS BURIED, having died at the age of sixty-three. His son would reach the same age. Although the cause of death is unknown, the miller had evidently lived his last years in a frail state, given that poor health had caused him to step down as neighbourhood master or *buurtheer* six years before.

Harmen was buried in the family grave in the Pieterskerk. It has always been assumed that the Van Rijn family grave was somewhere in the "middle church", the central part of the Pieterskerk nave, but it was never known exactly where. Collating the church's burial book for 1610 with the personal archives of a Leiden mathematician and amateur historian, Robert Oomes, which include a seventeenth-century floor plan with numbered graves, we can infer the precise location: right under the pulpit.

In the time that the windmills still stood outside Leiden, and millers lived beyond the formal city limits, Rembrandt's ancestors attended Mass at the Church of Our Lady every Sunday. They belonged to the confraternity and sorority of St Victor, patron saint of millers, who died as a martyr, according to legend, by being cast into the water with a millstone around his neck. The millers had their own altar in the church, above which hung a triptych depicting the drowning Victor and a tabernacle with gold and silver chalices and candlesticks.

All this changed after 1573, with the death of Gerrit Roelofsz, Rembrandt's grandfather, and the blaze that destroyed his windmill. His widow Lijsbeth remarried and went to live in Weddesteeg. She and her new husband, the miller Cornelis van Berckel, now lived within the city walls, in the parish of the Pieterskerk. Their son Harmen abandoned the Catholic Church and converted to Protestantism.

In 1610, the church wardens approved a drastic operation. Since the tombstone floor was damaged, they decided to replace broken slabs, straighten others and renumber each grave. A new grave book was started that year, and Harmen and his stepfather are both mentioned as owners. On 18th March 1611 they went to the church in this connection. The note beside number 60 in the middle church reads:

"belongs to Harmen Gerritsz, miller", while number 71 in the same section reads "belongs to Cornelis Claesz, miller".

These two graves, as is clear from the resurfaced floor plan of the church, lay end to end: the foot end of number 60 touched the head end of 71. That was no coincidence. It was good to know that you would be lying together after death, just as families lived together in Weddesteeg.

Furthermore, the proximity offered a practical advantage. Four coffins could be stacked in each tomb. If there was no space for a new deceased, it was permissible, some ten years after a relative's death, to flatten their coffin. But if the dead piled up too quickly, during an epidemic or following instances of child mortality, you could hack a hole in the partition between the two graves through which to push a coffin into the other space. At funerals, when the stone slab was lifted, the stench must have been unbearable.

In their grave number 60 in the middle church, Harmen and Neeltje had buried two young children not long before Rembrandt's birth. In 1625 their daughter Machtelt succumbed to the Plague. On 21st January 1627, Grandfather Cornelis had been interred in his final resting place in mid-section number 71, one place farther to the east, his head facing towards Jerusalem.

On 27th April 1630, Harmen's coffin was carried from Weddesteeg along Noordeinde and Rapenburg to the church, in the presence of his wife Neeltje, their sons and daughters, other relatives and in-laws. When the funeral procession reached the square outside the Pieterskerk and approached its massive open doors, the bells tolled.

The death of his father must have been a profoundly sad and existential experience. He made a drawing of the old man in red and black chalk, with a brush and bistre. Beneath the portrait, in the middle, he added a caption, as if chiselled into a gravestone:

HARMAN. GERRITS
Van den Rhijn

Is this drawing of Rembrandt's father, with a long grey beard, sunken features, eyes closed, a posthumous portrait? Harmen appears to be seated rather than lying down. Why, then, are his eyes shut?

It has been suggested that Harmen had gone blind, but there is no evidence for this in the testimony, notarial or neighbourhood registers. It is striking how frequently Rembrandt depicted blindness: poor Tobit, who lost his sight after a

Portrait of his Father (detail), seventeenth century.

sparrow defecated in his eye; the horrific scene in which Samson's eyes are gouged out. It must have been his greatest fear. How could it be otherwise for a painter whose everything came from the light in his eyes?

The father in *The Return of the Prodigal Son* from 1668, painted a year before Rembrandt's own death, appears to be blind. Without wishing to claim that Rembrandt was depicting his own father or that he consulted his drawing of Harmen while making his painting, Rembrandt must have felt an affinity with this theme. Had he not, as the youngest son, had opportunities that his elder brothers had lacked? Had his father not always supported him, even when he was sent down from the university and decided to be a painter?

Given the use of different materials and the unusual signature, the 1630 drawing of Harmen may have been created at two different moments in time. That might mean that Rembrandt, having come upon his father in his chair warming his bones at the fireside, dashed off a quick chalk drawing of him. Then, when his father was dead, he closed his eyes—on paper—in a tender gesture.

Art historians are still debating the question of whether Rembrandt ever drew, etched or painted his father and mother. And if so, in which works we can see them.

It was not uncommon for painters working in the sixteenth and seventeenth centuries to depict their relatives. Isaac Claesz van Swanenburg produced beautiful, stately portraits of his wife and close family members—and of himself. When Otto van Veen briefly returned to Leiden, he painted himself, standing in front of his panel with a paintbrush, at home on Pieterskerkhof, surrounded by his parents and siblings.

Throughout his life, Rembrandt also tried to find models in his immediate surroundings. He sometimes portrayed them "after life", but he usually had his relatives and loved ones pose for a *tronie*, in which it was not necessary to produce a likeness. He immortalized Saskia in paint not only as his wife, but also as Flora. He depicted his last wife, Hendrickje Stoffels, asleep, with a few perfect strokes of his brush—perhaps the most beautiful drawing in the world—and bathing as the pregnant nymph Callisto.

Why would the young Rembrandt *not* have asked his father and mother briefly to sit for him? They would not have needed to go anywhere. Even during his lifetime, the assumption was made that he did ask them. In 1644, a painting was recorded in a Leiden inventory, of the property of one Sybout van Caerdecamp, that depicted "a *tronie* of an old man, being the portrait of Mr Rembrandt's father".

Rembrandt's Mother Seated at the Table, 1629–33.

Sheet of studies with three heads of an old man, 1628–32.

And the 1679 inventory of the shop on Kalverstraat in Amsterdam run by the art dealer Clement de Jonghe includes two etching plates entitled "Rembrandt's father" and "Rembrandt's mother". De Jonghe knew the painter very well, and based his assertion on information gained at first hand.

The etching described as a portrait of "Rembrandt's mother" depicts an old woman who turns up with striking frequency in the master's early work. The woman has a head like a wrinkled apple and a somewhat pinched, pointed nose.

In the etching that was sold in Clement de Jonghe's shop, this old woman holds her blue-veined hand on her heart. She features in quite a number of etchings. In the best-known one, she sits at the table, hands folded in her lap, a black veil over her head. Is she in mourning? That etching was made in 1631, the year after father Harmen's death.

The old woman features, for instance, in the background of *Suffer Little Children to Come unto Me*, and as Anna, with the little kid under her arm, in *Tobit and Anna with the Kid*. In 1631 Rembrandt painted her again. She is wrapped in a dark cloak and a veil woven with gold thread. Engrossed in a book, she leans slightly forward and gropes her way through the letters—we cannot read them, but they appear to be Hebrew—with the fingers of her wrinkled and time-gouged hand.

Is this the prophetess Anna? In St Luke's Gospel we read that she was a widow of about eighty-four years of age. The ancient woman regarded Christ as the Messiah after she had seen him as a baby in the temple. Anna was "the personification of Faith".

Gary Schwartz does not think that Rembrandt's mother posed for this Anna. He compared the old woman to the portrait of Aeltje Pietersdr Uylenburgh, an aunt of Saskia's, who was only two years younger than Rembrandt's mother when he depicted her and still had fresh apple cheeks. "The old woman is at least ten years older than Neeltje's sixty-three or sixty-four years in 1631."

Does not one person age far more quickly than another? Can time not leave its merciless imprint on a face? Or did Rembrandt make his model older than she was? It is impossible to prove. It is a question of what you choose to believe.

What is certain is that the portrayal of decay held a certain fascination for Rembrandt. He regarded *tronies* of old men and women as more "painterly" than smooth young faces on which life had not yet left its traces. He was energized by the furrows in the faces of elderly men and women.

Many of the *tronies* and history paintings that Rembrandt made have a melancholy air about them. In 1631 he depicted the grieving prophet Jeremiah. A painting as a lamentation: the prophet rests his head on his left hand, eyes cast down. The

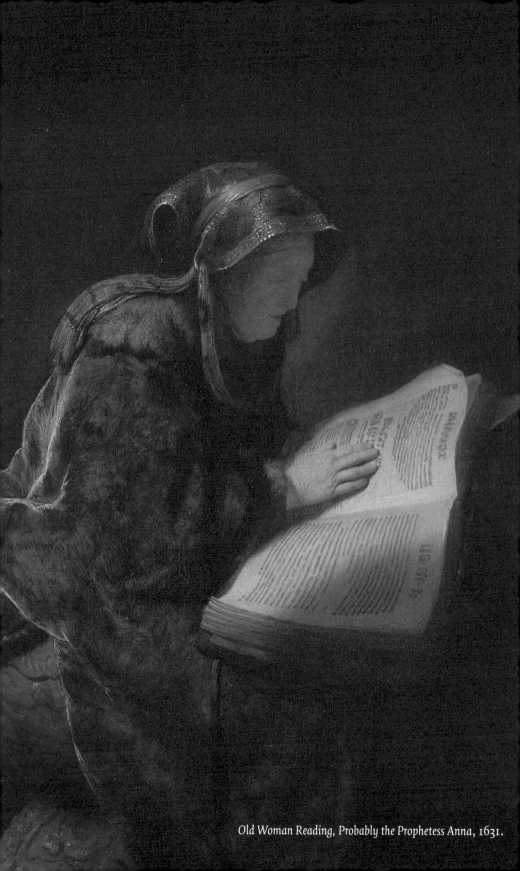

Old Woman Reading, Probably the Prophetess Anna, 1631.

light catches the lines of anguish in his forehead. Behind Jeremiah, in the distance, Jerusalem is ablaze.

Was Rembrandt in the throes of melancholy? Leiden was not being consumed by flames, but after his father's death he must have felt that there was little left to keep him there. That he was now truly a prodigal son.

Times were bad, the economy was stagnating. Many painters went in search of other places to market their talents. Jan Davidsz de Heem left for Haarlem. Jan van Goyen moved to The Hague. Prices for paintings were low in Leiden, since there was still no St Luke's Guild to protect its members.

Rembrandt's work was expensive. The fee he received for his paintings at the court in The Hague was far more than anyone in Leiden could afford to pay. He was never granted a single official commission by the Calvinist government of his native city—not only because the city's coffers were almost empty, but also, perhaps, because of his ties with leading Remonstrants. In inventories of people's property drawn up in Leiden in that era we scarcely come across a single one of his paintings, while works by Jan Lievens are found in abundance.

Yet even Lievens left Leiden, moving in 1631 to London. According to Orlers, he wanted to learn the customs and traditions of a different country. Lievens may himself have told his old neighbour from across the road that he "instantly became famous for his works of art" among the élite in London, where King Charles I and the Prince of Wales held their court.

Did Lievens spread his wings and soar, or skulk off with his tail between his legs? For years, Rembrandt had followed him when choosing subjects, developing new styles and techniques. More recently, however, they had been locked in ever fiercer rivalry—depicting the raising of Lazarus, making their historicizing portraits of the Winter King's young sons, in tronies and etchings—and in these contests, Rembrandt had surpassed him.

It is unclear how Lievens reacted to this. Was he envious? According to Huygens, Lievens had "too much self-assurance": "any criticism was either roundly rebuffed, or, if he conceded its veracity, borne ill". That cannot have helped.

Wherever Lievens went, he adapted his style to the prevailing fashion. In London that meant emulating Anthony van Dyck, the court painter of Charles I. After three years in London he moved to Antwerp, where he produced fashionable genre paintings and got married. Ten years later he finally settled in Amsterdam.

From 1644 onward, he and Rembrandt were once more living in the same city, but we cannot be sure whether the old friends renewed their acquaintance. It cannot be ruled out: the inventory of Rembrandt's property drawn up in 1656 contains a

great many works by Lievens: the list includes a remarkable nine paintings, a mix of landscapes and figurative pieces, and a folder containing etchings and drawings. Did he keep them out of a sense of nostalgia? It seems likelier that Rembrandt bought and sold Lievens's work, just as he traded work by Brouwer, Porcellis and Hercules Seghers.

The final piece of evidence of creative rivalry between the two friends is the adaptation of an etching. Rembrandt printed the contours of a number of Lievens's *tronies* on an etching plate and proceeded to freely elaborate them. In the etching plate of the *tronie* of an Oriental figure whom he had endowed with a richly decorated turban, he scribbled: "Rembrandt geretuck [retouched] 1635".

Irretrievably improved by Rembrandt.

On 20th June 1631, Rembrandt visited the notary Geerloff Jellisz Selden in Amsterdam to lend the art dealer Hendrick Uylenburgh "the sum of ten hundred guilders". A thousand guilders. This indicates that Rembrandt was a man of means. The terms applicable to the loan to Uylenburgh were recorded by the notary—five per cent interest and repayment within five years—but the transaction itself meant in fact that Rembrandt was buying a share in the art dealer's business. Uylenburgh frequently borrowed money with which to buy paintings that he then sold at a profit. He was a successful businessman with an impressive clientèle.

Uylenburgh was the son of a Frisian painter who had fled to Poland because he was a Mennonite. The Mennonites were radical Protestants who repudiated all violence and who were persecuted in the Netherlands. They found a safe haven in Poland. Hendrick's father became a successful painter at the court in Kraków and trained his son in the same profession. Hendrick mediated in art purchases for the Polish king.

In the 1620s, Hendrick dared to return to Amsterdam. In 1625 he purchased a building on Breestraat—the house right next to the locks—where he set up his studio and gallery. That was the very year in which Rembrandt was studying under Pieter Lastman, in the selfsame street. He may have met Uylenburgh in that early period. The talent of the nineteen-year-old apprentice would not have escaped the art dealer's notice.

Uylenburgh was in Leiden in March 1628 to prevent the sale of some of the paintings from his brother's estate in Leiden. A month later, a man from Leiden ordered several paintings from him. Was the art dealer visiting Rembrandt's studio at the time? It is possible that this was the point at which Uylenburgh started mediating in sales of Rembrandt's work.

The Third Oriental Head, after Jan Lievens, 1635.

Marten Soolmans (1613–41), 1634.

Oopjen Coppit (1611–89), 1634.

In his accounts, the wealthy Remonstrant Amsterdam patrician Joan Huydecoper noted down that he had purchased a *tronie* from "warmbrant" for twenty-eight guilders on 15th June 1628. (He then deleted his misspelling and wrote "rembrant" instead.) Huydecoper lived diagonally opposite Uylenburgh in Breestraat. What could be more likely than that the art dealer had mediated in the sale?

In the summer of 1631, the painter and the art dealer agreed to conclude a closer business relationship. Uylenburgh would procure commissions from wealthy burghers for individual and group portrait paintings, and Rembrandt would paint them.

From then on, Rembrandt was less and less often to be found in Leiden. He made frequent journeys to Amsterdam by ferry boat. After 1632 he was able to travel from Haarlem in the comfortable barge that navigated straight canals to the capital. The service had become a good deal faster and more reliable, and he could now also use it to ship packages, letters or paintings. Goods and post would arrive the same day. The transport of a chest would cost six to eight stivers, depending on its size.

When he was working on an Amsterdam commission, he would lodge with Uylenburgh and his family. In the first two years, Isaack Jouderville often went along on these journeys as his companion and assistant. Isaack's guardians always paid his travel expenses. Jouderville made sure that he always returned to Leiden, since he would otherwise forfeit his status as a burgher of the city and be required to pay ten per cent in taxes on his property.

Gerrit Dou initially remained behind to work in Rembrandt's studio, but started up for himself in 1632 on Galgewater, where he achieved miraculous effects in the north light of his dustless attic with a brush composed of two or three tail-hairs of a marten. With their meticulously rendered details, his little paintings suggested depth but were as smooth as a mirror.

It seems likely that the first portrait that Rembrandt produced in Uylenburgh's studio was that of Nicolaes Ruts in the autumn of 1631. Ruts was the son of Mennonite immigrants from Flanders who later became a Calvinist. He traded with Russia and Rembrandt therefore dressed him in a superb fur cloak and a fur hat. In January 1632, Rembrandt made a portrait of Marten Looten, who had been raised Calvinist but had converted in the opposite direction, becoming a Mennonite, bringing him into contact with Uylenburgh.

Looten had grown up in Leiden, where his parents worked in the cloth trade. He had moved to Amsterdam as early as 1615, so Rembrandt would not have known him. But there were others whom he knew from his Leiden days. They may have

included Marten Soolmans, for instance, whose portrait Rembrandt painted in 1634, on the occasion of his marriage to Oopjen Coppit.

Rembrandt painted Marten and Oopjen in two life-sized, full-length pendants—as princely rulers. Their garments were no less lavish than those of Princess Amalia, the wife of Frederik Hendrik, whose portrait Rembrandt painted in 1633. Oopjen wears a dress of napped black satin with a brilliant lace collar, while Marten sports a ribbed silk suit, a black hat, an equally magnificent collar, silver silk garters around his legs and the largest rosettes that had ever graced a pair of shoes. "A symphony in black and white" was Theophile Thoré's apt description of the companion pieces.

Marten's father, Jan Soolmans, was an Antwerp merchant who traded in Spanish goods and had taken refuge in Amsterdam. He ran a sugar refinery on Keizersgracht. Marten's mother, Wilhelmina Salen, was his second wife. Soolmans senior was fabulously rich, and an extremely unpleasant man. Church council records for 1624 document the "great turmoil in his relations with his wife", noting that he had "beaten her and also injured his daughter".

His father died in 1625, when Marten was aged thirteen. Three years later, the young man started studying law in Leiden and took lodgings on Rapenburg. He probably lived at number 55, part of the former Roma convent, the home of the Remonstrant family the Knotters. That was close to Rembrandt's own house. The painter and the law student must have met at De Drie Haringen, on the corner of Noordeinde and Rapenburg. That was the inn that Isaack Jouderville's father, Rembrandt's pupil, had run for almost twenty years, albeit under the name of 't Schilt van Vrankrijk. When the old Jouderville died in 1629 and his son Isaack stayed on living above the business, the inn was given back its old name and rented out to one Dionys Dammiansz.

This innkeeper crops up in a book of testimony records in Leiden's city archives. He was the victim of a gruesome attempt on his life. One summer's day in 1630, he had been attacked by a publican and his drunken wife outside the west city wall, on Rijndijk near the Valkenburg ferry. The publican set about the innkeeper with an axe and his wife beat him with a club, causing "injuries to the head". Blood spurted in all directions.

Marten Soolmans and his fellow student Johannes van der Meijden—son of the burgomaster of Rotterdam—witnessed the attack. The latter went to the innkeeper's assistance and managed to overpower the man with the axe. Beneath the witness statement, drawn up in the presence of the notary Pieter Oosterlingh, the signatures of the two law students are still clearly legible: Johannes van der Meijden and "Martinus Soolmans".

Four years later, the painter signed his portrait of Soolmans, on the left beside the silver silk garter around his leg: "Rembrandt f... 1643" (the "f" stands for *fecit*).

There is another place in the archives where Rembrandt and Soolmans almost touch. On 24th March 1631, the notary Karel Outerman drafted a document for Marten's mother Wilhelmina, who had gone to live with her son on Rapenburg, to arrange the sale of one house in Amsterdam and the management of another. That same day, the same notary, along with his colleague Dirc Jansz van Vesanevelt, drew up a separate document for a *tontine*.

A *tontine* was a collective annuity insurance. A hundred people would deposit a set amount. The deed does not specify the precise amount, but it must have been a large sum—some 100 guilders. A year later, a check would be performed to see which of the participants were still alive, after which the total would be divided among the survivors. The *tontine* was drawn up at the request of Gilles Thymansz van Vliet, "corn merchant within this city", the father of the etcher Jan Gillisz van Vliet. The second person on the list is "Master Rembrandt Harmenszoon, painter."

This document shows us at a glance the kind of circles that Rembrandt—who was evidently known as a "Master"—frequented in Leiden. Aside from a single maidservant, the list consists largely of young people from affluent Remonstrant families, who were in the ascendancy in seventeenth-century Leiden.

Let us look at a few of the other names on the *tontine* list: Silvester and Cornelis van Swanenburg, the son and brother of Rembrandt's first teacher; Caspar Barlaeus, who had been dismissed from the university after Prince Maurits had changed the composition of the executive, had lodged with the Viet family and was appointed that year to a chair in philosophy at the newly founded Athenaeum Illustre in Amsterdam; the Mennonite preacher Jan le Pla, who came from a wealthy family and owned several buildings on Breestraat, at least one of which had a painting by Rembrandt hanging on the wall; Yeffgen Adriaensz van de Werff, a descendant of one of Leiden's burgomasters during the siege; Pieter Pauw, son of the professor and anatomist who taught the first classes in anatomy; and Lijsbeth Wijbrantsdr, the mother of the painter Jan Steen.

The *tontine* produced something else rather wonderful. The notaries undertook in the deed to "see or speak to each of the 100 people" on the list one year later. And it is because of this that we can meet Rembrandt in the flesh, on 26th July 1632.

That day, the notary Jacob van Zwieten was despatched to the house of Hendrick Uylenburgh in Amsterdam to check if the painter was still alive. Van Zwieten knocked on the door at the gallery in Breestraat next to the locks at St Anthoniesluis.

When one of Uylenburgh's young daughters appeared, the notary asked her whether "Mr Rembrandt Harmensz van Rijn, the painter [who was lodging at that address] was at home and available".

The little girl nodded and went to fetch him. The painter appeared in the front part of the house, where Van Zwieten asked him formally if he was the painter.

"Yes," said he.

The notary asked if he was "hale and hearty".

Rembrandt replied: "Yes indeed. Thanks be to God, I am in good spirits and in the best of health."

It is clear from the notarial deed that Rembrandt was lodging only temporarily with the Uylenburgh family. He had not relinquished his studio in Leiden, but was rarely to be found there. It seems likely that after the death of his eldest, unfortunate brother Gerrit, who was buried on 23rd September 1631, he rarely returned to his native city.

We assume that he immediately returned in the barge from Amsterdam when he heard that his mother had died. That he attended the burial in the Pieterskerk, when her coffin was lowered into the family grave to the accompaniment of tolling bells on 14th September 1640. But whether he also went to the funeral of his brother Adriaen in 1652 is not known for certain.

Rembrandt rarely left Amsterdam because he was deluged with work there. There was also another reason: that was where he had met his future wife, the beguiling, vibrant Saskia van Uylenburgh, Hendrick's cousin, the youngest daughter of the wealthy burgomaster of Leeuwarden. They probably met in the spring of 1633, when Rembrandt had completed his striking portrait of Saskia's aunt, the church minister's wife Aeltje van Uylenburgh. The old lady makes a remarkably alert impression, with soft facial features and a twinkle in her eye. Saskia must have been struck by the portrait of her aunt and by the young painter who had made it.

On 9th June 1633, three days after they had announced their intention to marry—in what was seen as a binding vow to God—Rembrandt made a drawing of his wife-to-be. Silverpoint on vellum. "The third day of our betrothal", he wrote beneath it. He placed an elegant hat on Saskia's head, gave her a rose to hold and drew a smile hovering around her face that vied with that of the Mona Lisa.

In 1631, Rembrandt had made a full-length painting of himself as an Oriental. In this portrait, the artist wears a shiny gold robe, a dark velvet cloak and a turban sporting a frivolous feather. Rembrandt's pupils had told Arnold Houbraken that the painter was capable of spending two days "arranging a turban exactly as he wanted it".

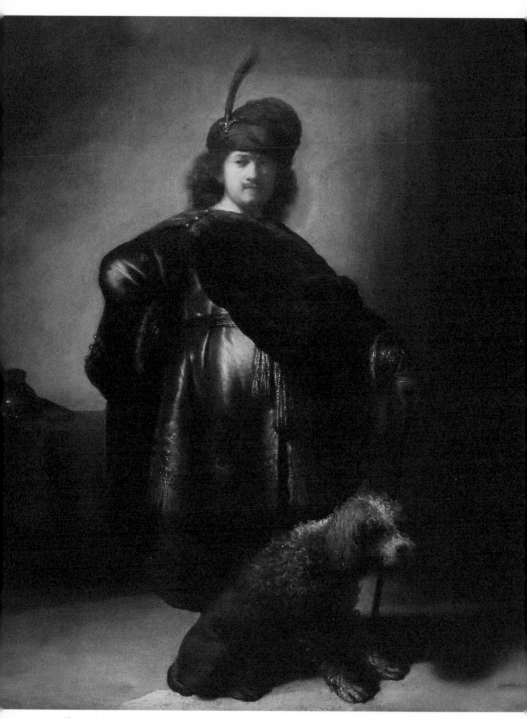

Self-portrait in Oriental Attire, 1631.

At the artist's feet lies an unusual Italian hunting dog: a Lagotto Romagnolo. With its fluffy curls, warm muzzle and the white stripe over his head, it steals hearts. Because of the breed's excellent sense of smell, these dogs were used as early as the fifteenth century to find truffles. They are keen swimmers and very adept at hunting ducks. In 1456, Andrea Mantegna painted frescoes on the wall of the bridal suite of the ducal palace in Mantua. One of them, entitled L'incontro ("The Meeting") features a Lagotto Romagnolo at the feet of Marquis Ludovico III.

Rembrandt's painting initially looked different. We know that because there is a copy of it without the dog—probably made by Isaack Jouderville—and because the X-ray of the original corresponds exactly to that copy. In other words, the animal must have been painted in later.

In the signature, "Rembrant f 1631", in other words, "Rembrandt made this", he spelt his name in full, but without the "d". The only period in which he used this spelling was towards the end of 1632 and at the beginning of 1633. He must have added the Lagotto Romagnolo in the spring of 1633. This painting once had a pendant, only a copy of which has been preserved, depicting Saskia in Oriental costume. Rembrandt placed the dog at his feet in Amsterdam, two years after painting his self-portrait in Leiden, as a sign of faithfulness to his future wife.

Orlers wrote that "the burghers and residents [of Amsterdam] derived pleasure and delight from Rembrandt's art" and that he was often being asked to make portraits and other pieces: "he therefore thought it right to move from Leiden to Amsterdam, and consequently departed from here".

His breakthrough with the general public was The Anatomy Lesson of Dr Nicolaes Tulp, painted in 1632. The people of Amsterdam must have been struck dumb with astonishment when it appeared at the new weighhouse, the old St Anthony's Gate, seat of the Surgeons' Guild. Rembrandt had transformed a picture of death into a lively group portrait.

In the upper floor of the old St Anthony's Gate building, at the end of the busy "artists' street", a specially refurbished anatomy theatre had been created. It was there that the praelector gave his second public dissection, which Rembrandt was to immortalize. On the cold morning of 31st January 1632—freezing temperatures were a prerequisite to obtain permission for the lesson, because of the body's decomposition—the painter donned a thick cloak and ambled over to the anatomy theatre from Uylenburgh's studio beside the lock, sketchbook under his arm. It was less than five minutes' walk.

Rembrandt chose not to depict the weighhouse or the dissecting room in his painting. He even left out the packed crowd of spectators. The composition did

not start to take shape until he contemplated the large canvas in Uylenburgh's studio. He moved the anatomy lesson to a darkly atmospheric, almost invisible setting. An ill-defined, murky underworld. He focused all his attention on the six surgeons and Dr Tulp, allowing the light to fall on the body.

Was Rembrandt startled when he saw the dead body lying on the dissecting table?

The convict to be dissected was a man from Leiden—indeed, it was someone that he may have known.

From the anatomy book, which has been preserved in the archives of the Surgeons' Guild, we know his name: Adriaen Adriaensz, known as "Ariskindt" ("child of Aris") or simply "Het Kindt" ("the child"). He was born as the son of a maker of baking pots from Leiden. In a book of judicial sentences dating from 1624, his age is recorded: "19 years of age". He was only a year older than Rembrandt.

Ariskindt had been "sentenced to death by hanging for his wantonness" the day before in connection with a robbery at the Herensluis. In stealing a cloak, he had attacked his victim so savagely that he would have killed him if the nightwatchman had not rushed to help and beaten the thief about the head with his pike.

Ariskindt was sentenced to death not only on account of this violent robbery, but above all because of his long and dreadful criminal record. During his interrogation, he was hoisted into the air with 200-pound weights suspended from his legs and left dangling in this way until he finally confessed his crimes: an endless list of thefts, burglaries and acts of violence.

The boy grew up in Leiden and ran wild from an early age. Ariskindt was not a clever thief and did not manage to conceal his crimes. He bought a chisel for ten stivers in Coornbrugsteeg to force windows. He was caught with his hand in the coat of a local gentleman. One night, a man found him in the cellar of his house, where he had broken in and lit a candle to look around.

In the book of judicial sentences, Sheriff De Bondt wrote in exasperated resignation on 16th January 1626 that Ariskindt had been arrested nine times, and four or five times he had been released "because of his youth and in hope that he might mend his ways". Might that have lent extra significance to his other nickname, "Het Kindt"? That he was incorrigible from earliest childhood and committed his first crimes when still young?

Rembrandt may have witnessed the event in 1625 in which an executioner tied the boy to a post on the square near Gravensteen and "flogged him vigorously with the birch", after which he was ordered not to show his face in Holland for twelve years.

Forgiveness or punishment: nothing helped. A year later, the miscreant was arrested once again. This time he was tied to a post in the field at Schoonverdriet with a "rope around his neck" and not just flogged but also branded with "the city's branding iron".

The keys of Leiden were burned into the young convict's skin. Rembrandt did not paint them.

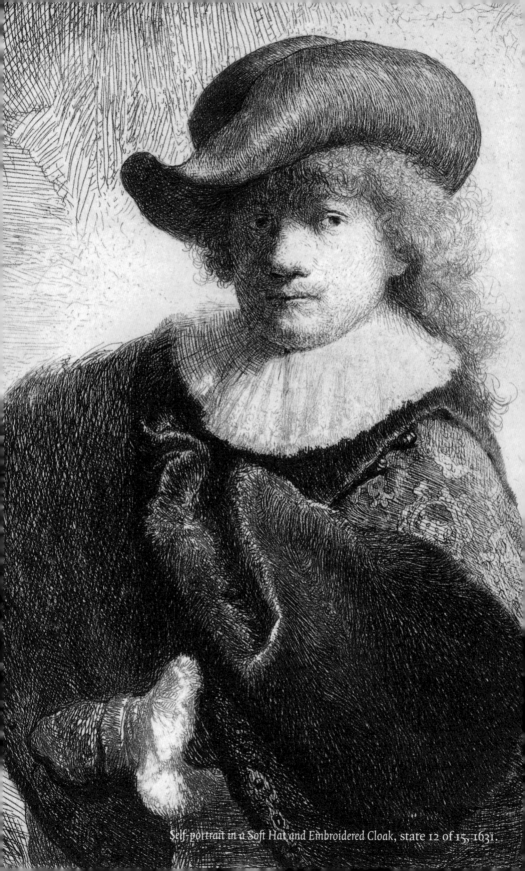

Self-portrait in a Soft Hat and Embroidered Cloak, state 12 of 15, 1631.

Epilogue

HOW DID REMBRANDT BECOME REMBRANDT?

That was the question.

Did he become one of the world's greatest artists as a function of the place where he grew up, what he experienced, learnt and saw in his surroundings, or was his development a highly personal, idiosyncratic inner adventure?

Constantijn Huygens thought it was the latter. In his opinion, Rembrandt's "consummate genius" had nothing to do with his humble origins. The miller's son had little of his father in him. Huygens saw the talent of Rembrandt and Lievens as the strongest possible evidence against the existence of a blood-based aristocracy.

"Had they been left to their own devices," wrote Huygens, "but had been fired by the urge to paint at some point in time, it is my firm belief that they would have achieved the same heights as now. It is wrong-headed to hold that their achievements can be attributed to the guidance of others."

Perhaps Rembrandt's exceptional talents, audacity and ambition were such that he would have become a superb painter if he had been born into an entirely different milieu. It is possible. But he was not.

He was born in 1606 as the son of a miller in Leiden. Rembrandt grew up in a large, loving family of tradespeople. His hard-working, prosperous parents appreciated the importance of procuring a good education for their youngest son. They sent him to the Latin school, in the hope of an academic career. He was a university student for at least two years.

Even so, when Rembrandt told his parents, Harmen and Neeltje, that he wanted to be a painter, they agreed to pay for his apprenticeship with two experienced, highly regarded masters. Once his apprenticeship was concluded, he set up as an independent artist—while living at his parental home, in his native city.

He grew up in the first university city of the Dutch Republic, where he came into contact with scientific discoveries, strange collections of objects, theological disputes, biblical, mythical and historical stories—all of which exerted a certain influence. They laid the foundations for the complexity of his thinking, encouraged him on his incessant, obsessive quest for new solutions to his artistic and intellectual problems.

That the mind of the young Rembrandt was sharpened for years at the Latin school and at university helps to explain how he was able to develop later so spectacularly as a history painter. His work attests to a profound knowledge and understanding of the biblical and mythological stories that he told in paint. He had a superb eye for detail, context, allusion and meaning.

The spirit of his most illustrious predecessor in the city, Lucas van Leyden, and of his two masters, Jacob van Swanenburg and Pieter Lastman in Amsterdam, kindled the fire of his imagination and set it ablaze. The boy wanted to be a painter. In the late 1620s he experimented as a true alchemist, working alongside his one-year-younger friend—and later rival—Jan Lievens, gradually developing his exuberant style: a palette of subtle, muted colours, with bold, constantly varying brushstrokes and a magnificent command of chiaroscuro. Rembrandt became the master of light and dark.

Huygens arranged valuable commissions for him at the court in The Hague. Rembrandt set up a successful workshop, and spread his fame by etching his own face and arranging for the distribution of those prints all over Europe. Since he saw too few opportunities in Leiden, because of the repressive religious climate and economic malaise, he travelled more and more often to Amsterdam in the summer of 1631, settling there permanently a year later. His youth was then behind him for good.

Leiden was a city full of contrasts. Proudly liberated and unconventional, but under the constant threat of war. Principled and multilingual, but narrow-minded, torn by religious strife. Founded on humanist principles, but ruled by strict Calvinists. Prosperous, but with a great many penniless labourers, orphans and beggars living with its confines.

Rembrandt lived with paradoxes on a daily basis. He was a product of his time and place in history, of his upbringing and education, but within this context he forged his own path—he was self-willed and headstrong. He was a working-class boy with an academic intellect and a razor-sharp intuition. Rembrandt was a realist, but in order to approach the effect of reality, he showed himself a master of illusion. He understood perfectly the ingredients of success, displayed unbridled ambition, but also dared to withstand the pressure of the prevailing fashions and moral dogmas.

As I was writing this book, I was struck by the painful relevance to today's world of the societal issues with which Rembrandt grappled. A young man growing up in Leiden in the twenty-first century also lives in a world in which war, intolerance, consumerism, immigration and religious extremism loom large.

Rembrandt made those themes timeless by adopting a human, intimate, personal perspective in his work. He is not only the painter of outward appearances but also—and most notably—of the inner life. His work, especially his self-portraits, provides insight into human nature in an age in which ideas about the individual and self-awareness, science and artistic skill were developing at lightning speed.

When Huygens went to see the "two noble young painters" in their studio, he advised them, as he had previously advised Rubens, to keep an accurate inventory and description of their works. "In these records," wrote Huygens in the memoirs of his younger years, "for each painting, after first giving a brief account of their working methods, they should indicate—for admiration and instruction down the ages—how and why they had designed, composed and elaborated it."

What a wonderful thing it would have been if Rembrandt had indeed kept a book like that for future generations. Then we would have known all sorts of things about him instead of constantly groping in the dark. It is a paradoxical desire: we strive to solve the enigmas surrounding Rembrandt, and yet what is more deflating than a solved mystery?

In my quest for his childhood I caught glimpses of what drove him. Now that I have seen those bright flashes, I look at the young master differently.

There he is. Vigorous and vulnerable. Self-assured, but slightly diffident. His clothes were intended to prove that he knew perfectly well, with his upturned little flaxen moustache, how things were done. Here the young artist poses on a single

Self-portrait in a Soft Hat and Embroidered Cloak, state 6 of 15, 1631.

Self-portrait in a Soft Hat and Embroidered Cloak, state 7 of 15, 1631.

occasion as a gentleman: a modern, prosperous burgher in a black cloak, a lace collar and wide-brimmed hat with a gold band around it.

The collar is painted in large, coarse strokes, from top to bottom, with thick white paint; threads of paint adhered to the panel when he lifted his coarse-haired brush. It is more like an imagined collar than a real one. And then that red tacking thread, to attach the ends of the collar. It dangles quasi-nonchalantly over the hem. Like a drop of blood that he has casually wiped out with his index finger.

Peter Paul Rubens wore just such an exuberant, wide-brimmed hat in a print in which he introduced himself to the public. Rubens: the most elegant painter of his day, who moved easily in the highest circles and executed one grand commission after another with superb élan.

For his own painting and his etching after the same subject, Rembrandt adopted the same pose, but worked and reworked it until it acquired an air of buoyancy amid a perfect play of light and he had at length surpassed the Antwerp master. That etching was an obsession. He modified it again and again, scratching a few lines and dipping the plate in acid once more. With hundreds of strokes of his etching needle, he wove a refined pattern in his cloak. Eleven states of the etching have been preserved. When he was finally finished, the result was dazzling: Rembrandt blew Rubens's hat right off his head.

With this proud self-portrait, Rembrandt entered the arena of cosmopolitan Amsterdam, the big city in which he sought to project his image: the calling card of the latest star on the firmament. The best way to show how well he could paint the people of the merchant class and portray them at their best. Look—that is how magnificent the end result can be! Signed: "RHL van Rijn, 1632".

In Leiden he had learnt virtually everything. In Amsterdam he was going to have it all: he would become the most famous painter in Europe, meet his first, great love, become a father himself. Rembrandt stood on the threshold of adulthood. His eyes sparkled with the thrill of expectation. Whatever was coming—he was ready for it.

When he signed his painting *The Anatomy Lesson of Dr Nicolaes Tulp* he no longer used the old initials "RHL". Instead he signed "Rembrant fecit". Like Leonardo, Michelangelo, Titian and Raphael, he now needed only his first name in the world.

He had invented himself.

Rembrandt had become Rembrandt.

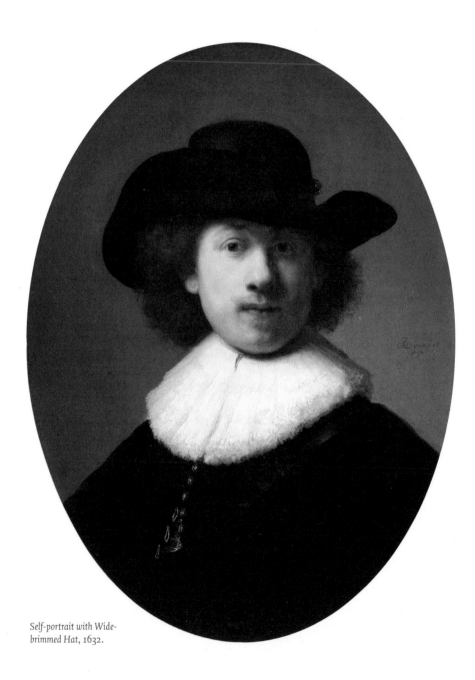

*Self-portrait with Wide-
brimmed Hat, 1632.*

The Parable of the Rich Fool, 1627.

Notes

PROLOGUE

11 While writing, I published a weekly column on my journey following the trail of the young Rembrandt in the daily newspaper *De Volkskrant*, starting on 2nd October 2018. These columns formed the building blocks for this book.

13 For the entire story of the "Rembrandt of the Third Reich" see Onno Blom, *Het litteken van de dood*.

15 For the appeal of Leiden's seventeenth-century city chronicler see also Willem Otterspeer, "Orlers en ik".

1 RHL

19 For the interpretation of *The Painter in his Studio* see Ernst van de Wetering, "Leidse schilders achter de ezels", in M.L. Wurfbain et al., *Geschildert tot Leyden anno 1626*.

21 The registration can be found in *volumen inscriptionum, 1618–1631*. Archives of the Senate and faculties, inv. no. 8 (ASF8). University of Leiden.

21 Constantijn Huygens text translated by. B.J. from the Dutch translation by C.L. Heesakkers.

24 With thanks to Jonathan Bikker for the background details relating to the 1628 self-portrait.

29 Indispensable source materials for everyone researching the life and work of Rembrandt are the expensive volumes of the *Corpus*, which can fortunately be consulted online: http://Rembrandtdatabase.org/literature/corpus and the Remdoc website of the Radboud University of Nijmegen, Huygens Institute for the History of the Netherlands (KNAW) and Museum Het Rembrandthuis: http://remdoc.huygens.knaw.nl.

2 REMBRANDT'S NATIVE CITY

37 "Vive les gueux!" derives from the memoirs of the Catholic jurist Pontus Payen (1559–78), in Luc Panhuysen and René van Stipriaan, *Ooggetuigen van de Tachtigjarige Oorlog*.

43 The two best articles about fact and fiction during and after the relief of Leiden are Judith Pollmann, "Een 'blij-eindend' treurspel: Leiden, 1574" and Jori Zijlmans, "Pieter Adriaensz van der Werff: held van Leiden".

3 THE MILLER'S SON

52 The first reference to Gerrit Roelofsz is in the hospital archives, Gasthuisarchief, inv. no. a302, f. 14, f. 16, 1484. Erfgoed Leiden (the new name of the city archives).

53 Permit issued to Lijsbeth Harmensdr for the building of a windmill: Secretarie Archief, sheriff Claes Adriaenszoon. Groot Privilegeboek, ff. 367–68, 23rd November 1574. Erfgoed Leiden.

53 Rembrandt's grandmother Lijsbeth Harmensdr draws up a second will: Rechterlijk Archief, Waarboek E, inv. no. RA 67, ff. 394v–39., 8th August 1575. Erfgoed Leiden.

58 For the observation that the mill's sails are rotating "the wrong way" I wish to thank the former city archivist (and miller's son) P.J.M. (Piet) de Baar. See also Ernst van de Wetering, "De molen", in Christiaan Vogelaar and Gregor J.M. Weber, *Rembrandts landschappen*.

4 THE CRADLE WOVEN FROM WILLOW RODS

61 Jan Jansz Orlers, "Staet ende inventaris van alle myne Goederen", 1640. Weeskamerarchief, inv. no. 3049 g, ff. 4v.–8. Erfgoed Leiden.

62 "Rembrant Harmansz. Van Rijn van Leyden" in the notice of the intended marriage of Rembrandt and Saskia van Uylenburgh: Archief van de burgerlijke stand. Extra ordinaris intekenregister 1622–36, inv. no. DTB 765, f. 25v., 10th June 1634. Gemeentearchief Amsterdam.

63 Harmen Gerritszoon claims the cradle from the estate of Gerrit Pietersz: Getuigenisboek lo, f. 184v., 26th October 1612. Erfgoed Leiden.

66 The wedding of Rembrandt's parents: Trouwboek (marriage register) Pieterskerk, inv. no. DTB 12, f. 61, 8th October 1589. Erfgoed Leiden.

66 The occupants of Rembrandt's parental home during the census held to determine head tax in 1622: Secretarie Archief. Bon Noord-Rapenburg, inv. no. SA 7541, 18th October 1622. Erfgoed Leiden.

5 THE EXPLODING MUSKET

71 Kees Walle, the passionate researcher and author of the book *Buurthouden*, drew up for me, on the basis of the Oud Belastingboek (tax register), a list of the owners of all the houses in Rembrandt's neighbourhood,

Letter from Rembrandt to Constantijn Huygens, 12th January 1639.

as bounded by Galgewater, Weddesteeg, Vestwal (now Rembrandtstraat), Groenhazengracht, Rapenburg and Kort Rapenburg, which was traversed by the busy thoroughfare Noordeinde. Walle combined the information he found with the records on inns and taverns as commissioned by Jan van Hout in 1607, thus providing me with a highly accurate, detailed and lively picture of the neighbourhood.

72 Rembrandt's father called to testify after a brawl in 't Sant: ONA 58, f. 233, 2nd October 1594, notary Willem Claesz van Oudevliet. Erfgoed Leiden. The Oud Belastingboek records indicate that the waggoner Harmen Willemsz himself lived on 't Sant.

76 For the disturbance with the militiamen that took place around the entry into the city of Queen Consort Henrietta Maria and in which Rembrandt's brother and nephew were involved see Getuignisboek W, ff. 113v.–116v., 7th June 1642. Erfgoed Leiden.

77 The information on the admission of orphans by Rembrandt's father was first published in Kees Walle, *Buurthouden* and derives from AHGW, inv. no. 3386, Kinderboek 1598–1615, f. 53v. Erfgoed Leiden. (Not included in Remdoc.)

77 The chronicle of the Van Heemskerck and Van Swanenburg families was published by R.E.O. Ekkart, the biographer of Isaac Claesz van Swanenburg.

78 For the request submitted by Rembrandt's father to be relieved of his duties in the civic guard see archives of the Schutterij, inv. no. 5, f. 53v., 22nd February 1611. Erfgoed Leiden.

79 For David Bailly's indignation see Christiaan Vogelaar, "Schilderen en bouwen voor burgerij en stad", *Geschiedenis van Leiden*, vol. 2, 2002, p. 157.

79 The information that Rembrandt erased part of Van Ruytenburgh's shoulder was communicated to me by Ernst van de Wetering.

81 On the hasty action to draw up a will: "On this day, the sixteenth day of March in the year 1621, near the hour of 12 noon, appeared before me, Ewout Henricxz. Craen, Notary Public at the Court of Holland as nominated by the city of Leiden, the following witnesses, the honourable gentleman Harmen Gerytsz. van Rijn and the honourable lady Cornelia Willemsdr., man and wife, residing within the city of Leiden and known to me as notary, the aforesaid Harmen Gerytsz. van den Rijn being in good health and the aforesaid Cornelia Willemsdr. being in poor health and bedridden." Oud Notarieel Archief, access no. xiii. Notary Ewout Hendricxz Craen. Originals of notarized deeds, 1611–27: 1621 I, ONA 137, f. 56, 16th March 1621. Erfgoed Leiden.

81 Harmen was relieved of his obligation to pay six guilders a year to the civic guard after his son Adriaen enlisted in his place: archives of the Schutterij, inv. no. 5, f. 132v., 2nd May 1617. Erfgoed Leiden.

83 The grave of Adriaen Harmensz van Rijn: Grafboek (register of graves) Pieterskerk 1647, f. 160, 25th September 1645. Erfgoed Leiden.

6 THE NEW CITY

85 With thanks to Jeremy Bangs, also for his hospitality in the delightful Leiden American Pilgrim Museum in Beschuitsteeg, which gives you the sense of entering Rembrandt's own home.

85 With thanks to Leo Lucassen for his illuminating observations on immigration in Leiden in the seventeenth century.

88 See also *Leids woordenboek* at www.dickwortel.nl.

91 Blok, P.J., "Rembrandt en zijn tijd".

93 For the negotiations between Rembrandt's father and the city council on the tax to be paid see inv. no. 4346, f. 57. Erfgoed Leiden.

7 BEHIND MINERVA'S SHIELD

96 The most important source of information on the Latin school is the book by my former headmaster, A.M. Coebergh van den Braak, *Meer dan zes eeuwen Leids gymnasium*.

97 For the education provided to Leiden's youngest children see D. Stremmelaar, "Spelen en leren in Leiden rond 1600".

99 The description of the duties to be carried out by Lettingius is quoted by Ingrid Moerman in "Leiden: de stad en haar bewoners in Rembrandts tijd", in Roelof van Straten, *Rembrandts Leidse tijd*, p. 282.

100 On the inventory of items possessed by Schrevelius in Haarlem see Oud Notarieel Archief Haarlem, ONA 163, f. 68v.

100 The Buchelius quotation is as follows: "Molitoris etiam Leidensis filius magni fit, sed ante tempus", in G.J. Hoogewerff and J.Q. van Regteren Altena, "Arnoldus Buchelius: Res pictoriae," p. 67.

100 The discovery of the name of the drawing master Rieverdinck: J.G. van Gelder, "Rembrandts vroegste ontwikkeling", p. 273, note 2.

101 The quotation from Ovid's *Metamorphoses* is from A.S. Kline's translation, published online.

101 My attention was drawn to the use of Claudian by Amy Golhany in *Rembrandt's Reading*.

8 THE HAND OF GOD

105 The entry in the *volumen inscriptionum* was found by Jef Schaeps and Mart van Duijn, curators of Leiden University Library. I am extremely grateful to them for notifying me of their discovery before it was publicized. See also Jef Schaeps and Mart van Duijn, *Rembrandt en de Universiteit Leiden*.

106 For a scintillating picture of the earliest history of the University of Leiden see Willem Otterspeer, *Groepsportret met dame: De Leidse universiteit*, vol. 1.

109 The comments on Scaliger and the Dutch translation (translated into English here by B.J.) of his satirical poem are taken from H.J. de Jonge, "Josephus Scaliger in Leiden".

110 On the library, publishers and printers see A. Bouwman, B. Dongelmans, P. Hoftijzer et al., *Stad van boeken: Handschrift en druk in Leiden 1260–2000*.

112 On Clusius see Kasper van Ommen, *The Exotic World of Carolus Clusius 1526–1609*.

116 For Rembrandt's household inventory see Desolate Boedelkamer (Bankruptcy Office), Register van Inventarissen B, inv. no. DBK 364, ff. 29r.–38v. Stadsarchief Amsterdam.

119 The passage on the anatomy theatre includes a quotation from J.J. Orlers, *Beschrijvinge der Stadt Leyden*.

120 The visitor to Rembrandt's studio was Pieter van Brederode. Bibliotheek van de Hoge Raad van Adel. Quartieren, Helmteekens en Genealogie, f. 7, 2nd October 1669.

9 THE ARMINIAN REDOUBT

131 The popular anecdote that Prince Maurits wondered aloud whether predestination was "green or blue" is a charming fiction. Nonetheless, it serves to indicate that predestination was a highly complex issue and that Maurits had no head for abstract ideas.

135 For the entry in the diary of Johannes Wtenbogaert see *Memorieen J.Wtenbogaert 1624–1633: Dagelijkse aantekeningen in den Comptoir Almanak van het jaar 1629–1634*, inv. no. Ms. Sem. Rem., f. 43, 13th April 1633. Leiden University Library.

137 For the words that Scriverius is said to have uttered to the bailiff see Geeraert Brandt, *Historie van de Regtspleging*, pp. 76–86.

138 The skirmishes that took place outside the Knotter family home were discovered and described by Bas Dudok van Heel in his splendid PhD dissertation "De jonge Rembrandt onder tijdgenoten", pp. 29–31.

10 THE GHOST OF LUCAS

141 For the interpretation of Lucas's *Last Judgement* I am indebted to Christiaan Vogelaar, with whom I have made many visits to the triptych over the past few years.

142 For the history of *The Last Judgement* see also Rick Vos, *Lucas van Leyden*.

142 For the quotation on Lucas see Dominicus Lampsonius, *Pictorum aliquot celebrium Germaniae Inferioris*.

11 LITTLE NAPLES ON LANGEBRUG

147 For the information on Master Nicolai—as he is called by J.J. Orlers—see the fine catalogue produced by R.E.O. Ekkart, *Isaac Claesz van Swanenburg 1537–1614: Leids schilder en burgemeester*.

149 Quotations from the family chronicle: R.E.O. Ekkart, "Familiekroniek Van Heemskerck en Van Swanenburg".

150 For the information on Langebrug and the Penshal (tripe hall) I would like to thank Piet de Baar, who checked Master Jacob's address for me: Langebrug 89. According to the 1622 census drawn up to determine head tax, the following people lived in the Zevenhuizen neighbourhood (f. 2v.) in October or November: Jacob Isacxz van Swanenburch, painter, Margrieta Cardon, his wife, Marijtgen, Silvester, Isack, Jacop's children, and Jannetgen Aryensdr, maidservant.

154 Ernst van de Wetering drew my attention to the "tablet". For detailed background information see Ernst van de Wetering, *Rembrandt: The Painter at Work*.

156 When I was nearing the end of my Master's programme in 1994, I had the good fortune to spend three months at the Istituto Olandese in Rome. Every day I followed the trail of famous Dutch painters and writers as I moved around the Eternal City. Every day I entered the San Luigi dei Francesi, the French church between Piazza Navona and the Pantheon. In the cool darkness I went to the Contarelli chapel and put a 500-lire coin in the meter. The lights clicked on and I gazed open-mouthed at the sweet angel whispering its words of inspiration to the old Evangelist Matthew.

157 One copy has been preserved in the Netherlands of the cookery book by Antonius Magirus, *Koock-boeck oft familieren keuken-boeck* (Antwerp, 1655). It is in the Special Collections, University of Amsterdam.

12 INNOCENCE SLAIN

161 *Christ in the Storm on the Sea of Galilee* was stolen in the early morning of 18th March 1990 from the Isabella Stewart Gardner Museum in Boston. The thieves, disguised as police officers, knocked out the guards

and stole thirteen masterpieces valued at a total of 500 million US dollars, including a Vermeer, a Degas, a Flinck and three Rembrandts. The painting was never found. The heiress Gardner stipulated in her will that the interior of her house, which became the museum that bears her name, was to be left unchanged. That is why we find today, exactly twenty-nine years after the biggest art robbery of all time, the frame from which the thieves cut Christ in the Storm still hanging in its old place on the wall: an empty space, as flat as a Dutch polder.

162 For the facts on the life of Lastman see Astrid Tümpel and Peter Schatborn, *Pieter Lastman: Leermeester van Rembrandt.*

164 On the charming angel see also Henk van Os, *Rembrandts offer van Abraham in de Hermitage.*

170 On all the interpretations that have been advanced down to the present day, right up to this book's publication, Gary Schwartz wrote the illuminating article "Putting ourselves and Rembrandt to the test", op www.garyschwartzarthistorian.nl.

172 See also Piet Calis, *Vondel. Het verhaal van zijn leven.*

175 With thanks to Jan Six for telling me his story of the discovery and for giving me an opportunity to spend a few hours in the company of Rembrandt's painting. Thanks also to Ernst van de Wetering for his account of the painting's authenticity. See also Onno Blom, "Kunsthandelaar Jan Six ontdekt wéér een 'nieuwe' Rembrandt".

13 TWO NOBLE YOUNG PAINTERS OF LEIDEN

180 With thanks to Piet de Baar for the data on the houses of the fathers of Rembrandt and Jan Lievens respectively. Roelof van Straten, *Rembrandts Leidse tijd 1606–1632*, a treasure trove of reliable information, contains the minor error that the Lievens family moved to Noordeinde while Rembrandt was living in Leiden. See Waarboek II, f. 252 in the archives of Erfgoed Leiden: Pieterskerk-Choorsteeg 15, north section, named De Rosencrans, a newly built *huysinge*, was officially transferred on 16th July 1608 by Aernt Cornelisz, a baker in Den Draeck, for 2,100 guilders, in addition to an annual payment of 31 guilders 50, to Lieven Henricxz filius Joos, who sold it on 31st July 1634 to the unmarried person Annetgen Jacobsz Visscher for 3,100 guilders (Waarboek III, f. 170).

183 The quest for the shared studio has always kept the minds of the people of Leiden occupied. A building at Muskadelsteeg number 5 was long believed to be the location. The alley derives its name from the fact that a liquor store and tavern in the alley sold, among other things, sweet wine made from muscatel grapes. In the early seventeenth century, one Trijntje Harmensdochter lived there; this must have been one of Rembrandt Harmenszoon's sisters. The popular author Jan Mens wrote a novel entitled *Meester Rembrandt* (1946) in which the painter moves in with his friend and rival Jan Lievens. In the later 1980s, the then director of De Lakenhal, M.L. Wurfbain, and Ernst van de Wetering of the Rembrandt Research Project together went to see if the seventeenth-century front room corresponded to Rembrandt's *The Painter in his Studio* (c.1628). Sadly, they soon noted that the wide floorboards in the painting did not run in the same direction as in the historical front room in Muskadelsteeg. Yet this did not break the spell for the students who lived in that building. They set a memorial tablet in the façade: "Here lived and worked / Rembrandt van Rhijn 1622–1624." Years later, after fierce protests by the historian Ingrid Moerman and Piet de Baar, Leiden's burgomaster ordered the tablet's removal. Rembrandt's father's name was certainly Harmen, but did he have a sister called Trijntje? As it happened, he did not. The tablet was completely wrong. On the shared studio see also Ernst van de Wetering, "De symbiose van Lievens en Rembrandt".

190 For the report and the analysis of the painting competition see Ernst van de Wetering, "Leidse schilders achter de ezels", in M.L. Wurfbain et al., *Geschildert tot Leyden anno 1626.*

193 With thanks to the eminent scholars Frans Blom (no relation) and Ad Leerintveld, who took me to Hofwijck, the country estate of Constantijn Huygens in Voorburg. That same day, in the Koninklijke Bibliotheek (National Library) in The Hague, we pored over Huygens's original manuscript. On a cushion lay the thick bound volume. We opened the book in the manner of high priests handling the Holy Scriptures and leafed through until we came to the five densely inscribed pages. Our index fingers moved across the rough seventeenth-century paper, line by line. We read sections in Latin, then the Dutch translation by C.L. Heesakkers, and were astonished. Nowhere did the secretary's even hand betray the slightest hint of emotion, but he wrote with such eloquence. His words ring out, silver-toned. Bravo Huygens!

14 THE FIRST HERETIC IN THE ART OF PAINTING

205 I have based my retelling of Houbraken's anecdotes on the version by Jan Konst and Manfred Sellink (1995).

209 With thanks to Peter Zuur who took me to the attic of the Leiden art society Ars Aemula Naturae for a demonstration of the technique of etching. It is a magical place: Willem van Mieris, Frans van Mieris's son, who was in turn the best pupil of Rembrandt's best Leiden pupil Gerrit Dou, established the first

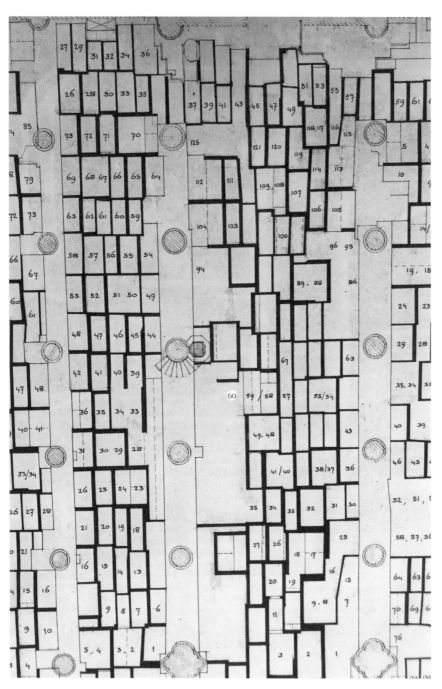

The grave of Rembrandt's parents, number 60, central section of the nave of the Pieterskerk in Leiden.

art academy in the country on that spot in 1694. Despite the clarity of Peter Zuur's explanation of the technique, it remained a mystery—even to him—that no one has ever succeeded in improving upon Rembrandt's bizarre method of etching. Sheer sorcery.

216 Gary Schwartz on "antedating" in *Rembrandt: Zijn leven, zijn schilderijen*, p. 84.

222 Rembrandt's letter of 12th January 1639 to Constantijn Huygens contained a section that may be translated as follows: "Sir, it has been with great delight and affection that I have executed the two paintings that his Highness commissioned from me, viz. one depicting the dead body of Christ being laid in the grave and the other showing Christ rising from the dead to the great terror of the guards. These same two paintings have now been completed, partly as a result of studious diligence, so that I am now ready to deliver them to your Highness for your enjoyment, since in these two I have pursued the most natural moving quality, which is the primary reason why I have had them in hand for so long." Collection of the Royal Archives, The Hague.

15 EYES SHUT

225 The archives of the late Robert Oomes, a huge trolley containing many boxes of paper, are still waiting to be opened and explored in the storage facility of Erfgoed Leiden. Oomes spent years researching the numbering and names of the graves. In the course of his research, in 2009, he identified the precise location of the grave of Jan van Hout in the Pieterskerk. With the aid of his numbered floor plan of the church we can find the locations of grave numbers 60 and 71: we find them in the church's burial book (Grafboek Pieterskerk) for 1610, ff. 72v. and 73v, Erfgoed Leiden. Without the assistance of Kees Walle and Piet de Baar I would have found the transcription and interpretation of these documents an impossible task. The burial books also show that the church—probably because the graves of Harmen and grandfather Cornelis were beneath the pulpit—moved them both on 26th September 1645 to grave number 101 in the central section of the nave. That is where Adriaen Harmenszoon van Rijn, who died on 19th October 1652, was laid to rest.

227 The authenticity of the drawing and the inscription has at times been challenged. Peter Schatborn, who has been the leading authority on Rembrandt's drawings for decades, has assured me that there is no need to harbour any doubt that this is a genuine Rembrandt.

228 The portrait of Rembrandt's father in the inventory of the estate of Sybout van Caerdecamp: Oud Notarieel Archief, no. LXI. Willem Pietersz van Leeuwen, ONA 785, f. 13, 23rd February 1644. Erfgoed Leiden.

229 Rembrandt's etching plates in Clement de Jonghe's shop: Notarieel Archief, no. 186. Johannes Backer, NA 4528. Stadsarchief Amsterdam.

229 For Gary Schwartz's comments on the portrait of the old woman see *De grote Rembrandt*, p. 48.

236 "Een tronitgen van warmbrant": Huydecoper family archives, inv. no. 30, f. 5v. Utrechts Archief.

236 For Jouderville see also Ernst van de Wetering, "Isaac Jouderville. A pupil of Rembrandt", in Albert Blankert et al., *The Impact of a Genius: Rembrandt, His Pupils and Followers in the Seventeenth Century*.

237 For the notes on Marten Soolmans see also Jonathan Bikker, *Marten en Oopjen*.

237 Jonathan Bikker was the first to publish an account of the brawl witnessed by Soolmans. The original document is to be found in Notarieel Archief, Pieter den Oosterlingh, f. 10, akte 115, 19th March 1630. Erfgoed Leiden. With thanks to Piet de Baar for the transcription.

238 For the *tontine* see ONA 425, akte 26, 8th/24th March 1631, notary Karel Outerman. Erfgoed Leiden. With thanks to Kees Walle for the transcription, including the complete list of subscribers. For the statement attesting to Rembrandt's good health see Notary Jacob van Zwieten, inv. no. Notarieel Archief 861, ff. 244v.–245r., pp. 488–89, 26th July 1632. Stadsarchief Amsterdam. With thanks to the curator, Eric Schmitz, for showing me and transcribing the original. In the margin of the notary's records (*notarisboek*) is a red cross, placed there by the person who discovered the document: Abraham Bredius, the renowned Rembrandt researcher and one-time director of the Mauritshuis.

240 With thanks to Jan Six for identifying the breed of the dog at Rembrandt's feet.

241 That the dissection took place at the Weighhouse (De Waag) is an educated guess. It is impossible to prove, but highly likely. See also Ernest Kurpershoek, *De Waag op de Nieuwmarkt*, pp. 42–64.

243 The first piece of research to discover the background details of this case was conducted by I.H. van Eeghen: "De anatomische lessen van Rembrandt". Kees Walle transcribed for me the vast quantity of documents on Ariskindt. Those drawn from the Gemeentearchief Amsterdam were as follows: Confessieboek inv. no. 295, pp. 136–7, 16th November 1623; Confessieboek inv. no. 297, p. 35, 27th November 1625; Confessieboek inv. no. 297, pp. 66v.–67, 10th March 1626; Confessieboek inv. no. 299, pp. 31v.–32, 4th December 1631; Confessieboek inv. no. 299, pp. 37–38, 12 December 1631; Confessieboek inv. no. 299, p. 48, 24th January 1632. Crimineel Vonnisboek 1629–33, pp. 158–62, 31st January 1632.

The documents drawn from Erfgoed Leiden were: ORA, Crimineel Vonnisboek 10, f. 251v., 23rd July 1624; ORA, Crimineel Vonnisboek 11, ff. 47, 47v. and 48, 22nd August 1625; ORA, Crimineel Vonnisboek 11, ff. 72, 72v. and 73, 24th October 1625; ORA, Crimineel Vonnisboek 11, ff. 85, 85v., 86 and 86v., 19th/26th January 1626.

Illustration credits

208 (top left) *Self-portrait in a Cap, Laughing*, etching with strokes in drypoint needle, 1630. Rijksmuseum, Amsterdam.
208 (top right) *Self-portrait, Open-mouthed, as if Shouting*, etching, 1630. Rijksmuseum, Amsterdam.
208 (below) *Sheet of studies: self-portrait, a few beggars, heads of an old man and a woman etc.*, etching, 1630–34. Rijksmuseum, Amsterdam.
210 *Andromeda*, oil on panel, c.1630. Mauritshuis, The Hague.
212 *Nude Woman, Seated on a Mound*, etching and burin, 1629–30. Rijksmuseum, Amsterdam.
214 (left) *The Laughing Man*, gilded copper, c.1629–30. Mauritshuis, The Hague.
214 (right) *Self-portrait in a Cap*, oil on copper, 1630. Nationalmuseum, Stockholm/Bridgeman Images.
215 *Old Woman at Prayer*, oil on copper, 1629–30. Alte Residenz, Salzburg.
218 (left) Studio of Rembrandt, *Prince Rupert of the Palatinate and his Tutor as Eli and Samuel*, oil on canvas, c.1629–30. J. Paul Getty Museum, Los Angeles.
218 (right) Jan Lievens, *Prince Charles Louis with his Tutor*, oil on canvas, 1631. J. Paul Getty Museum, Los Angeles.
221 (left) *Portrait of Maurits Huygens*, oil on panel, 1632. Hamburger Kunsthalle, Hamburg/Bridgeman Images.
221 (right) *Portrait of Jacques de Gheyn III*, oil on canvas, 1632. Dulwich Picture Gallery, London.
223 *Raising of the Cross*, oil on canvas, 1645. Alte Pinakothek, Munich.

15 EYES SHUT

224 *Jeremiah Lamenting the Destruction of Jerusalem*, oil on panel, 1630. Rijksmuseum, Amsterdam.
227 *Portrait of his Father* (detail), chalk with brown wash on paper, seventeenth century. Ashmolean Museum, University of Oxford/Bridgeman Images.
228 (left) *Rembrandt's Mother Seated at the Table: three-quarters length, from the right*, etching and engraving, 1629–33. Rijksmuseum, Amsterdam.
228 (right) *Sheet of studies with three heads of an old man*, etching, 1628–32. Rijksmuseum, Amsterdam.
230 *Old Woman Reading, Probably the Prophetess Anna*, oil on panel, 1631. Rijksmuseum, Amsterdam.
233 *The Third Oriental Head*, after Jan Lievens, etching, 1635. Rijksmuseum, Amsterdam.
234 *Marten Soolmans* (1613–41), oil on canvas, 1634. Joint purchase of the Netherlands and France, Collection of the Rijksmuseum, Amsterdam/Collection of Musée du Louvre, Paris.
235 *Oopjen Coppit* (1611–89), oil on canvas, 1634. Joint purchase of the Netherlands and France, Collection of the Rijksmuseum, Amsterdam/Collection of Musée du Louvre, Paris.
240 *Self-portrait in Oriental Attire*, oil on panel, 1631. Petit Palais, Paris.

EPILOGUE

244 *Self-portrait in a Soft Hat and Embroidered Cloak*, state 12 of 15, etching with strokes with drypoint needle, 1631. Rijksmuseum, Amsterdam.
247 (left) *Self-portrait in a Soft Hat and Embroidered Cloak*, state 6 of 15, etching with strokes with drypoint needle, 1631. Rijksmuseum, Amsterdam.
247 (right) *Self-portrait in a Soft Hat and Embroidered Cloak*, state 7 of 15, etching with strokes with drypoint needle, 1631. Rijksmuseum, Amsterdam.
249 *Self-portrait with Wide-brimmed Hat*, oil on panel, 1632. Burrell Collection, Glasgow. CSG CIC Glasgow Museums Collection/Bridgeman Images.

NOTES

250 *The Parable of the Rich Fool*, oil on panel, 1627. Staatliche Museen, Berlin. Photo: Scala/BPK.
252 Letter from Rembrandt to Constantijn Huygens, 12th January 1639. Royal Archives, The Hague.
256 The grave of Rembrandt's parents, number 60, central section of the nave of the Pieterskerk in Leiden. Floor plan from the estate of Robert Oomes. Erfgoed Leiden.

BIBLIOGRAPHY

262 *The Music Party* (detail), oil on panel, 1626. Rijksmuseum, Amsterdam.

INDEX OF NAMES

268 *Judith at the Banquet of Holofernes* (detail), oil on canvas, 1634. Museo Nacional del Prado, Madrid. Photo: MNP/Scala.

ACKNOWLEDGEMENTS

274 *Simeon's Song of Praise*, oil on canvas, 1631. Mauritshuis, The Hague.

The Music Party (detail), 1626.

Bibliography

Aa, Pierre van der, *Les délices de Leide*. Leiden, 1712.

Alderkerk, Joannes, *Beleg ende Ontzet der stadt Leyden*. Leiden, 1756.

Angel, Philip. *Lof der schilder-konst*. Leiden, 1642. Photographic reprint, Utrecht, 1969.

Baar, P.J.M. de, "Het milieu waarin Rembrandt opgroeide". *Leidsch Dagblad*, 5 November 1990.

Baar, P.J.M. de, *De Leidse verwanten van Rembrandt van Rijn en hun Leidse afstammelingen tot heden*. Leiden, 1992. Second edition.

Baer, Ronni, *Gerrit Dou 1613–1675*. Zwolle, 2000.

Bakker, Boudewijn et al., *Het landschap van Rembrandt: Wandelingen in en om Amsterdam*. Amsterdam/Bussum/ Paris, 1998.

Baldinucci, Filippo, "Vita di Reimbrond Vanrein". In *Cominciamento, en progresso dell'arte dell' intagliare in rame, colle vite di molti de'piu eccelenti maestri della stessa professione*. Florence, 1686.

Bangs, J.D., *Cornelis Engebrechtsz's Leiden*. Assen, 1979.

Bangs, J.D., *Strangers and Pilgrims, Travellers and Sojourners: Leiden and the Foundations of Plymouth Plantation*. Plymouth, 2009.

Bauch, Kurt, *Der frühe Rembrandt und seine Zeit*. Berlin, 1960.

Beck, H.U., *Ein Skizzenbuch von Jan van Goyen*. The Hague, 1966.

Beets, N., *Lucas van Leyden*. Amsterdam, 1913.

Benesch, Otto, *Rembrandt as a Draftsman*. London, 1960.

Berkvens-Stevelinck, Christiane, *Magna Commoditas: Geschiedenis van de Leidse Universiteitsbibliotheek 1575–2000*. Leiden, 2001.

Bevers, Holm, Schatborn, Peter and Welzel, Barbara, *Rembrandt, De meester en zijn werkplaats: Tekeningen en Etsen*. Amsterdam/Zwolle, 1991.

Bicker Kaarten, A., "Rembrandt als molenaarszoon". *Leids jaarboekje* 48, 1956.

Bikker, Jonathan, *Marten en Oopjen*. Amsterdam, 2016.

Bikker, Jonathan, *Rembrandt: Biografie van een rebel*. Amsterdam, 2019.

Blankert, Albert et al., *The Impact of a Genius: Rembrandt, His Pupils and Followers in the Seventeenth Century*. Amsterdam, 1983.

Blok, P.J., "Rembrandt en zijn tijd". *Leids jaarboekje* 3, 1906.

Blok, P.J., *Geschiedenis eener Hollandse stad*. Four vols. The Hague, 1918.

Blom, J.C.H., van Maanen, R.C.J. and Smit, C.B.A., *Historische canon van Leiden*. Leiden, 2008.

Blom, Onno, *Bloem der steden: Schrijvers over Leiden*. Leiden, 2009.

Blom, Onno, *Stad van verf: Over de levens en werken van Leidse schilders van de middeleeuwen tot heden*. Leiden, 2010.

Blom, Onno, *Het litteken van de dood: De biografie van Jan Wolkers*. Amsterdam, 2017.

Blom, Onno, "Kunsthandelaar Jan Six ontdekt wéér een 'nieuwe' Rembrandt". *De Volkskrant*, 14 September 2018.

Blom, Onno, "Rembrandt studeerde langer in Leiden dan werd aangenomen". *De Volkskrant*, 16 July 2019.

Blom, Onno and Pfeijffer, Ilja Leonard, *Oude and nieuwe Leidsche. Verhalen van een stad*. Leiden/Amsterdam, 2009.

Bolten-Rempt, Jetteke et al., *Hoogtepunten uit de collectie van Stedelijk Museum de Lakenhal*. Leiden, 1993.

Bolten-Rempt, Jetteke, *Rembrandt Leydensis verovert de wereld*. Leiden, 2005.

Bontius, Reinier, *Beleg en ontzet der stad Leiden*. Amsterdam, 1660.

Boogert, Bob van den, "Rembrandt's history painting: The clemency of Charles V? 1626". In Ernst van de Wetering and Bernhard Schnackenburg (eds), *The Mystery of the Young Rembrandt*. Kassel/Amsterdam, 1998.

Boogert, Bob van den (ed.), *Rembrandts schatkamer*. Amsterdam/Zwolle, 1999.

Boon, K.G., *Rembrandt de etser: Het volledige werk*. Amsterdam, 1963.

Bostoen, Karel, "Het nieuwe Leiden en zijn icoon: het stadhuis. Leiden rond 1600". *Leids jaarboekje* 100, 2008.

Bostoen, Karel, *Hart voor Leiden. Jan van Hout (1542–1609), stadssecretaris, dichter en vernieuwer*. Hilversum, 2009.

Bostoen, Karel, de Baar, P.J.M. and Walle, Kees, *Jan van Houts nalatenschap*. Leiden, 2013.

Bouwman, A., Dongelmans, B., Hoftijzer, P. et al., *Stad van boeken: Handschrift en druk in Leiden 1260–2000*. Leiden, 2008.

Braak, A.M. Coebergh van den, *Meer dan zes eeuwen Leids gymnasium*. Leiden, 1988.

Brandt, Geeraert, *Het leven van Joost van den Vondel*. Amsterdam, 1682.

Brandt, Geeraert, *Historie van de Regtspleging, gehouden in den jaaren 1618 en 1619 ontrent de drie gevangene heeren mr. Johan van Oldenbarnevelt, mr. Rombout Hoogerbeets, mr. Hugo de Groot.* Rotterdam, 1721.

Bredero, G.A. van, *De klucht van de Molenaer.* Amsterdam, 1613.

Bredius, A. et al., *Rembrandt-Hulde te Leiden: Catalogus der tentoonstelling van schilderijen en tekeningen van Rembrandt en van schilderijen van andere Leidsche Meesters der Zeventiende Eeuw.* Leiden, 1906.

Brons, Ingrid and Postma, Annemarie, *Rembrandt in Leiden: Portret van een schildersjongen en zijn stad.* Leiden, 2005.

Brown, Beverly Louise, *The Genius of Rome, 1592–1623.* London, 2001.

Brown, Christopher, Kelch, Jan and van Thiel, Pieter, *Rembrandt, De meester en zijn werkplaats: Schilderijen.* Amsterdam/Zwolle, 1991.

Bruyn, J., "David Bailly". *Oud Holland* 66, 1951.

Bull, Duncan, Dibbits, Taco et al., *Rembrandt-Caravaggio.* Amsterdam/Zwolle, 2006.

Burger, W., *Musées de la Hollande. Amsterdam et La Haye. Études sur l'école Hollandaise.* Paris, 1858.

Buvelot, Quentin, *Frans van Mieris 1635–1681.* The Hague/Zwolle, 2005.

Calis, Piet, *Vondel. Het verhaal van zijn leven.* Amsterdam, 2008.

Carr, John, *A Tour through Holland.* Philadelphia, 1807.

Chapman, H. Perry, Kloek, Wouter and Wheelock, Arthur K. Jr, *Jan Steen: Schilder en verteller.* Amsterdam, 1996.

Chong, Alan (ed.), *Rembrandt Creates Rembrandt. Art and Ambition in Leiden, 1629–1631.* Boston/Zwolle, 2000.

Chong, Alan and Kloek, Wouter, *Het Nederlandse Stilleven 1550–1720.* Amsterdam/Zwolle, 1999.

Dudok van Heel, S.A.C., "De jonge Rembrandt onder tijdgenoten: Godsdienst en schilderkunst in Leiden en Amsterdam". PhD dissertation. Nijmegen, 2006.

Dürer, Albrecht, *Reis naar de Nederlanden.* Translated into Dutch by Anne Pries. Hoorn, 2008.

Eeghen, I.H. van, "De anatomische lessen van Rembrandt". *Amstelodanum,* January–February 1948, pp. 84–86.

Ekkart, R.E.O., *Isaac Claesz van Swanenburg 1537–1614: Leids schilder en burgemeester.* Leiden/Zwolle, 1998.

Ekkart, R.E.O., "Familiekroniek Van Heemskerck en Van Swanenburg". *Jaarboek van het centraal bureau voor genealogie en het Iconografisch Bureau* no. 32, 1978 and no. 33, 1979.

Emmens, Jan, *Rembrandt en de regels van de kunst.* Amsterdam, 1979.

Filedt Kok, Jan Piet, *De dans om het Gouden Kalf van Lucas van Leyden.* Amsterdam, 2008.

Fruin, R., *Het beleg en ontzet der stad Leiden.* The Hague, 1874.

Fruytiers, Jan, *Korte beschryvinge van de strenge belegeringe en wonderbaarlyke verlossinge der stad Leiden in den jaare 1574.* Leiden, 1739.

Fuchs, Rudi, *Dutch Painting.* London, 1978.

Fuchs, Rudi, *Rembrandt spreekt.* Amsterdam, 2006.

Gelder, J.G. van, "Rembrandts vroegste ontwikkeling". In *Mededelingen der Koninklijke Academie van Wetenschappen, Afdeling Letterkunde.* Nieuwe reeks, vol. 16, no. 5, 1953.

Gerson, Horst, *Rembrandt Paintings.* New York, 1968.

Golhany, Amy. *Rembrandt's Reading: The Artist's Bookshelf of Ancient Poetry and History.* Amsterdam, 2003.

Gool, Johan van, *De nieuwe Schouburg der Nederlantsche kunstschilders en schilderessen.* Two vols. The Hague, 1751.

Groenveld, S., van Maanen, R.C.J. and Penning, W.E., *Leiden. Historische Plattegronden van Nederland,* vol. 7. Alphen, 1997.

Groenveld, S. et al., *De Tachtigjarige Oorlog. Opstand en consolidatie in de Nederlanden (1560–1650).* Zutphen, 2012. Second edition.

Guicciardini, Lodovico, *Beschryvinghe van alle de Nederlande.* Amsterdam, 1612.

Haak, Bob, *Rembrandt: Tekeningen.* Amsterdam, 1976.

Haak, Bob et al., *Opkomst en bloei van het Noordnederlandse stadsgezicht in de 17de eeuw.* Aerdenhout, 1977.

Haak, Bob, *Rembrandt: Zijn leven, zijn werk, zijn tijd.* Amsterdam, 1990. Revised edition.

Hall, James, *Het zelfportret: Een culturele geschiedenis* (Dutch translation by Willem van Paassen of *The Self-Portrait: A Cultural History*). Kerkdriel, 2015.

Hartog, Elizabeth den et al., *De Pieterskerk in Leiden.* Leiden, 2011.

Hartog Jager, Hans den, *Dit is Nederland: In tachtig meesterwerken.* Amsterdam, 2008.

Hecht, Peter, *De Hollandse fijnschilders: Van Gerard Dou tot Adriaen van der Werff.* Amsterdam/Maarssen/The Hague, 1989.

Hecht, Peter, "Could this be it? Rembrandt's Leiden history painting of 1626 depicts Orestes and Pylades before King Thoas in Tauris". *Simiolus,* vol. 40, no. 4, 2018.

Hinterding, Erik et al., *Rembrandt the Printmaker*. Amsterdam/London, 2000.

Hinterding, Erik et al., *Rembrandt x Rijksmuseum*. Amsterdam, 2019.

Hofdijk, W.J., *Leydens wee en zegepraal*. 1573–1574. Leiden, 1874.

Hoftijzer, Paul and van Ommen, Kasper, *Langs Leidse letters: Een boekhistorische wandeling*. Leiden, 2008.

Hooft, P.C., *Nederlandse Historiën*. Amsterdam, 1642.

Hoogewerff, G.J. and van Regteren Altena, J.Q., "Arnoldus Buchelius: Res pictoriae". In *Quellenstudien zur Holländischen Kunstgeschichte XV*. The Hague, 1928.

Hoogstraaten, Samuel van, *Inleyding tot de hooge schoole der schilderkunst: anders de zichtbaere werelt*. Rotterdam, 1678.

Houbraken, Arnold, *De Groote Schouburgh der Nederlantsche konstschilders en schilderessen*. The Hague, 1753. Photographic reprint of the second, revised edition, Amsterdam, 1976.

Houbraken, Arnold, *De Grote Schouwburg: Schildersbiografieën*. Compiled by Jan Konst and Manfred Sellink. Amsterdam, 1995.

Huet, Conrad Busken, *Het land van Rembrand*. Haarlem, 1901. Second edition.

Huisman, Tim, *The Finger of God: Anatomical Practice in 17th-century Leiden*. Leiden, 2009.

Huizinga, Johan, "Toespraak op den Gedenkdag van Leiden's ontzet, op 3 oktober 1942 in het gijzelaarskamp te St Michielsgestel". *De Gids*, vol. 109, 1946.

Huygens, Constantijn. *Mijn jeugd*. Translated into Dutch with commentary by C.L. Heesakkers. Amsterdam, 1994.

Immerzeel, Johannes, "Rembrandts voorspoedige reis". In *Gedichten*. Rotterdam 1823.

Ireland, Samuel, *A picturesque tour through Holland, Brabant and a part of France made in the autumn of 1789*. Two vols. London, 1790.

Jonge, H.J. de, "Josephus Scaliger in Leiden". In *Leids jaarboekje 71*, 1979.

Jongh, E. de, *Tot Lering en Vermaak: Betekenissen van Hollandse genrevoorstellingen uit de zeventiende eeuw*. Amsterdam, 1976.

Jorink, Eric, *Het Boeck der Natuere: Nederlandse geleerden en de wonderen van Gods schepping 1575–1715*. Leiden, 2006.

Karstens, W.K.H. and Kleibrink, Herman, *De Leidse hortus: Een botanische erfenis*. Leiden/Zwolle, 1994.

Koppenol, Johan, *Het Leids ontzet: 3 oktober 1574 door de ogen van tijdgenoten*. Amsterdam, 2002.

Kurpershoek, Ernest, *De Waag op de nieuwmarkt*. Amsterdam, 1994.

Laabs, Annegret, *De Leidse fijnschilders uit Dresden*. Leiden/Zwolle, 2001.

Lairesse, Gérard de, *Groot Schilderboek*. Haarlem, 1740.

Lammers-Keijsers, Y.M.J. (ed.), *Ongekend Leiden: Het verleden in kaart*. Leiden, 2009.

Lammertse, Friso and van der Veen, Jaap, *Uylenburgh and Zoon: Kunst en commercie van Rembrandt tot De Lairesse. 1625–1675*. Amsterdam/Zwolle, 2006.

Lampsonius, Dominicus, *Pictorum aliquot celebrium Germaniae Inferioris*. Antwerp, 1572.

Leerintveld, Ad and van den Boogert, Bob, *Huygens ontdekt Rembrandt*. Voorburg, 2006.

Leeuwen, Simon van, *Korte Besgryving van het Lugdunum Batavorum nu Leyden*. Leiden, 1672.

Lem, Anton van der, *De Opstand in de Nederlanden, 1568–1648. De Tachtigjarige oorlog in woord en beeld*. Nijmegen, 2018.

Lugt, Freek, *Het ontstaan van Leiden: Over de burggraaf, de ontginning, de opwas, het stadsrecht*. Leiden, 2012.

Lunsingh Scheurleer, Th.H. and Posthumus Meyes, G.H.M. (eds), *Leiden University in the Seventeenth Century: An Exchange of Learning*. Leiden, 1975.

Lunsingh Scheurleer, Th.H. et al., *Het Rapenburg: Geschiedenis van een Leidse gracht*. Seven vols. Leiden, 1986.

Maanen, R.C.J. van (ed.), *Leiden: De geschiedenis van een Hollandse stad*. Four vols. Leiden, 2002–04.

Maat, Dr G.J.R., "Onderzoek naar skeletmateriaal". In *Graven in de Pieterskerk*. Leiden, 1981.

Mak, Geert, *De levens van Jan Six: Een familiegeschiedenis*. Amsterdam, 2016.

Mander, Karel van, *Het Schilder-Boeck of de Grondt der Edel Vry Schilder-Const*. Haarlem, 1604.

Mander, Karel van, *Het leven der doorluchtige Nederlandsche en eenige Hoogduitsche schilders*. Two vols. Naar de besten druk van 't jaar 1618, Amsterdam, 1764.

Matsier, Nicolaas, *Het bedrogen oog*. Amsterdam, 2009.

Mens, Jan, *Meester Rembrandt. Roman*. Amsterdam/Antwerp, 1946.

Middelkoop, Norbert et al., *Rembrandt onder het mes: De anatomische les van Dr Nicolaes Tulp ontleed*. The Hague/Amsterdam, 1998.

Mieris de Jonge, Frans van and van Alphen, Daniël, *Beschrijving van Leyden*. Three vols. Leiden, 1762–84.

Moerman, Ingrid, "Leiden: de stad en haar bewoners in Rembrandts tijd". In Roelof van Straten, *Rembrandts Leidse tijd, 1606–1632*. Leiden, 2005.

Montaigne, Michel de, *De essays*. Translated into Dutch by Hans van Pinxteren. Amsterdam, 2004.

Nellen, Henk, *Hugo de Groot: Een leven in strijd om de vrede. 1583–1645*. Amsterdam, 2007.
Neumann, Carl, *Rembrandt*. Two vols. Munich, 1922.
Noordam, Dirk Jaap, *Geringe buffels en heren van stand: Het patriciaat van Leiden, 1574–1700*. Hilversum, 1994.
Noorman, Judith and de Witt, David (eds), *Rembrandts naakte waarheid: Het tekenen van naaktmodellen in de Gouden Eeuw*. Amsterdam/Zwolle, 2015.
Nooteboom, Cees, *Het raadsel van het licht*. Amsterdam, 2009.

Oerle, H.A. van, *Leiden binnen en buiten de stadsvesten: De geschiedenis van de stedenbouwkundige ontwikkeling binnen het Leidse rechtsgebied tot aan het einde van de gouden eeuw*. Leiden, 1975.
Ommen, Kasper van, *The Exotic World of Carolus Clusius 1526–1609*. Leiden, 2009.
Oomes, R.M.Th.E. and Groos, K.S., "Identificatie van zerken, graven en begravingen". *Graven in de Pieterskerk*. Leiden, 1981.
Orlers, J.J., *Beschrijvinge der Stadt Leyden*. Leiden, 1641. Second edition.
Os, Henk van, *Rembrandts offer van Abraham in de Hermitage*. Amsterdam, 2005.
Otterspeer, Willem, *Groepsportret met dame: De Leidse universiteit*. Three vols. Amsterdam, 2000.
Otterspeer, Willem, *Het bolwerk van de vrijheid: De Leidse universiteit in heden en verleden*. Leiden 2008.
Otterspeer, Willem, "Orlers en ik". *De Gids*, vol. 171, 2008.
Ovid, *Metamorphoses*. Translated into English by A.S. Kline, published online.

Panhuysen, Luc and van Stipriaan, René, *Ooggetuigen van de Tachtigjarige Oorlog: Van de eerste ruzie tot het laatste kanonschot*. Amsterdam, 2018.
Pollmann, Judith, "Een 'blij-eindend treurspel': Leiden, 1574". In Herman Amersfoort et al. (eds), *Belaagd and belegerd*. Amsterdam, 2011.
Ponte, Mark, "Twee mooren in een stuck van Rembrandt". In Lex Heerma van Voss, *Wereldgeschiedenis van Nederland*. Amsterdam, 2018.

Roding, Juliette, Sneller, Agnes and Thijs, Boukje, *Beelden van Leiden: Zelfbeeld en representatie van een Hollandse stad in de Vroegmoderne tijd, 1550–1800*. Hilversum, 2006.
Roskam Abbing, Michiel, *Rembrandt: Leven en werk van de grootste schilder aller tijden*. Utrecht/Antwerp, 2006.
Rulkens, Charlotte, *Rembrandt en het Mauritshuis*. The Hague/Zwolle, 2019.

Sandrart, Joachim von, *Teutsche Academie der Bau-, Bild- und Mahlerey-Künste*. Three vols. Nuremberg, 1675–80.
Schaeps, Jef van Duijn, Mart, *Rembrandt en de Universiteit Leiden*. Leiden, 2019.
Schama, Simon, *De ogen van Rembrandt*. Translated into Dutch by Karina van Santen and Martine Vosmaer. Amsterdam, 1999.
Schenkeveld-van der Dussen, M.A., *Nederlandse literatuur in de tijd van Rembrandt*. Utrecht, 1994.
Schwartz, Gary, *Rembrandt. Zijn leven, zijn schilderijen*. Maarssen, 1984.
Schwartz, Gary, *De grote Rembrandt*. Zwolle, 2006.
Schwartz, Gary, *The Night Watch*. Amsterdam, 2008.
Schwartz, Gary, *Ontmoet Rembrandt: Leven en werk van de meesterschilder*. Amsterdam, 2009.
Schwartz, Gary, "Putting ourselves and Rembrandt to the test". *Schwartzlist* 373, 2019, www.garyschwartzarthistorian. nl.
Severinus, Adrianus, *Oorspronckelijke beschrijving van de vermaerde belegering en 't ontzet der stad Leiden*. Leiden, 1674.
Six, Jan, *Rembrandts portret van een jongeman*. Amsterdam, 2018.
Slive, Seymour, *Drawings of Rembrandt*. Two vols. New York, 1965.
Sluijter, Eric J. (ed.), *Leidse fijnschilders. Van Gerrit Dou tot Frans van Mieris de Jonge 1630–1760*. Leiden/Zwolle, 1988.
Stipriaan, René van, *Het volle leven. Nederlandse literatuur en cultuur ten tijde van de Republiek (1550–1800)*. Amsterdam, 2002.
Stipriaan, René van, *De hartenjager: Leven, werk en roem van Gerbrandt Adriaensz Bredero*. Amsterdam, 2018.
Stipriaan, René van, "Shakespeare, Bredero, Rembrandt: Het theater van de hartstochten in de zeventiende eeuw". *De Nederlandse Boekengids* 22, October/November 2018.
Stoter, Marlies and Lange, Justus (eds), *Rembrandt and Saskia: Liefde in de Gouden Eeuw*. Leeuwarden/Zwolle, 2019.
Straten, Roelof van, *Rembrandts Leidse tijd 1606–1632*. Leiden, 2005.
Stremmelaar, D., "Spelen en leren in Leiden rond 1600". *Leids jaarboekje*, vol. 110, 2018.
Suchtelen, Ariane van and Wheelock Jr, Arthur, *Hollandse stadsgezichten uit de Gouden Eeuw*. Exhibition catalogue, Mauritshuis. Zwolle, 2008.

Taylor, Paul, "Rembrandt's Injustice of Piso". *Oud Holland*, vol. 124, nos 2–3, 2011.

Tjon Sie Fat, L., *De tuin van Clusius: Het ontstaan van de Leidse hortus*. Leiden, 1992.
Tümpel, Astrid and Schatborn, Peter, *Pieter Lastman: Leermeester van Rembrandt*. Amsterdam/Zwolle, 1991.

Vasari, Giorgio, *De levens van de grootste schilders, beeldhouwers en architecten*. Amsterdam, 1998.
Veth, Jan, *Rembrandt*. Paris, 1924.
Vogelaar, Christiaan, *Een jong en edel schildersduo: Rembrandt and Lievens in Leiden*. Exhibition catalogue, Stedelijk Museum de Lakenhal. Zwolle, 1991.
Vogelaar, Christiaan, *Jan van Goyen*. Leiden/Zwolle, 1996.
Vogelaar, Christiaan and Korevaar, Gerbrand, *Rembrandts Moeder: Mythe en werkelijkheid*. Leiden/Zwolle 2005.
Vogelaar, Christiaan and Weber, Gregor J.M., *Rembrandts landschappen*. Leiden/Zwolle, 2006.
Vos, Rick, *Lucas van Leyden*. Maarssen, 1978.
Vosmaer, Carel, "Een pelgrimstocht naar de Weddesteeg", 1860. Reprinted in *Vogels van diverse pluimage*. Leiden, 1874.
Vosmaer, Carel, *Rembrandt Harmens van Rijn, sa vie et ses oeuvres*. The Hague, 1868.
Vosmaer, Carel, *Onze hedendaagse schilders*. Two vols. Amsterdam, 1884.
Vries, Dirk J. de, "In de ban van Rembrandt, huizen en herdenkingen". *Bulletin knob* 4, 2006.

Walle, Kees, *Buurthouden. De geschiedenis van burengebruik en buurtorganisaties in Leiden (14e–19e eeuw)*. Leiden, 2005.
Wentink, K., *Rembrandt molenaarszoon*. Leiden, 1991.
Wetering, Ernst van de, "De symbiose van Lievens en Rembrandt". In Christiaan Vogelaar, *Een jong en edel schildersduo: Rembrandt and Lievens in Leiden*. Exhibition catalogue, Stedelijk Museum de Lakenhal. Zwolle, 1991.
Wetering, Ernst van de, *Rembrandt: The Painter at Work*. Amsterdam, 1997.
Wetering, Ernst van de, *Jonge Rembrandt groot: Het Leidse werk*. Leiden, 2006.
Wetering, Ernst van de, *Rembrandt: Zoektocht van een genie*. Amsterdam/Zwolle, 2006.
Wetering, Ernst van de, *Rembrandt in nieuw licht*. Amsterdam, 2009.
Wetering, Ernst van de, *Rembrandt: The Painter Thinking*. Amsterdam, 2016.
Wetering, Ernst van de, *Rembrandt's Paintings Revisited: A Complete Survey. A Reprint of a Corpus of Rembrandt's Paintings* VI. Dordrecht, 2017.
Wetering, Ernst van de and Schnackenburg, Bernard, *The Mystery of the Young Rembrandt*. Kassel/Amsterdam, 2002.
Weyerman, Jacob Campo, *De Levens-Beschryvingen der Nederlandsche Konst-Schilders en Konst-Schilderessen*. The Hague/Dordrecht, 1729–69.
Wheelock Jr, K. Arthur, *Jan Lievens. A Dutch Master Rediscovered*. Amsterdam/Washington, 2009.
White, Christopher, *Rembrandt: Biografieën in woord en beeld*. Translated into Dutch by J.M. Komter. The Hague, 1964.
White, Christopher and Buvelot, Quentin (eds), *Rembrandt by Himself*. Zwolle, 1999.
Wolkers, Jan, *De spiegel van Rembrandt*. Zwolle, 1999.
Wolkers, Jan, "Rembrandt is Rembrandt". In *De schuimspaan van de tijd*. Amsterdam, 2001.
Wurfbain, M.L., *IJdelheid der ijdelheden. Hollandse vanitas-voorstellingen uit de zeventiende eeuw*. Leiden, 1970.
Wurfbain, M.L., *Catalogus van de schilderijen en tekeningen: Stedelijk Museum de Lakenhal*. Leiden, 1983.
Wurfbain, M.L. et al., *Geschildert tot Leyden anno 1626*. Leiden, 1976.

Zijlmans, Jori, "Pieter Adriaensz van der Werff: held van Leiden". In Joris van Eijnatten (ed.), *Heiligen of helden: Opstellen voor Willem Frijhoff*. Amsterdam, 2007.
Zijlmans, Jori, *Leidens ontzet: Vrijheidsstrijd and Volksfeest*. Leiden, 2011.
Zwakenberg, Johan, "Het historiestuk (1626) van Rembrandt te Leiden: Een bronnenonderzoek". In *Leids jaarboekje* 102, 2010.
Zwakenberg, Johan, "Prins Yusupov, Leiden en twee Rembrandtportretten". In *Leids jaarboekje* 110, 2018.

Judith at the Banquet of Holofernes (detail), 1634.

Index of Names

Numbers in **bold** refer to images or captions.

Simeon's Song of Praise, 1631.

Acknowledgements

REMBRANDT REMAINS AN ENIGMA, THANK GOODNESS, HOWEVER HARD you try to explain the power of his artistic genius and the enchantment of his youth. Yet without the dedicated efforts, expertise and support of the following people, I would not have succeeded in coming close to that boy who grew up in my own city four centuries ago, and to write down his story.

There are many people to whom I owe a great debt of gratitude:

The spiritual fathers of *Young Rembrandt*, Gary Schwartz and Ernst van de Wetering, *grands seigneurs* of Rembrandt studies, both of whom dedicated over half a century of their lives to the painter, each in his own inimitable way. They invited me to their homes, read along critically and alerted me to pitfalls, provided valuable advice and constantly pointed me in the direction—sometimes opposing directions—of new possibilities and perspectives for continuing research on Rembrandt.

The archive tigers Piet de Baar and Kees Walle, from whom nothing in the history of Leiden remains hidden. Both were generous and indefatigable in their efforts to help me search, transcribe and analyse seventeenth-century documents on the city and on Rembrandt and his surroundings.

The people of Leiden who felt committed to the project and assisted me expertly and in a spirit of friendship: Ingrid Moerman for making available her archival documents and notes on Rembrandt, André van Noort of Erfgoed Leiden, Boy Heijnekamp, Ward Hoskens and Frieke Hurkmans of the Pieterskerk, Jeremy Bangs of the Leiden American Pilgrim Museum and Lucien Geelhoed and Martijn Bulthuis of Marketing Leiden.

Christiaan Vogelaar, "*detto Il Corvo*", curator of Old Master art at the Museum De Lakenhal, was not in a position to support me as he did in the case of *Stad van verf* since he was immersed in writing his own book about the young Rembrandt. Nonetheless, he provided personal and moral support as a true friend. I should also like to thank Jef Schaeps, Mart van Duijn, Erik Weber and Kasper van Ommen for sharing their knowledge and showing me the gems in the treasury of Leiden University Library.

Leo Lucassen for his illuminating observations on immigration in Leiden in the sixteenth and seventeenth centuries, Paul Hoftijzer for clarifying the world of books in Rembrandt's time and George Maat for allowing me to inspect his research

on the graves in the Pieterskerk in Leiden. The eminent literary scholars Frans Blom and Ad Leerintveld for their insights into the world and thinking of Constantijn Huygens in the course of a glorious sunny day in The Hague. Jonathan Bikker for his personal guided tour of the works of the young Rembrandt in the Rijksmuseum, Peter Schatborn, former director of the Print Room of the Rijksmuseum, for his explanatory remarks on Rembrandt's drawings.

My editor-in-chief at de Volkskrant, Chris Buur, who gave me a weekly column in which to report on my quest to follow the trail of the young Rembrandt. My expert English translator Beverley Jackson for what she warned might be "hysterical telephone calls" in which she constantly alerted me to details in my language and style that needed to be formulated with ever greater clarity.

The buzzing workers in the beehive of the De Bezige Bij publishing house: Francien Schuursma, Haye Koningsveld, Henrike de Goede, Pascalle Veltstra, Rutger Wilmink, Geurt Naber, Anne Kramer, Inky Menssink, Suzanne Holtzer, Marijke Nagtegaal and last but not least my inspired editor Aafke van Hoof, who helped to retain my faith in the book in hours of need.

Jan de Boer and Ingrid Vonk for the imagination with which they designed this book.

Willem Otterspeer, my doctoral supervisor, for sharing with me his astounding knowledge of Leiden, its university and its history. But above all for his dazzling good humour and outstanding conversation. My learned and empathic friend Wim Willems, who threw himself into the correction of my manuscript with such fervour that he injured his hand. My most severe and most loving critic, Marika Keblusek, for her caustic deletions of my unforgiveable errors of reasoning and slips of the pen.

My elegant Amsterdam friend Jan Six for sharing his boundless knowledge and love of Rembrandt and his doomed efforts to curb my passionate preference for Leiden.

My Maecenas, Bert van Eenennaam, for his unflagging, valuable and generous support. It still renders me speechless at times. Without Bert, Young Rembrandt would never have been written.

The "furious Wolkers widow" Karina, whom I called on the telephone every Monday morning to read out my column. I can always take refuge in her place on Texel.

Jochem Myjer, Alexander van Nimwegen, Menno Bentveld, Roland Mans, Richard van Leeuwen and all the guys at the coffee table at Borgman Borgman— roughly where Petrus Scriverius lived in Rembrandt's day—for their patience during

my absence over the past two years. When I did turn up, I was pelted with really, really bad jokes. Just as well. Among my Leiden friends, I would like to thank in particular the painter and photographer Casper Faassen, whose life has been dedicated to Rembrandt from the moment he drew *The Night Watch* on his bedroom wallpaper as a small boy. He kept a suspicious eye on me while I was writing about his hero. I regard his grumbles as an act of friendship.

My wider family: my brother Just and his family, and the "Suwi men", to whom I have belonged for over twelve years, for their unconditional solidarity, support and love.

My parents, without whom I would not be full of love for Leiden, for literature, for art and history.

Without Donna, Flo, Julia and Sofie, my existence would not exist. Even so, they had to endure their father's absence, day in, day out, while he was out hunting a ghost from the seventeenth century.

Finally: this book is for Lot, love of my life.